THE JOKER

First published in the United States of America in 2011 by Universe Publishing, A Division of Rizzoli International Publications, Inc.
300 Park Avenue South
New York, NY 10010
www.rizzoliusa.com

2012 2013 2014 2015 / 10 9 8 7 6 5 4 3

Printed in China

ISBN: 978-0-7893-2247-0

Library of Congress Control Number: 2011927225

Page 1: The Joker collects Jimmy Olsen's bow tie, signal watch, and Daily Planet ID in Andy Kubert's cover to *Countdown* #50 (July 2007).

Page 2: Dick Sprang captures a rare moment: the Joker without his grin. From *Batman* #19 (October–November 1943).

Page 5: Sam Kieth's rendition of the Joker channels his insanity through a gaze that seems to say to the viewer, "You're next." From *Arkham Asylum: Madness* (2011).

Page 6: This Jim Lee sketch was a gift from the artist to actor Heath Ledger, who won a posthumous Best Supporting Actor Academy Award for his portrayal of the Joker in 2008's *The Dark Knight*.

Page 8: Mike Deodato Jr. drew this rare battle between the Joker and the Amazing Amazon in *Wonder Woman* #96 (April 1995).

Page 9: A cracked magnifying glass symbolizes the Joker's splintered psyche in this Carl Critchlow trading card from Fleer's *Batman Master* series (1996).

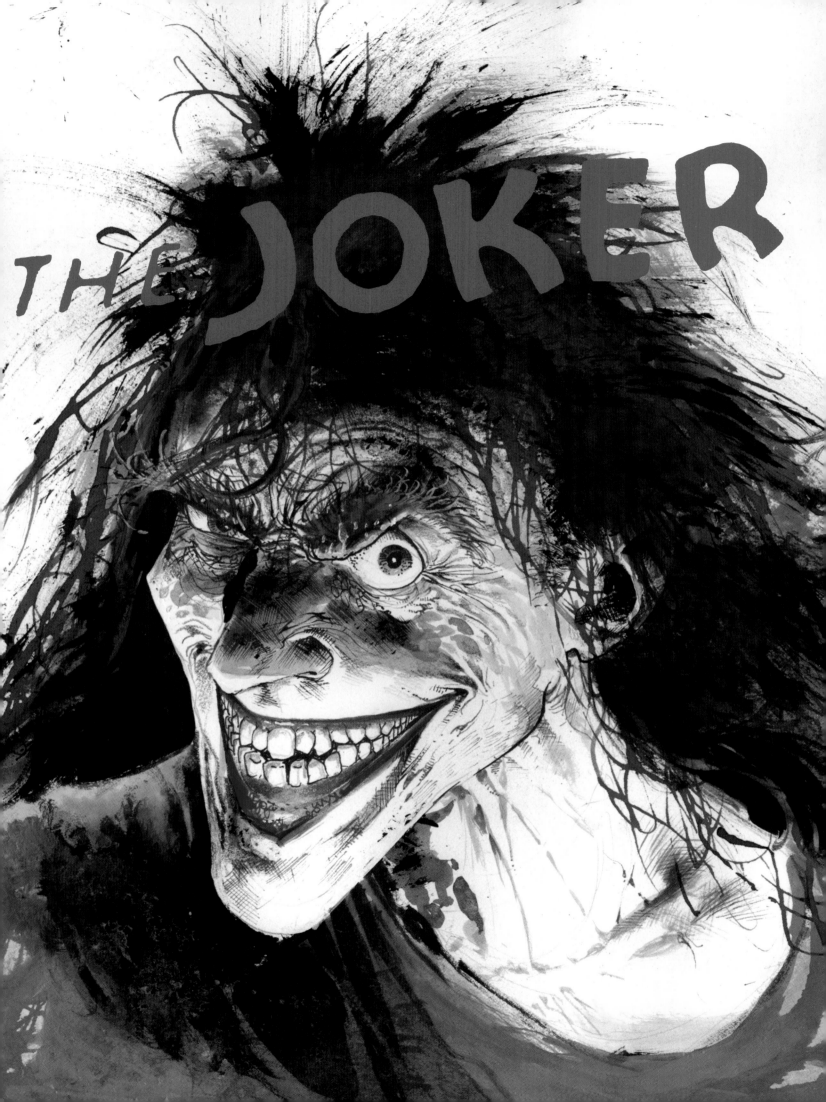

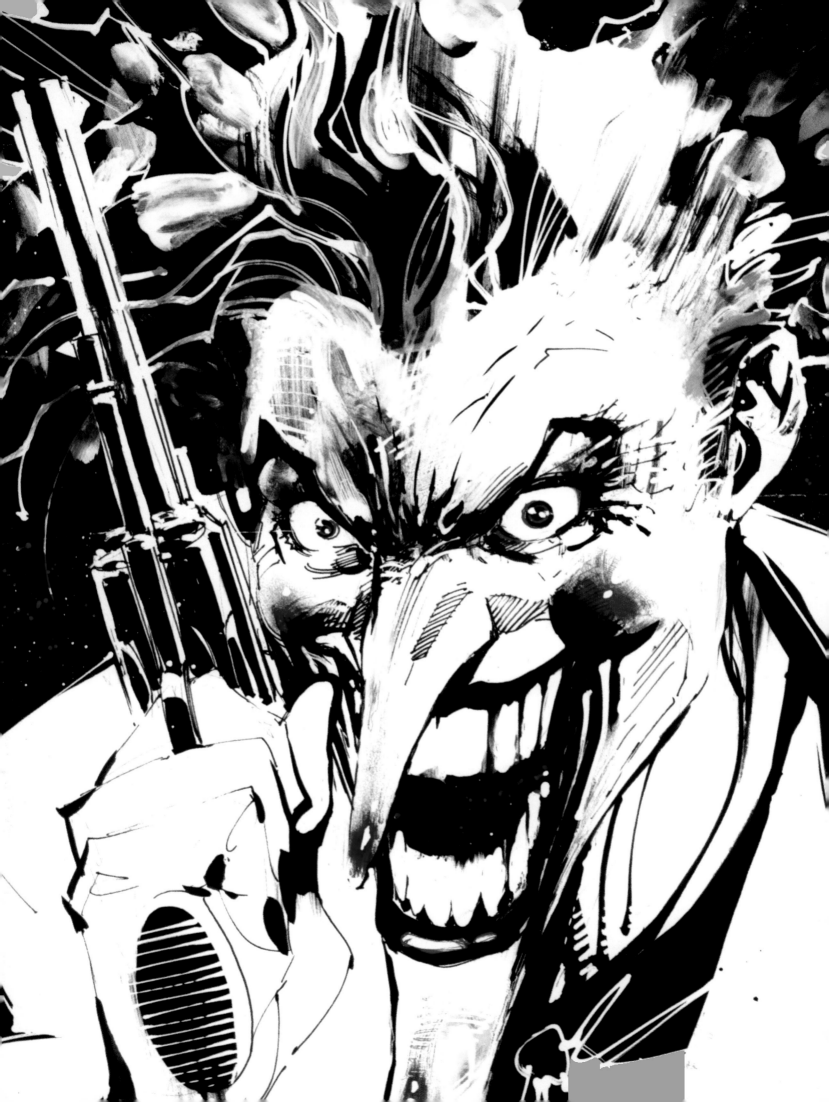

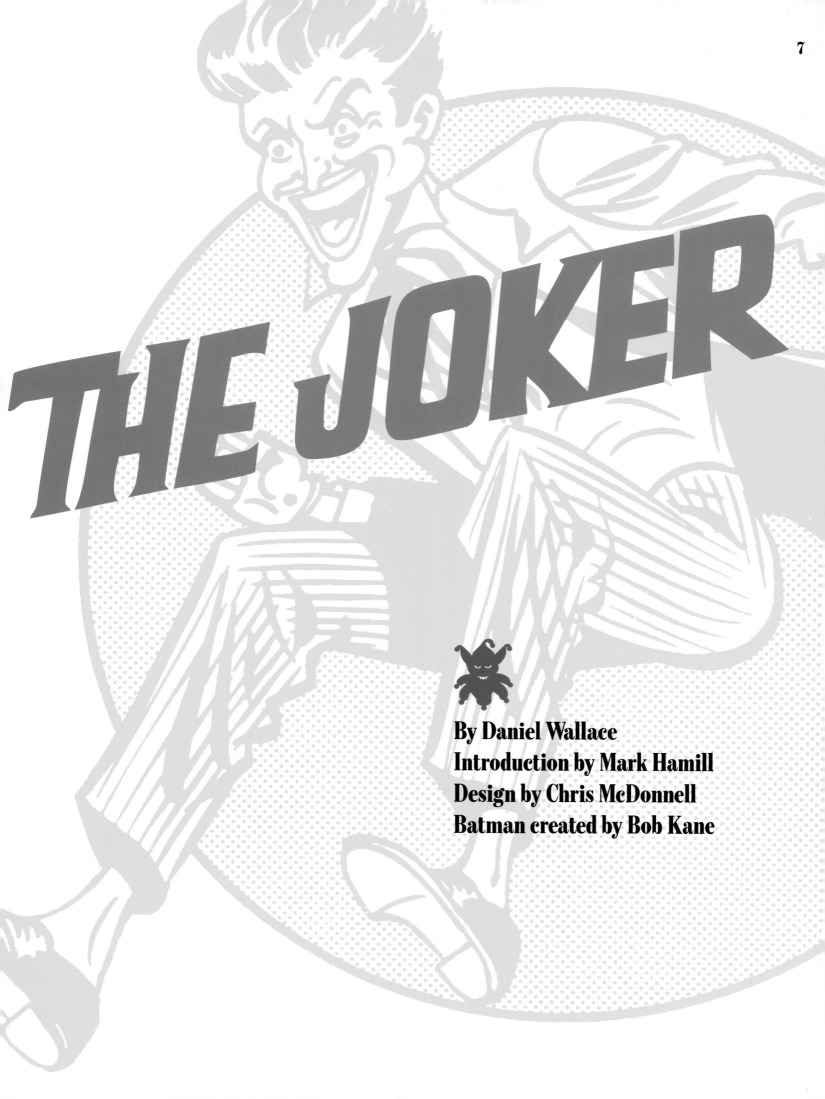

THE JOKER

By Daniel Wallace
Introduction by Mark Hamill
Design by Chris McDonnell
Batman created by Bob Kane

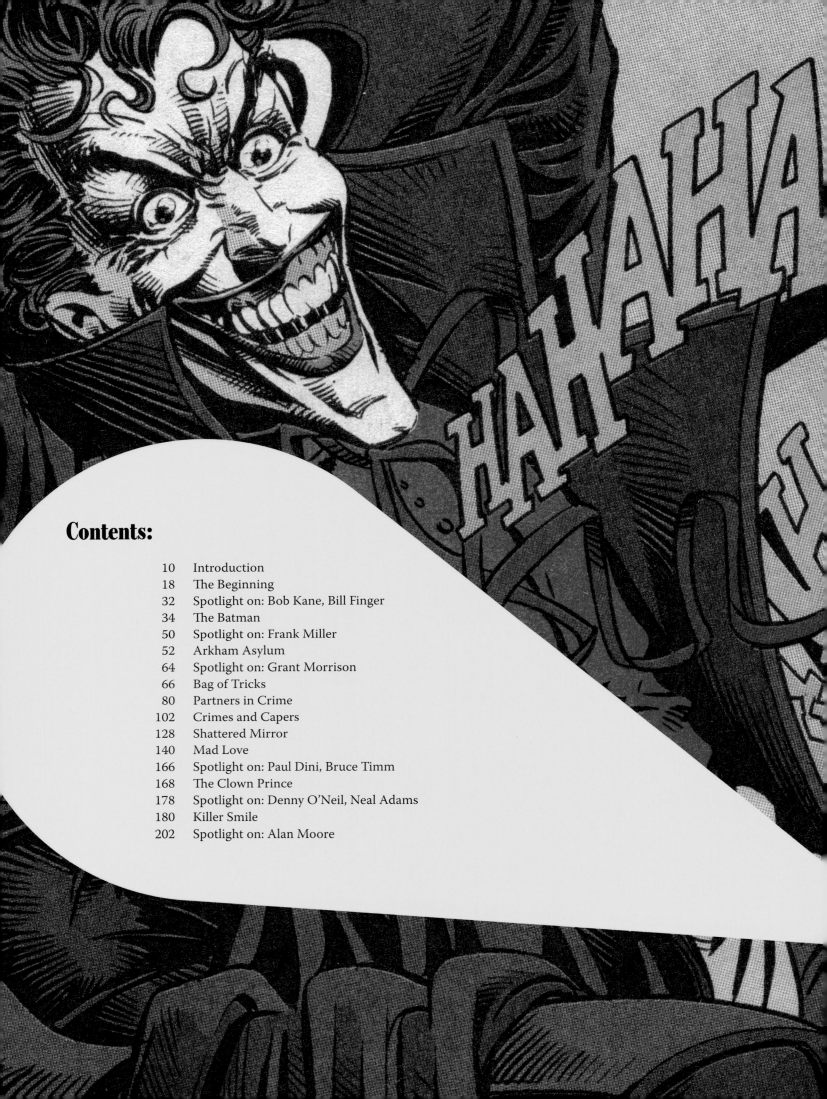

Contents:

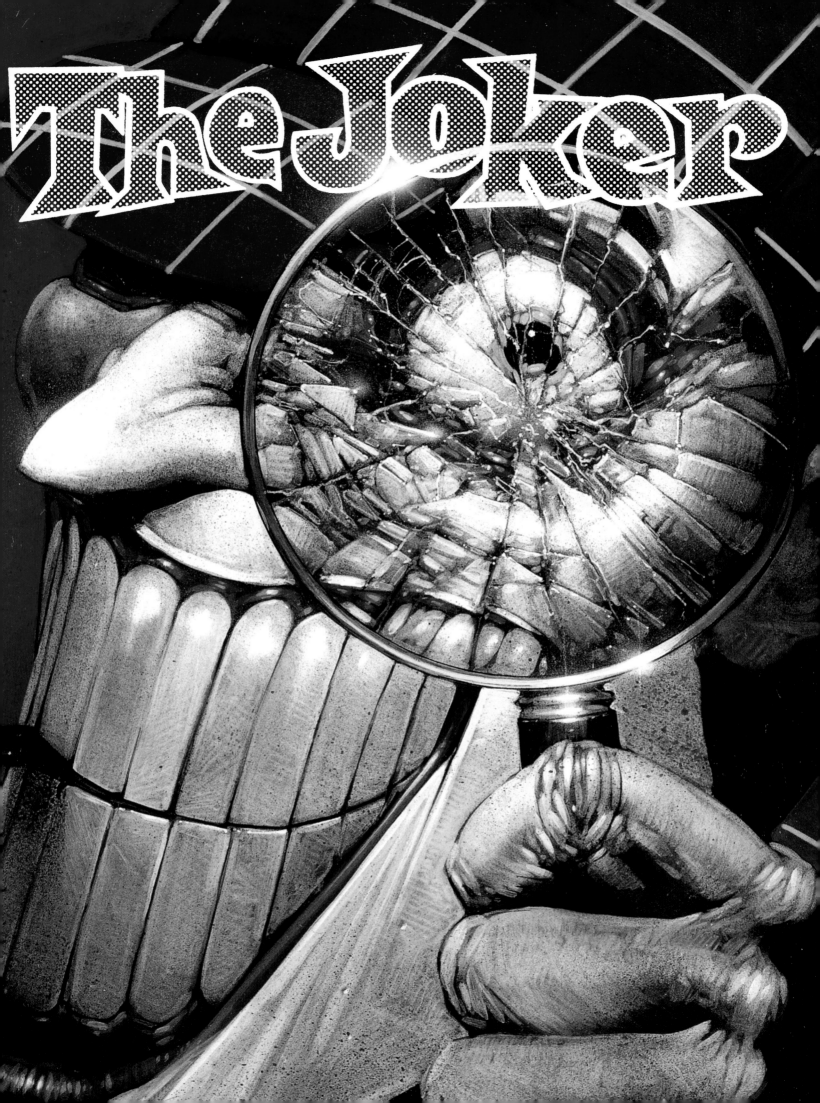

Introduction

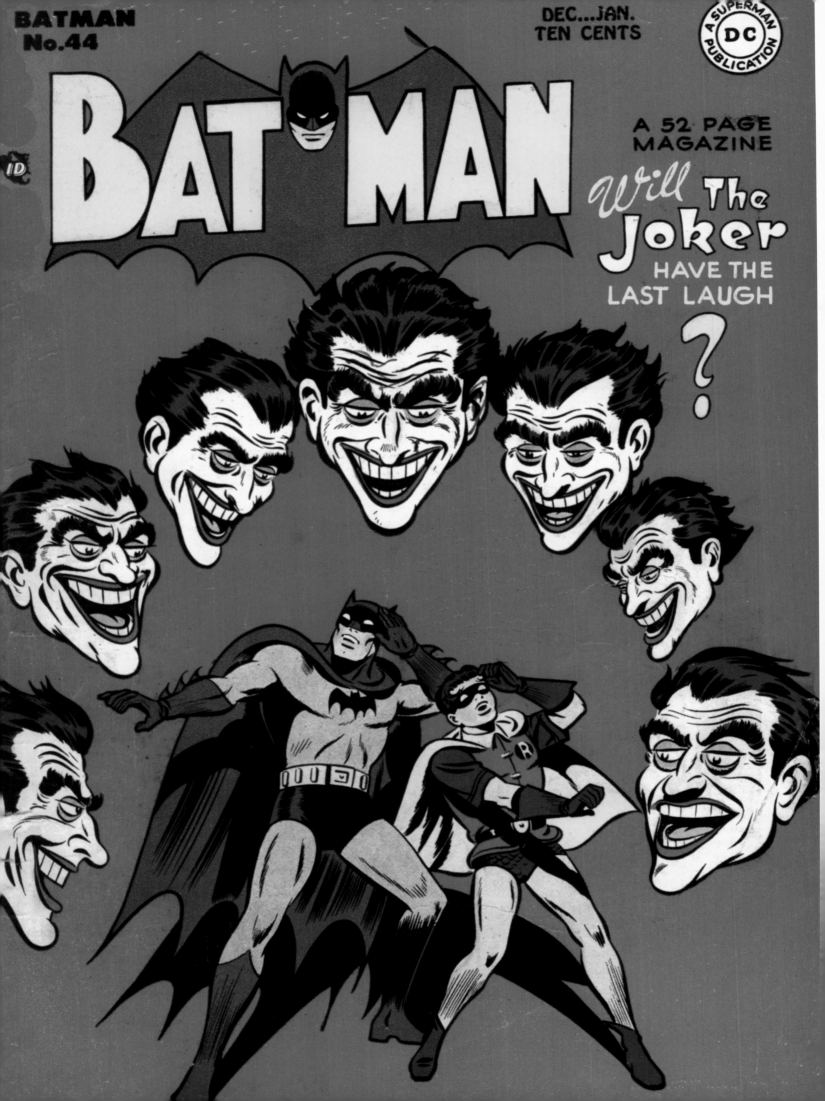

"Without Batman, Crime Has No Punchline!"
—The Joker, from "The Man Who Killed Batman",
written by Paul Dini

This line, spoken when the Joker mistakenly believes Batman has been elimi-
nated by a second-rate, run-of-the-mill, no-name thug, helped me gain a greater insight
into the character and his motivations than perhaps anything he had ever said or done
before. The Joker's monumental ego shattered, he became an aimless, bewildered, and
broken man. Deprived of his ultimate goal of triumphing over his hated archenemy once
and for all, he had simply lost the will to live, or murder, or commit a crime of any kind,
ever again. Oh sure, he would make an exception in the case of the crook who had stolen
his thunder by bringing down the Dark Knight, of course. In fact, after sealing this
hapless man alive in a coffin, then plunging it into a vat of acid, the Joker actually rallies
briefly, delivering a eulogy full of fire and brimstone, riddled with bitter contempt and
words of vengeance. Temporarily satisfied, he does a complete emotional 180, declaring:
"Well, that was fun! Who's for Chinese?"

Actors wait all their lives for dialogue that rich, a character that complex
and profoundly diabolical. I have performed that speech a handful of times before a
live audience and it never fails to bring down the house with a rapturous, thunderous
response. I only wish I were back on Broadway so I could deliver it eight times a week!

In 1991, when I first learned of plans for an animated Batman series, two facts
stood out for me: the order was for 65 episodes and their stated goal was to emulate
the quality of Max Fleischer's classic *Superman* cartoons of
the 1940s. This seemed to indicate that they would be making
enough shows to expand the subject matter beyond anything
they had ever done with the character outside of the comic
books, and that they were determined to strive for excellence
in doing so. As a lifelong fan of both animation and comics, I
wanted in! My agent let the producers know I was greatly inter-
ested in participating and much to my surprise, they responded
immediately, giving me the role of Ferris Boyle in their first
Mr. Freeze episode, "Heart of Ice", without even requesting an
audition. Ignoring my slight disappointment at not being offered
the role of Freeze himself, I couldn't wait to read the script.
When it arrived, I have to tell you, I wasn't prepared for just how
well written it was. Rather than a standard mad scientist, Victor
Fries had been reimagined as an epic tragic figure so driven to
save his wife from a terminal illness, he had dedicated himself
to developing a cryogenic method of preserving her until a cure
could be found. My character, the real villain in the story, was a
sleazy corporate CEO, who, in a physical altercation kicked Fries

Previous spread: The Joker snaps! Bruce Timm illustrated this confrontation from the award-winning comic *Batman Adventures: Mad Love* (1994).
Opposite: Jim Mooney and Charles Paris provided a hallucinatory gaggle of Jokers on the cover of *Batman* #44 (December 1947/January 1948).

into the very chemicals that sealed his fate as a freak of nature, doomed to live forevermore in sub-zero temperatures. Drenched in pathos, the final shot of Mr. Freeze contemplating the delicate figure of his beloved lost mate within a small snow globe, while confined in a specially constructed refrigerated cell at Arkham Asylum, was deeply heart-wrenching. Michael Ansara delivered a haunted and, yes, chilling portrayal of Mr. Freeze. It was one of the best scripts I had ever read in any medium, and I knew that this show had the potential to be something very special indeed. I couldn't wait to get to the studio and record it.

When that day came, my enthusiasm only increased as I scrutinized the artwork displayed around the room. Artist renderings of Gotham City were paradoxically retro and futuristic at the same time, with an airbrushed, deep three-dimensional quality and an overall darkness that would make the flatter, more colorful and cartoon-like drawings of the major characters really pop in contrast. It was on this day that I first met the creative team and peppered them with questions I had about the direction of the show. Would there be shows without costumed villains? With 65 episodes to produce, it seemed likely they could do scripts that were straight-ahead mysteries, accentuating Batman's superlative skills as a detective, an element that had

Above: As the voice of the Joker in *Batman: The Animated Series*, Mark Hamill racked up more hours of screen time as the Clown Prince of Crime than any other actor.

Opposite: Alex Ross's painted cover for *The Joker: The Greatest Stories Ever Told* smooths the clown's extreme facial contours, but his grin still chills the blood.

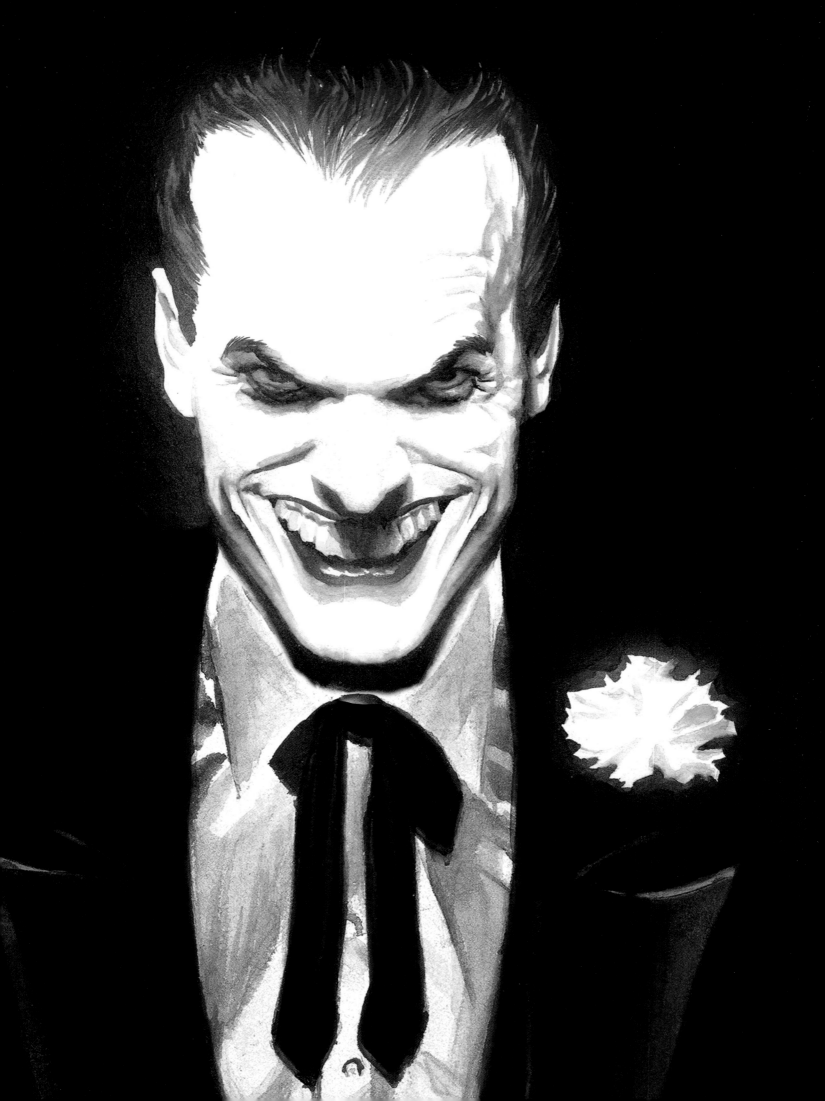

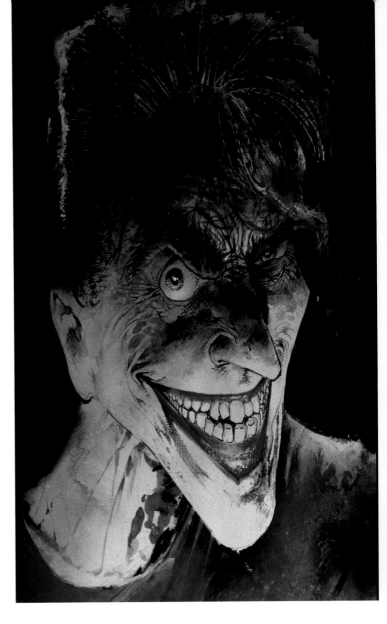

fallen by the wayside in previous incarnations. Would they be adapting any of the actual comic book scripts? Would they have to cater to the youngest audience members, avoiding the gothic horror and adult themes that older fans preferred? Would they be including antagonists that had never been done in animation before, like Ra's Al Ghul, Hugo Strange, Killer Croc, Killer Moth, Clayface, or even, (gulp) Polka-Dot Man? Though they were somewhat circumspect on the specifics, it was clear they were kindred spirits who were as enamored of the source material as I was, maybe even more so, considering their past collective track records of having actually worked on super hero cartoons, something I had never done. (Listen to the show's DVD commentary for Bruce Timm's memories of me on that day. I knew he was a brilliant artist, now I know he's a hilarious mimic!)

About a month later, the producers wondered if I would be interested in auditioning for the role of the Joker. What a silly question! I still wonder if they would have thought of me at all, had I not done the prior episode and let my fanboy flag fly unashamedly. There were only a few pages of dialogue and one small drawing of him to inform my interpretation, but under the expert guidance of vocal director Andrea Romano (who would eventually guide me through many years of episodes and remain a dear friend to this very day) and a liberating note on page one,

"Don't think Nicholson," I managed to conjure up my version of the "Grim Jester," a sort of cross between Claude Rains and the Blue Meanie from Yellow Submarine. Within days, I received a phone call and heard the words "Congratulations, they want you for the Joker." I was numb. My elation quickly evaporated into self-doubt as I agonized over the enormous responsibility I had undertaken. He is among the greatest villains in history. An institution in pop-culture. He's the Clown Prince of Crime. He's the Harlequin of Hate. He's... THE JOKER!!! I was terrified of disappointing his legion of fans who were sure to be brutal in their assessment if I displeased them in any way. Looking back, it's easy to see what an overreaction that was. I was about to become a part of a collaboration between some of some of the greatest writers, artists, musicians and actors I've ever been privileged to work with. They say a hero is only as good as his villain and I believe the reverse is also true. And I had the best: Kevin Conroy. With his two effortless and distinct characterizations of Bruce Wayne and his alter ego, he will always be my Batman and a loyal friend.

Above: Sam Kieth renders the Joker with a leer and a stretched fun house mirror exaggeration.
Opposite top: The voices of Batman and some of his foes gathered for a photo during the recording of "Almost Got 'Im" in 1992. Standing, left to right: Aron Kincaid (Killer Croc), Mark Hamill (the Joker), Richard Moll (Two-Face), Paul Williams (the Penguin), Kevin Conroy (Batman). Seated, left to right: Diane Pershing (Poison Ivy), Arleen Sorkin (Harley Quinn).

What is it about the Joker that has kept his audiences spellbound for more than 70 years? Is it because he's insane and therefore unpredictable? He may be crazy, but he's never boring, as you will learn in the pages of this marvelous book: the first in DC's history devoted solely to a villain. He is also the first villain to be rewarded, however briefly, with his own comic book title. There is another antagonist who would eventually earn her own title: Harley Quinn, the Joker's impossibly optimistic, delusional and abused girlfriend with the heart of gold. She is also the only character from the animated series to become a permanent member of the DC Universe. Created by Paul Dini and Bruce Timm, she was meant to appear only once, in "Joker's Favor." Thanks, in no small part, to Arleen Sorkin's hugely appealing and unforgettably poignant performance, she became an instant favorite and returned repeatedly, earning her own origin story, *Mad Love.* Long after the 109th and final episode, she continues to thrive, a female figure that holds her own among DC's finest, including Catwoman and Poison Ivy.

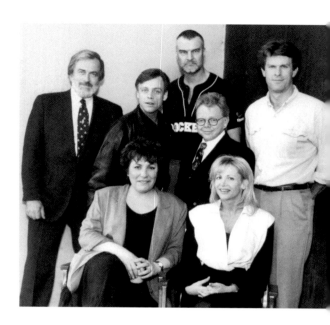

All good things must come to an end, and as the original incarnation of the show came to a conclusion (*Batman: The Animated Series, The Adventures of Batman & Robin, The New Batman Adventures*, plus the feature, *Batman: Mask of the Phantasm*) it was hard to relinquish a character that was so exhilaratingly thrilling to portray. Any chance I had to reprise the role was an unexpected gift I couldn't resist, including the feature-length *World's Finest: The Superman/Batman Movie* and *Batman Beyond: Return of the Joker*, as well as three episodes of *Justice League* and an appearance in *Static Shock.* There were the talking toys, amusement park voice-overs, and the video games: *Batman Vengeance, The Adventures of Batman & Robin*, DC Universe Online and my nastiest, most lethal version ever, *Arkham Asylum.* Just when I think I've had my last crack at that gleeful psychopathic genius, he grabs me by the throat once more, much like he has regularly cheated death since 1940. In fact, even as I type these words, I'm doing my final sessions for the new *Arkham City* video game. Can I ever quit this killer clown extraordinaire? One thing I can say with certainty: in all my years on stage, screen and television, this is easily one of the most challenging, most rewarding, most enjoyable characters I have ever experienced as an actor.

And that, my friends, is no joke.

Mark Hamill

Above: Bob Kane and Jerry Robinson's defining take on the Joker, from *Batman* #8 (December 1941/January 1942)
Overleaf: Dick Sprang and Charles Paris serve up a host of hideous harlequins in the classic "The Joker's Utility Belt!" from *Batman* #73 (October/November 1952).

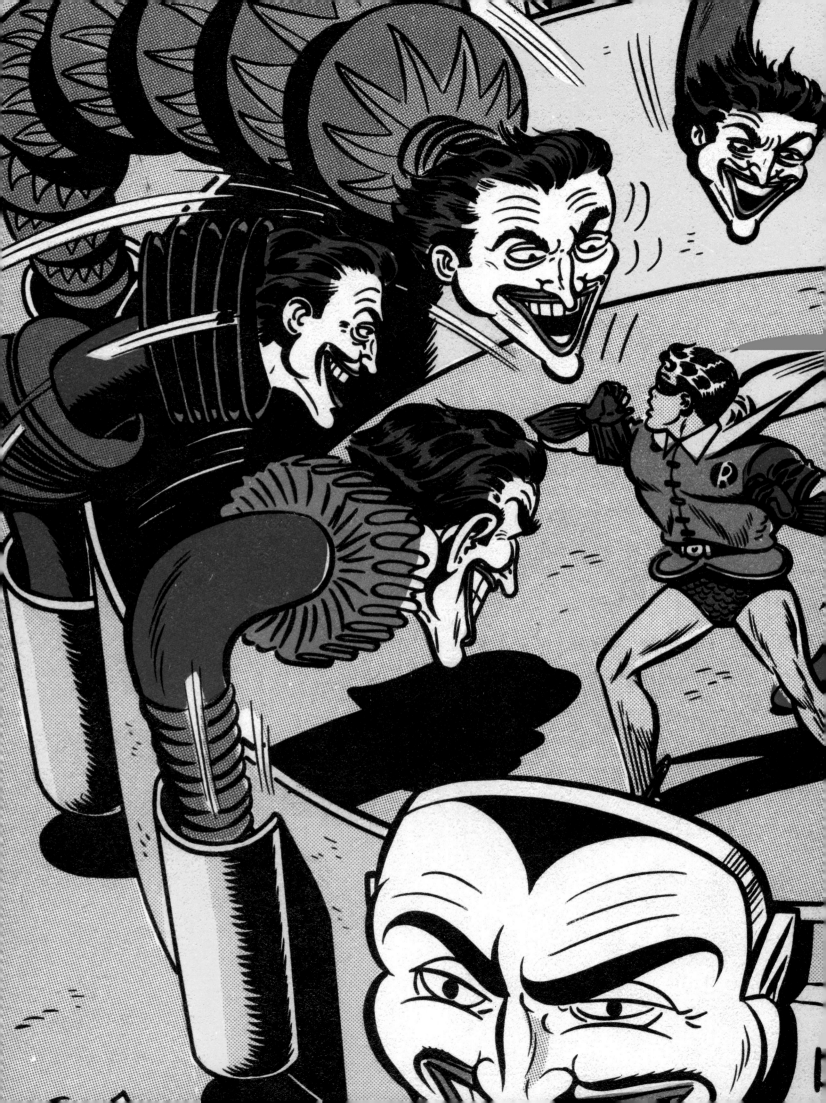

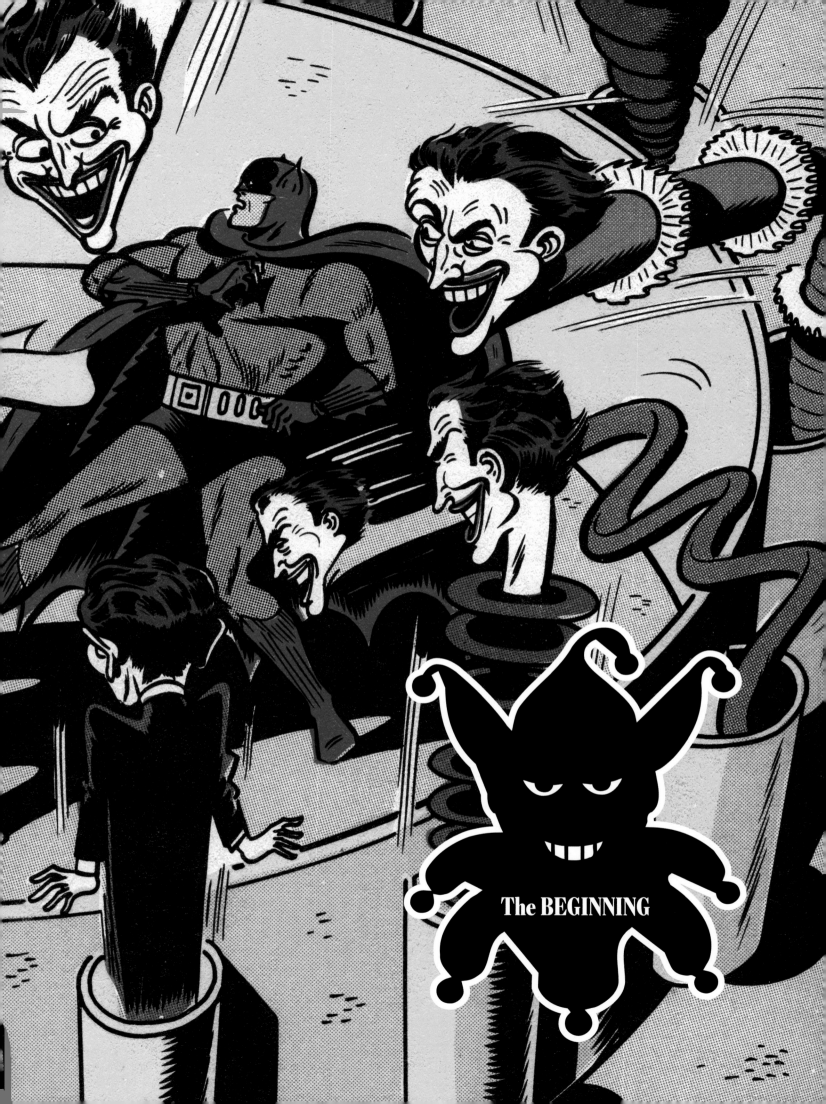

The BEGINNING

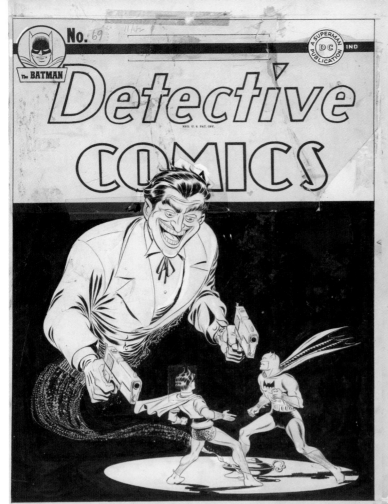

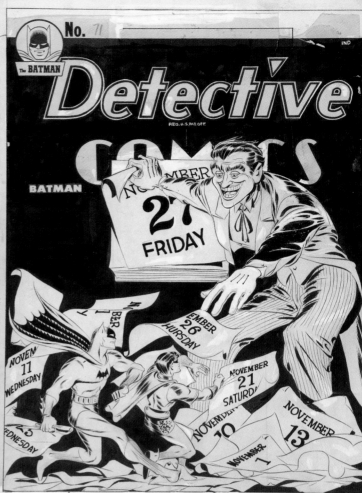

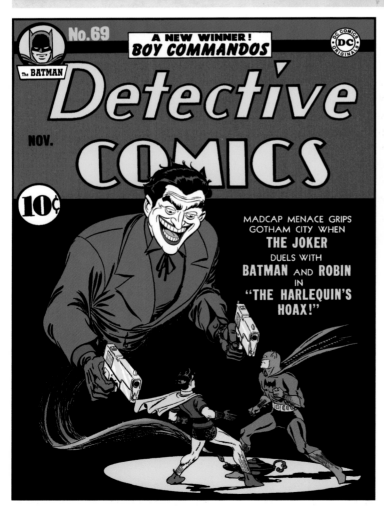

Above: Inks and final renditions of two *Detective Comics* covers (1942-1943) demonstrate how the Joker had already begun to overshadow the Dynamic Duo.

"If the police expect to play against the Joker, they had best be prepared to be dealt from the bottom of the deck!"
—*Batman* #1 (1940)

Some duos take time to develop. Superman didn't meet Lex Luthor until issue #23 of *Action Comics*, and it took five years before Moriarity bedeviled Sherlock Holmes. Not so with the Joker and Batman. Sparks (and knives, and venom) flew between the two in *Batman* #1, mere months after the Dark Knight made his own debut in the pages of *Detective Comics*.

Even more remarkable, the grinning killer reappeared in the very next issue. DC knew they had a winner on their hands, and they weren't about to wait until reader letters rolled in to validate their hunch. In the first dozen *Batman* issues, the Joker played the villain in nine.

It was another home run for Batman's creative team. Artist Bob Kane had dreamed up Batman the previous year, hoping to create another character for DC that would prove as popular as Jerry Siegel and Joe Shuster's Superman. Kane's sketches of a costumed mystery man evolved with input from writer Bill Finger. An origin story of a mugging that left wealthy Bruce Wayne an orphan provided motivation for Bruce to become the Batman, a black-garbed avenger who cast a pointy-tipped silhouette.

The Joker was the product of similar alchemy, though the specifics have become muddied by time. Kane's assistant Jerry Robinson brought in a joker playing card as inspiration for a new villain, and Finger drew comparisons between the Joker's wide smile and a photo of the tortured clown Gwynplaine, played by Conrad Veidt in the 1928 silent film *The Man Who Laughs*. Finger's son has suggested that a grimacing face used to advertise the Coney Island Steeplechase amusement park may also have influenced the team.

The Joker hit the ground running. His debut came packed with all the elements familiar to modern readers—the mirthless grin, the trademark "Joker Venom," the absence of remorse while racking up a gruesome tally of kills. At issue's end the Batman caused the Joker to fall on his own knife, prompting the villain to deliver his hysterical prognosis: "Ha! Ha! Ha! The Joker is going to die! Ha! Ha! The laugh is on the Joker! Ha! Ha! Laugh, clown, laugh!"

Top: The Joker's signature calling card. Art by Jerry Robinson.
Above: In *Batman* #1, the Joker kills a police officer with a poisoned dart hidden in a telephone earpiece.

This spread: The Joker earns a reprieve from the Grim Reaper in the final panel of his debut issue, written by Bill Finger, with art by Bob Kane and Jerry Robinson.

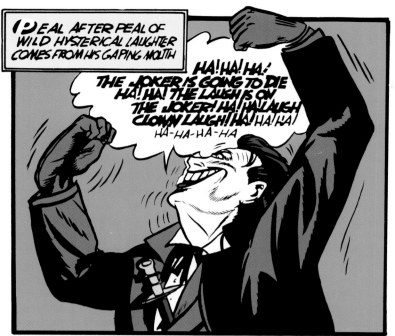

PEAL AFTER PEAL OF WILD HYSTERICAL LAUGHTER COMES FROM HIS GAPING MOUTH

HA! HA! HA! THE JOKER IS GOING TO DIE HA! HA! THE LAUGH IS ON THE JOKER! HA! HA! LAUGH CLOWN LAUGH! HA! HA! HA! HA-HA-HA-HA

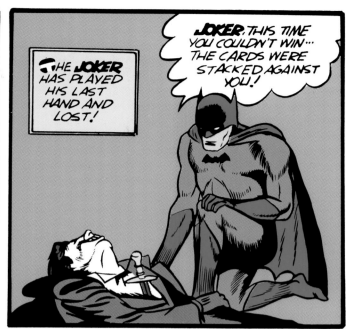

JOKER, THIS TIME YOU COULDN'T WIN... THE CARDS WERE STACKED AGAINST YOU!

THE JOKER HAS PLAYED HIS LAST HAND AND LOST!

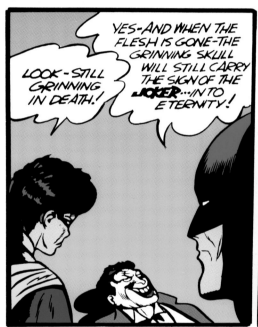

LOOK - STILL GRINNING IN DEATH!

YES - AND WHEN THE FLESH IS GONE - THE GRINNING SKULL WILL STILL CARRY THE SIGN OF THE JOKER... INTO ETERNITY!

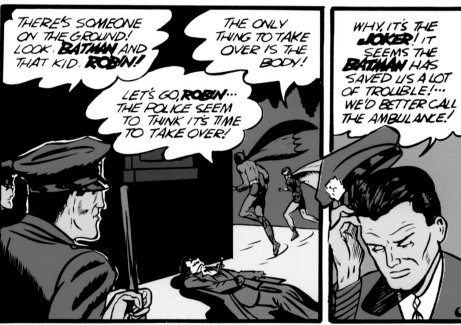

THERE'S SOMEONE ON THE GROUND! LOOK, BATMAN AND THAT KID, ROBIN!

LET'S GO, ROBIN... THE POLICE SEEM TO THINK IT'S TIME TO TAKE OVER!

THE ONLY THING TO TAKE OVER IS THE BODY!

WHY, IT'S THE JOKER! IT SEEMS THE BATMAN HAS SAVED US A LOT OF TROUBLE!... WE'D BETTER CALL THE AMBULANCE!

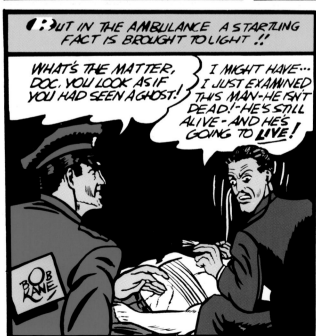

BUT IN THE AMBULANCE A STARTLING FACT IS BROUGHT TO LIGHT!!

WHAT'S THE MATTER, DOC, YOU LOOK AS IF YOU HAD SEEN A GHOST!

I MIGHT HAVE... I JUST EXAMINED THIS MAN - HE ISN'T DEAD! - HE'S STILL ALIVE - AND HE'S GOING TO LIVE!

GOLDEN RULES FOR "ROBIN'S REGULARS"

ROBIN'S CODE:

R EADINESS
O BEDIENCE
B ROTHERHOOD
I NDUSTRIOUSNESS
N ATIONALISM

OH NO, SIR, I COULDN'T TAKE ANYTHING! YOU SEE, I'M A MEMBER OF THE "ROBIN'S REGULARS" OUR FIRST MOTTO IS... "ALWAYS BE HELPFUL TO THOSE WHO NEED HELP!"

THANK YOU VERY MUCH FOR HELPING AN OLD MAN ACROSS THE STREET - I'D LIKE TO REPAY YOU FOR IT!

WHY NOT BECOME ONE OF "ROBIN'S REGULARS?" NO BUTTON OR BADGE IS NEEDED - THE WORLD WILL RECOGNIZE YOUR GOLDEN ACTS WITHOUT THEM! BE A "ROBIN REGULAR" BY BEING REGULAR!

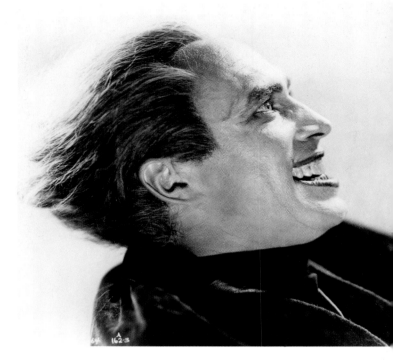

Said DC editor Jack Schiff, "I wanted to get good opponents for Batman, somebody powerful to fight against so the kids could get interested." But it was editor Whitney Ellsworth who recognized the Joker's superstar potential and rescued him from the meat wagon in the issue's final panel. As a startled medic put it, "I just examined this man—he isn't dead! He's still alive, *and he's going to live*!"

Truer words were never spoken. The Joker returned in the very next installment, sharpening his game against Batman and his short-pants sidekick Robin. And he wasn't just a comedian—he could fight, too! The Joker easily held his own when swinging punches, and proved so skilled at swordplay that he nearly brought the Dark Knight's career to an early end. It was almost easy to root for the Joker this time, since Batman's plans involved capturing the Joker and forcibly subjecting him to brain surgery "so he can be cured and turned into a valuable citizen."

Fortunately for readers, that didn't happen. By the early 1940s Batman and Robin were unqualified smashes. The Joker, by sheer volume of printed ink, became their archenemy. He began gracing *Batman* covers, and a splash page in issue #4 depicted him looming large as he literally held the Dynamic Duo in the palms of his hands. His appetite for mayhem went unslaked, resulting in multiple murders and, in issue #7, a train derailment.

But by issue #13 the Joker's crimes had taken a turn for the comic. In "Comedy of Tears" he kidnapped Robin and demanded a ransom of $100,000. Batman, honor bound to deliver the payout, wrote a personal check so the Joker couldn't cash it without facing arrest. A funny punchline, but also a sign of things to come as the Joker became more interested in harmless pranks than disfigured corpses. Not coincidentally, DC found it easier to market their comics to kids without the salacious overtones of the pulp magazines from which many superhero comics had sprung.

Around the same time, Bob Kane took over primary responsibilities for the newly launched *Batman* syndicated newspaper strip. This left even less time for him to contribute to the comics, and editor Ellsworth leaned on artist Dick Sprang to pick up the slack. Ellsworth himself sketched many covers. Editor Jack Schiff, meanwhile, collaborated with Bill Finger to

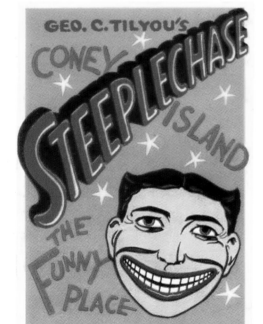

Top: Conrad Veidt as Gwynplaine in *The Man Who Laughs*.
Above: The Coney Island Steeplechase sign that may have influenced the Joker's creators.
Opposite: A dejected Joker has bats (and birds!) in his belfry in *Batman* #37 (October/November 1948), illustrated by Jerry Robinson.

hash out story concepts. All of these ghost contributors went unrecognized at the time. A 1946 issue of DC's *Real Fact Comics* promised to reveal "The True Story of Batman and Robin," but the making-of story was a fanciful tale that featured only Kane.

Dick Sprang's artwork set the tone for the next two decades. Sprang's pencils were inked by Charles Paris, and other Batman artists who followed the same style included Jack Burnley and Win Mortimer. Sprang remained philosophical about the job, which didn't make him famous but did allow him to relocate to sunny Arizona and mail his penciled pages to DC's New York offices. "To me it was a darn good way to make a living and have the freedom to choose where I lived." The Batman of this era had short horns on his Bat-Cowl and a friendly face that seemed like he would be just as happy if he were collaring crooks or directing traffic. The Joker retained his creepy frozen smile, but his stories played up the silliness and dialed down the sadism.

In 1952's "The Joker's Millions" from *Detective Comics* #180 (with art by Sprang and an uncredited script likely by Bill Finger or William Gibson), the Joker was a celebrity among Gothamites, a sort of folk hero of crime whose antics were the stuff of chats around the water cooler. In place of casual murders were bank heists and other showy stunts guaranteed to get him on the front page. So concerned was the Joker with buffing his reputation that, when he discovered the fortune left to him by a mob boss was made of counterfeit bills, he went to absurd lengths to prevent anyone from learning that someone had pulled a joke on the Joker.

Robberies with any degree of comedic flair still looked like his handiwork, but since his "fortune" implied he didn't need the cash, the Joker spent recklessly to prove it. Ultimately his need to be perceived as a master criminal overtook his desire to act like a millionaire, and Gotham learned the Joker didn't have a penny to his name. "The Joker's Millions" was clever and funny, but it also sent a clear signal that the Harlequin of Hate was no longer dangerous.

But the Joker wasn't dying, just transforming. The villain crafted by Kane, Robinson, and Finger proved to have a life of his own. Now that the DC universe had its trickster, he would only get better with age.

Above: Dick Sprang's distinctively angular Joker has an epiphany in the classic "The Joker's Millions" from *Detective Comics* #180 (February 1952).

Opposite: This tale from *Batman* #8 (December 1941/January 1942) leads off with a bold promise from Batman, but the Joker always has the last laugh.

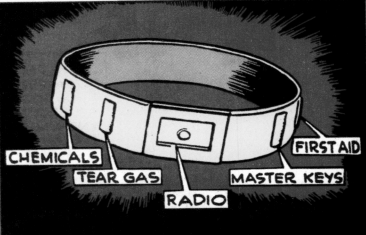

This spread: An oversimplified accounting of Batman's origins from *Real Fact Comics* #5 (November/December 1946) was written by Jack Schiff and illustrated by Win Mortimer.

AND SO WAS INSPIRED THE CREATION OF ROBIN, THE BOY WONDER···

..TO HELP FORM THE DARE DEVIL TEAM SOON TO BECOME KNOWN AS THE DYNAMIC DUO!

ONE EVENING, AS KANE WAS SHOPPING IN A NOVELTY STORE WITH A FRIEND...

HA, HA, WHAT A JOKE! HA, HA!

VERY FUNNY!

ODD NOVELTIES FOR PARTIES

PLAY JOKE ON YOUR FRIEND

BUT THE JOKE WAS ON KANE'S FRIEND, FOR THIS PRANK INSPIRED BOB TO INVENT THE MOST BIZARRE VILLAIN IN CARTOON HISTORY...THAT PRINCE OF PRANKSTERS—THE JOKER!

THE JOKER, WITH HIS TWISTED SENSE OF HUMOR, SHOULD BE A FITTING OPPONENT FOR BATMAN AND ROBIN!

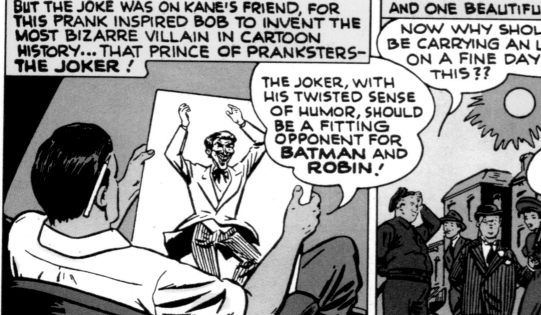

AND ONE BEAUTIFUL SUMMER AFTERNOON...

NOW WHY SHOULD ANYONE BE CARRYING AN UMBRELLA ON A FINE DAY LIKE THIS??

ECCENTRIC CHAP, ISN'T HE? I'LL SKETCH HIM IN MY NOTE-BOOK.

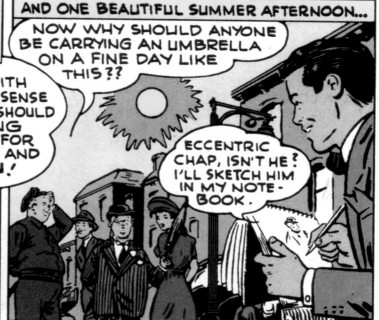

THE SKETCH CRYSTALLIZED IN KANE'S MIND AND MONTHS LATER WAS BORN ANOTHER ADVERSARY FOR THE BATMAN...THE DROLL PENGUIN, MAN OF 1,000 UMBRELLAS..

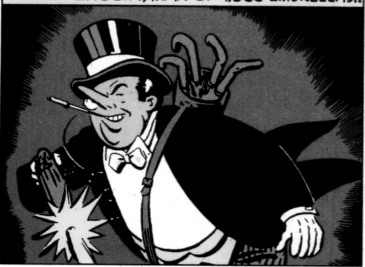

TODAY, BATMAN AND ROBIN, ONCE A DREAM, HAVE BROUGHT BOB KANE FAME AND FORTUNE...

THANKS FOR YOUR INTEREST AND WONDERFUL FRIENDSHIP, BATMAN FANS!

AND THANK YOU, BOB KANE, FOR BRINGING US TO LIFE!

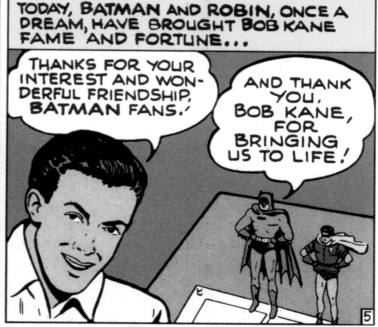

5

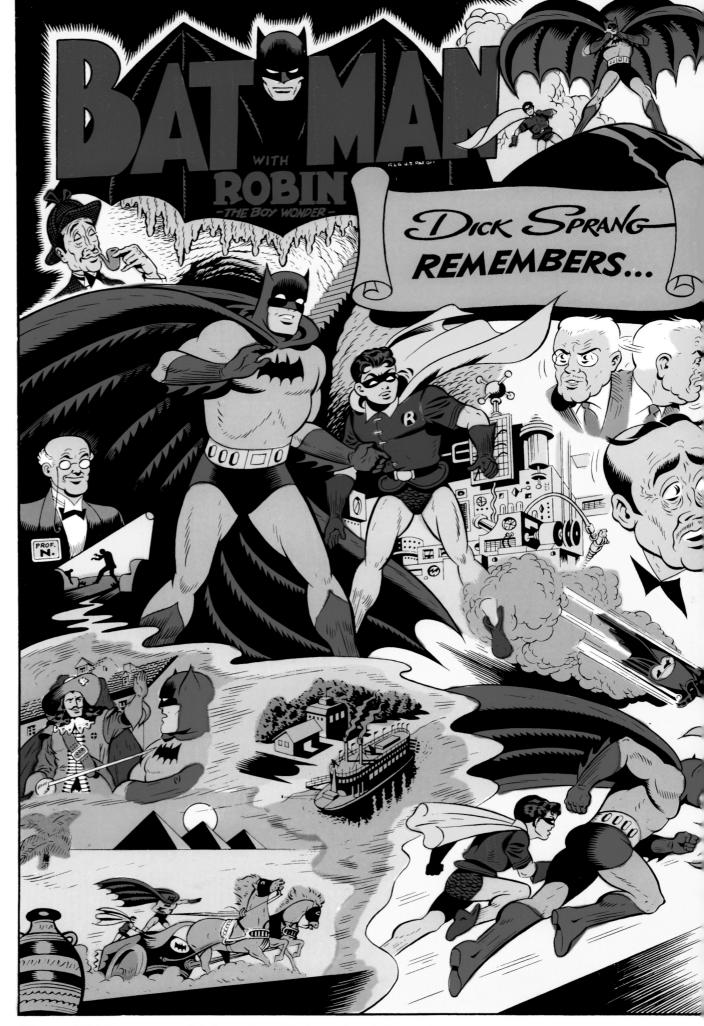

This spread: Dick Sprang encapsulated an entire publishing era in a single spread in this commemorative illustration for *Detective Comics* #572 (March 1987).

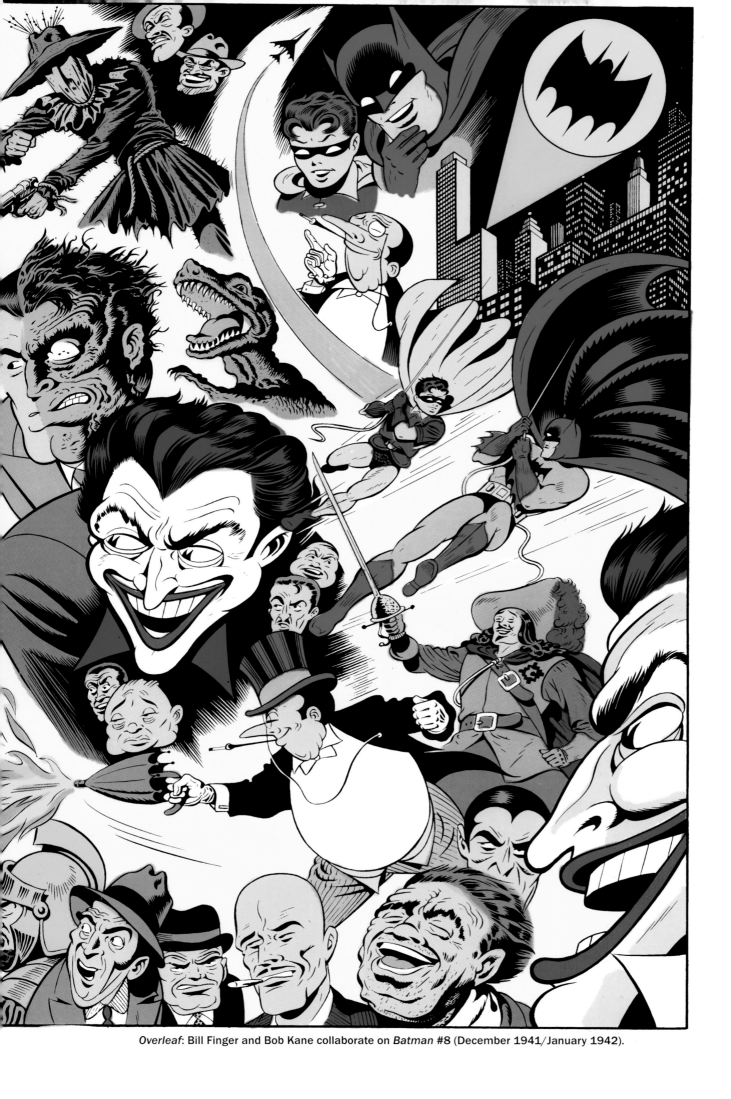

Overleaf: Bill Finger and Bob Kane collaborate on *Batman* #8 (December 1941/January 1942).

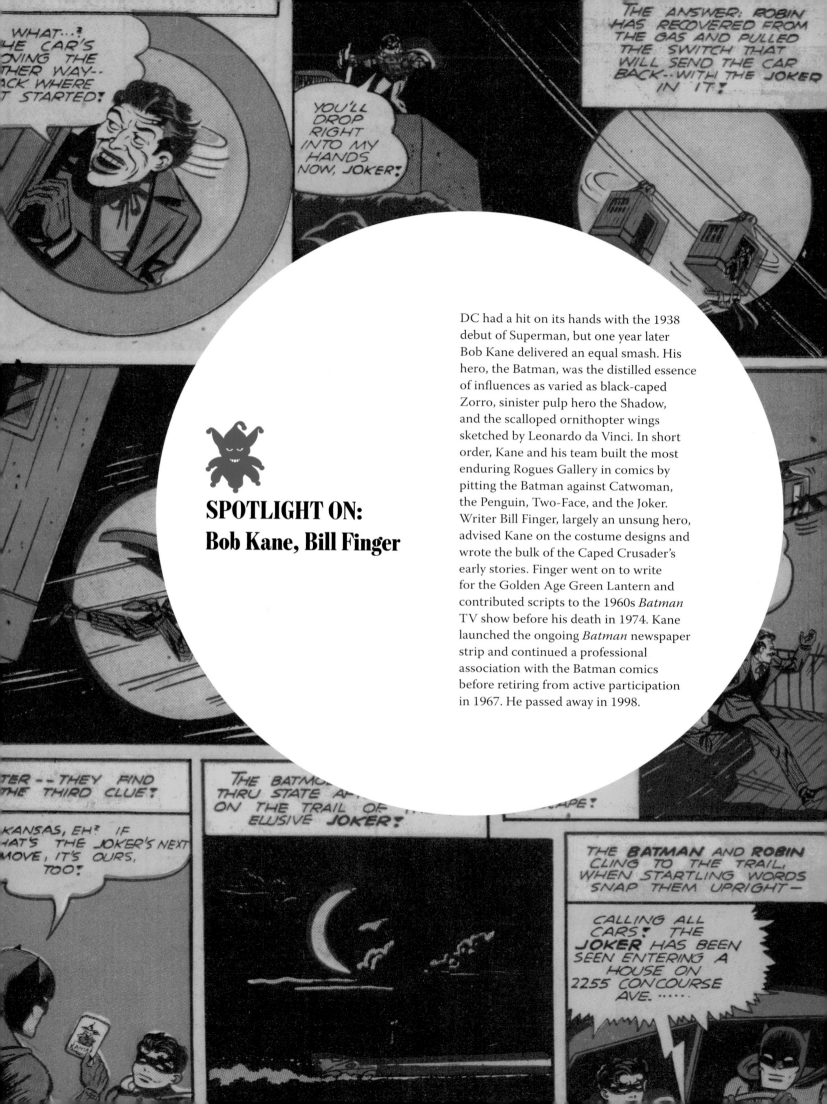

SPOTLIGHT ON:
Bob Kane, Bill Finger

DC had a hit on its hands with the 1938 debut of Superman, but one year later Bob Kane delivered an equal smash. His hero, the Batman, was the distilled essence of influences as varied as black-caped Zorro, sinister pulp hero the Shadow, and the scalloped ornithopter wings sketched by Leonardo da Vinci. In short order, Kane and his team built the most enduring Rogues Gallery in comics by pitting the Batman against Catwoman, the Penguin, Two-Face, and the Joker. Writer Bill Finger, largely an unsung hero, advised Kane on the costume designs and wrote the bulk of the Caped Crusader's early stories. Finger went on to write for the Golden Age Green Lantern and contributed scripts to the 1960s *Batman* TV show before his death in 1974. Kane launched the ongoing *Batman* newspaper strip and continued a professional association with the Batman comics before retiring from active participation in 1967. He passed away in 1998.

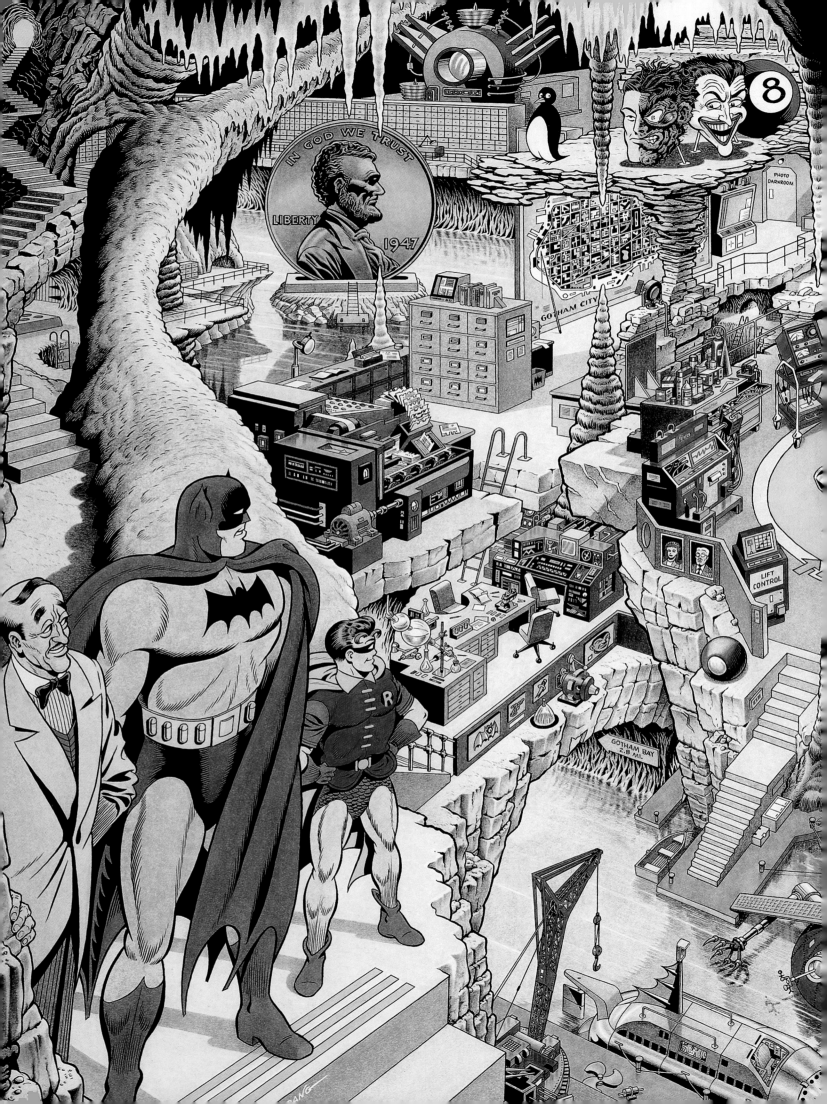

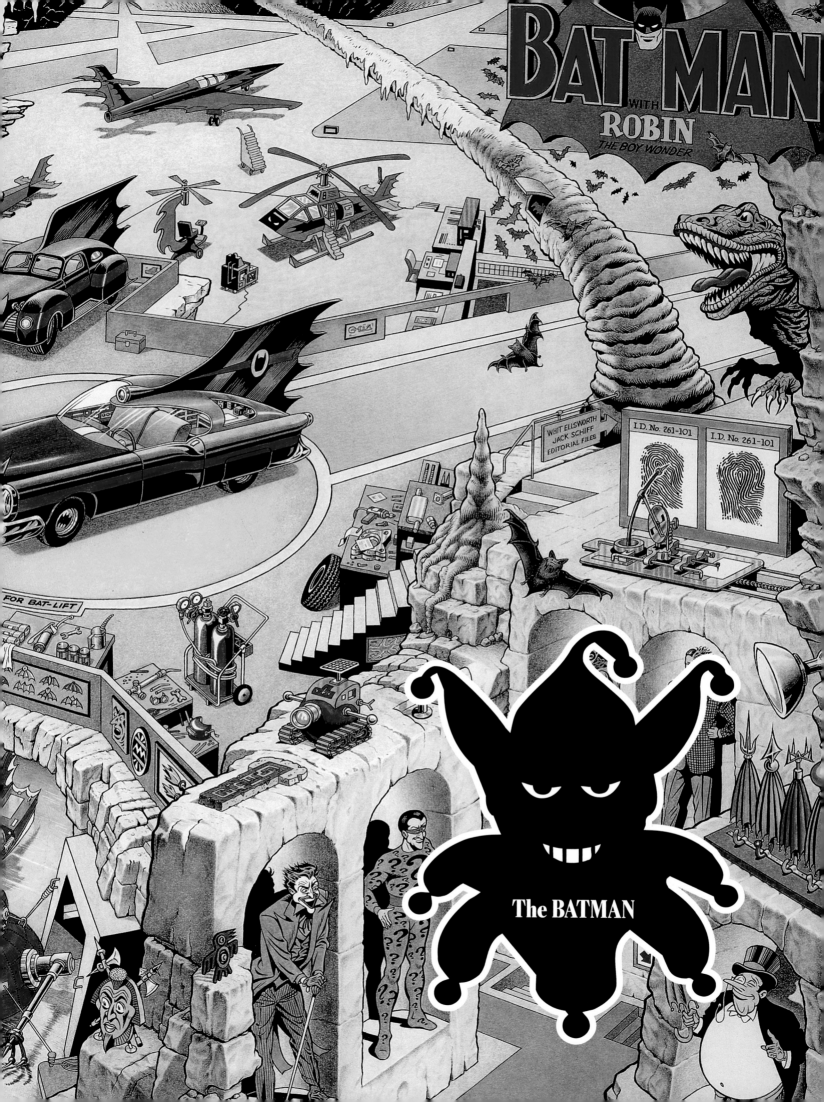

"You'll never be sad, and you'll never be lonely.
You'll always have me to dance with."
—*Batman Confidential* #12 (2008)

The Joker needs Batman. The two are a yin-yang swirl of light and dark, though it's the Joker who's always trying to brighten up grim Gotham with his hysterical brand of humor. Batman is the dark element, the shadowy agent of vengeance who rarely speaks and never cracks a smile. If the Joker is the comedian, Batman is his straight man, and his refusal to play by the Joker's rules only reinforces his role. He's the Bud Abbott to the Joker's Lou Costello, even if the Joker is the only one who can see it.

The ways in which the two foes stand apart could fill a book—color vs. monochrome, extrovert vs. introvert, fun loving vs. straightlaced. To the Joker, Batman's rejection of chaos is a cosmic joke, but Batman can't function any other way. In an episode of the animated series *Batman: The Brave and the Bold*, the Dark Knight tricked the Joker into entering a visual manifestation of his psyche. "An organized mind is a disciplined mind, Joker," he said, as a horrified Joker viewed row after row of spotless file cabinets. "And a disciplined mind is a powerful mind."

But chaos is the Joker's muse. He can only make sense of the world through its fractured facets, which has been declared clinical madness by countless judges, juries, and psychologists at Arkham Asylum. But the Joker might have a better grip on reality than you think. He definitely understands that his felonies hurt others, making any "not guilty by reason of insanity" verdict legally dubious. In "Case Study" from *Batman Black and White*, writer Paul Dini speculated that the Joker was perfectly in possession of his senses, and that his antics were merely an act. Or, to put it another way, the killer clown is a mask. It's the Joker's version of Batman's cape and cowl.

Writer Grant Morrison's take on the Joker isn't too far removed from this premise. In Morrison's stories the Joker possesses a highly-evolved "super sanity," leaving him better equipped to deal with life's absurdities. When things get tough the Joker becomes hilarious, homicidal, or something else entirely. As the Joker himself puts it in Morrison's *Batman and Robin*, "I'm not mad at all. I'm just differently sane."

But pointing out the differences between Batman and the Joker misses the fact that they share a lot of the same DNA. Both lack superpowers, yet they have become the undisputed overlord and underlord of Gotham City on a planet filled with bulletproof metahumans. Both are so driven that they're slightly maniacal—like sharks, they'd probably suffocate if they didn't keep moving forward. And, even though they're both top

Previous spread: Dick Sprang's "Secrets of the Batcave" lithograph (1994).

Opposite: Even with Batman's hands at his throat, the Joker feels a sense of triumph at getting a rise out of his straight man. Art by Jim Lee and Scott Williams from *Batman* #614 (June 2003).

fighters, their best assets are their brains. Batman has become the world's greatest detective, while the Joker is a mad artist. Linear progression is a bore to the Joker, and standard mysteries hold no appeal. When presented with an opportunity to unmask his foe in the graphic novel *Arkham Asylum*, he only rolled his eyes. "Oh, don't be so predictable, for Christ's sake! That *is* his real face."

The Joker and Batman might even *need* one another – maybe not as lovers, but at least as dance partners. Many times, the Joker seems to be trying to get a rise out of his rival. Batman's insistence on putting the Joker into easily escapable situations only encourages more of the same. On some level both foes seem to enjoy the challenge. As the Joker put it in *Batman* #663, "You can't kill me without becoming like me. I can't kill you without losing the only human being who can keep up with me."

What would the Joker be without Batman? According to one account, completely ordinary. In *Legends of the Dark Knight*'s "Going Sane" by J. M. DeMatteis and Joe Staton, Batman was believed killed in an explosion and the Joker had no one to laugh at his jokes. But rather than go out in a blaze of glory and a pile of grinning corpses, the Joker did the unexpected and reverted to normalcy.

The transformation occurred outside of the Joker's conscious control. Going by the name of Joseph Kerr, he altered his appearance to resemble any average Joe—but one with an appreciation for the Marx Brothers and a barely contained violent streak. He even struck up a romance with a woman who found charm in his old-fashioned ways.

But news of Batman's return splintered his carefully constructed ego. *If a Batman exists*, his subconscious seemed to whisper, *then a Joker must stand in his way.* In a twinkling, the happy home life vanished, and in its place came the familiar waltz of lawmaker vs. lawbreaker.

The faceoff seems fated to continue, not just into the future but into alternate universes. Bob Hall's *I, Joker* took place in a world where Batman's successor was a tyrant and the Joker's analogue needed to put an end to his gladiatorial games. In *Batman: Digital Justice*, artist Pepe Moreno dreamt up a computer-generated reality in which the Joker persisted as an electronic virus to vex a distant generation's Dark Knight.

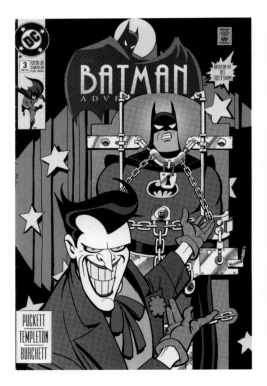

Top: The Joker wears his second-most frequent costume: a straightjacket. From *Batman: Going Sane* (2008), art by Joe Staton and Rodney Ramos.
Above right: This Ty Templeton cover from *Batman Adventures* #3 (December 1992) captures the Joker in his favorite role: sadistic showman.
Opposite: Dick Sprang and Charles Paris demonstrate that, even through harmless fun, the Joker can be troublesome to Batman's logical mind. From *Batman* #74 (December 1952/January 1953).

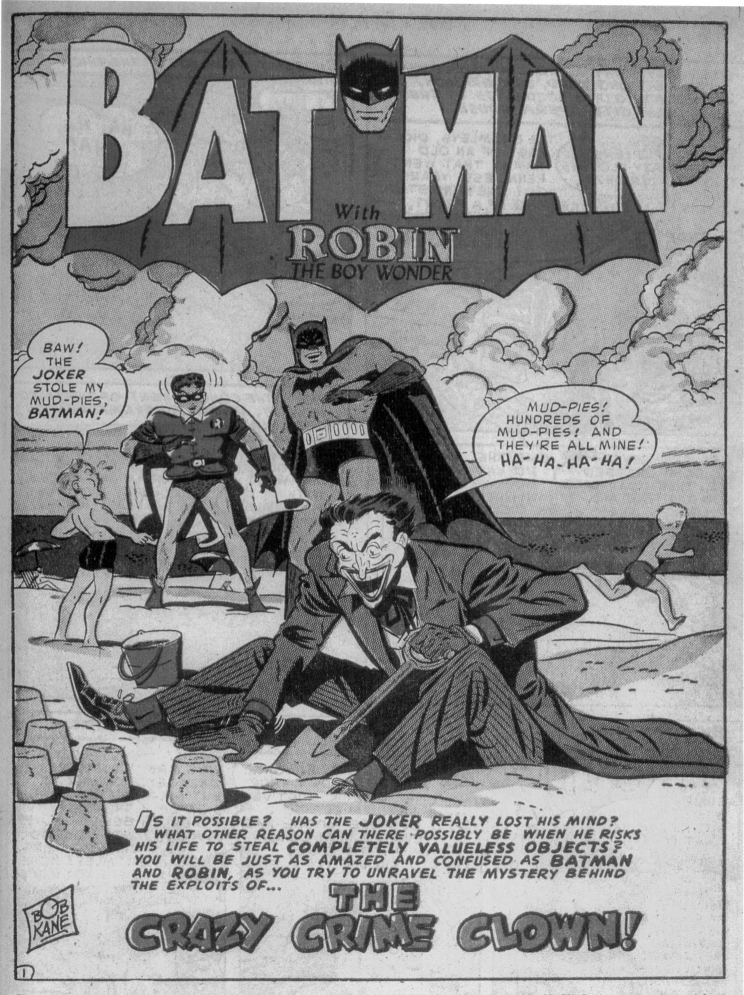

BATMAN, No. 74, Dec., '52-Jan., '53. Published bi-monthly by National Comics Publications, Inc., 480 Lexington Ave., New York 17, N. Y. Whitney Ellsworth, Editor. Reentered as second class matter Aug. 1, 1941 at the Post Office at New York, N. Y. under the act of March 3, 1879. Yearly subscription in the U. S. 75c including postage. Foreign, $1.50 in American funds. For advertising rates address Richard A. Feldon & Co., 205 E. 42nd St., New York 17, N. Y. Entire contents copyrighted 1952 by National Comics Publications, Inc. Except for those who have authorized use of their names, the stories, characters and incidents mentioned in this periodical are entirely imaginary and fictitious and no identification with actual persons, living or dead, is intended or should be inferred.

Printed in U.S.A.

This spread: In 1990's *Batman: Digital Justice*, Pepe Moreno used the era's emerging palette of computer art tools to create an alternate Gotham.

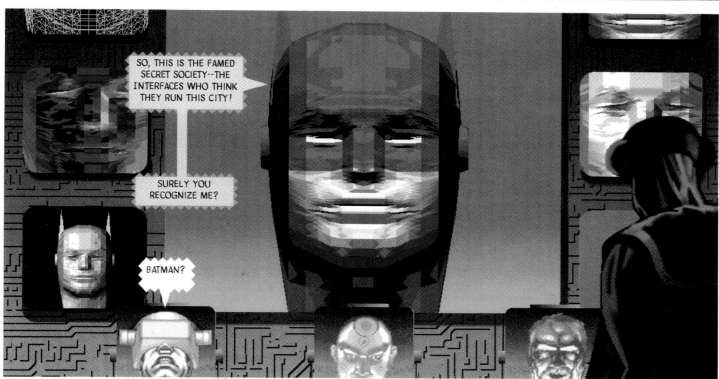

SO, THIS IS THE FAMED SECRET SOCIETY--THE INTERFACES WHO THINK THEY RUN THIS CITY!

SURELY YOU RECOGNIZE ME?

BATMAN?

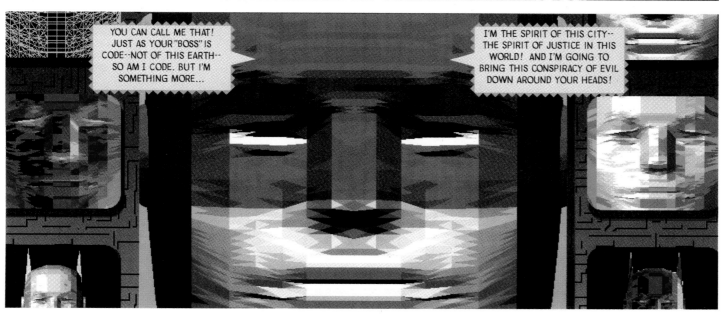

YOU CAN CALL ME THAT! JUST AS YOUR "BOSS" IS CODE--NOT OF THIS EARTH-- SO AM I CODE. BUT I'M SOMETHING MORE...

I'M THE SPIRIT OF THIS CITY-- THE SPIRIT OF JUSTICE IN THIS WORLD! AND I'M GOING TO BRING THIS CONSPIRACY OF EVIL DOWN AROUND YOUR HEADS!

Above: Neal Adams contributed this alternate cover to *All Star Batman & Robin, The Boy Wonder* #8 (January 2008), in which the Joker's face and that of his nemesis blend in a psychological overlap.

Opposite: Neal Adams's trademark realism takes hold in 1973's *Batman* #251.

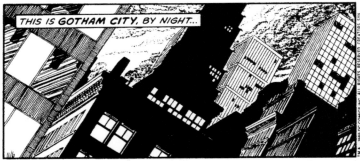

THIS IS GOTHAM CITY, BY NIGHT...

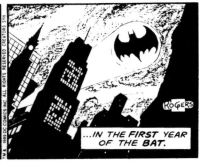

...IN THE FIRST YEAR OF THE BAT.

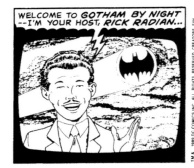

WELCOME TO GOTHAM BY NIGHT --I'M YOUR HOST, RICK RADIAN...

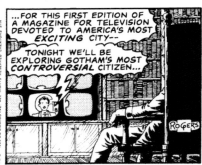

...FOR THIS FIRST EDITION OF A MAGAZINE FOR TELEVISION DEVOTED TO AMERICA'S MOST EXCITING CITY--

TONIGHT WE'LL BE EXPLORING GOTHAM'S MOST CONTROVERSIAL CITIZEN...

...THE BATMAN.

YOUR MINERAL TONIC, SIR.

OUR FIRST GUEST ON "GOTHAM BY NIGHT" IS MS. VICKI VALE--

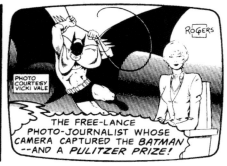

PHOTO COURTESY VICKI VALE

THE FREE-LANCE PHOTO-JOURNALIST WHOSE CAMERA CAPTURED THE BATMAN --AND A PULITZER PRIZE!

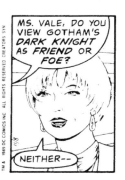

MS. VALE, DO YOU VIEW GOTHAM'S DARK KNIGHT AS FRIEND OR FOE?

NEITHER--

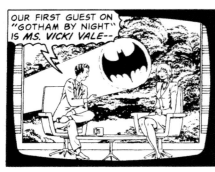

IT'S NOT MY PLACE TO JUDGE WHETHER THE BATMAN IS OR IS NOT A BENIGN PRESENCE IN GOTHAM CITY--

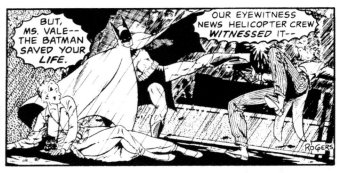

BUT, MS. VALE-- THE BATMAN SAVED YOUR LIFE.

OUR EYEWITNESS NEWS HELICOPTER CREW WITNESSED IT--

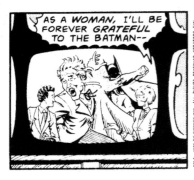

AS A WOMAN, I'LL BE FOREVER GRATEFUL TO THE BATMAN--

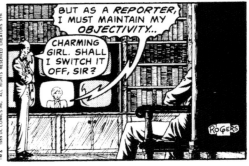

BUT AS A REPORTER, I MUST MAINTAIN MY OBJECTIVITY...

CHARMING GIRL. SHALL I SWITCH IT OFF, SIR?

AND ARE YOU "OBJECTIVE" ABOUT YOUR TORMENTOR --THE JOKER?

NOT JUST YET, ALFRED...

NOT MUCH IS KNOWN ABOUT THE JOKER--

OTHER THAN HE IS BRILLIANT AND QUITE INSANE.

JOKER IS RUMORED TO BE AN UNDERLING OF AN ORGANIZED CRIME BOSS ASSASSINATED EARLIER THIS YEAR.

WHEN THE JOKER MOVED IN, BATMAN STOPPED HIM.

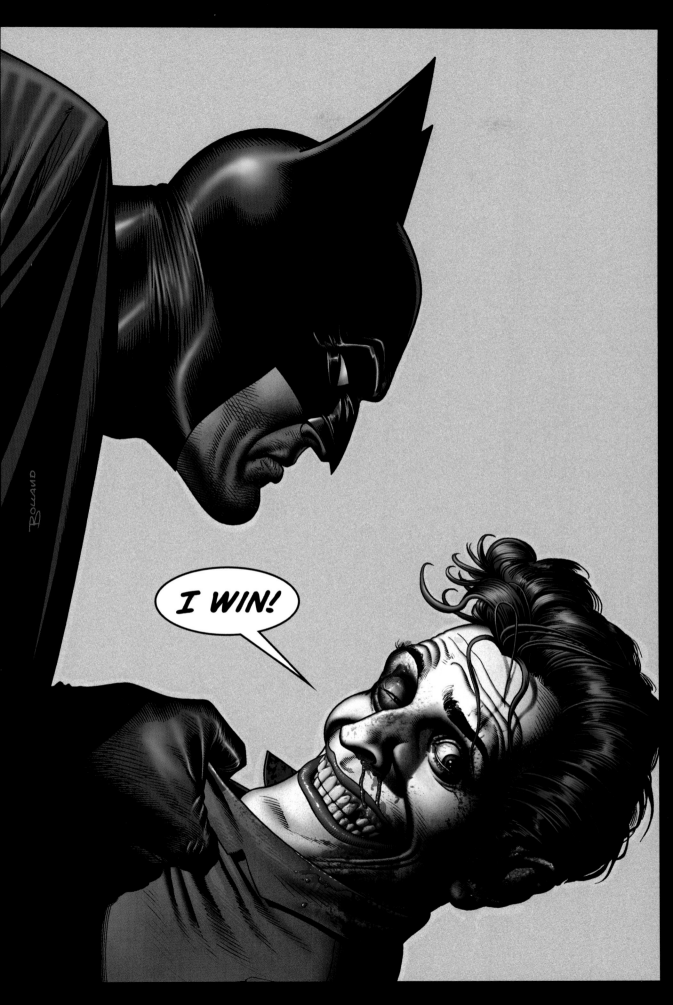

Above: In Brian Bolland's cover to *Joker: Last Laugh* (2002), it's clear why a clown as crazy as the Joker can never truly be defeated.
Opposite: Batman newspaper strips by writer Max Allan Collins and artist Marshall Rogers
launched in 1989 to tie in with the big-screen blockbuster.

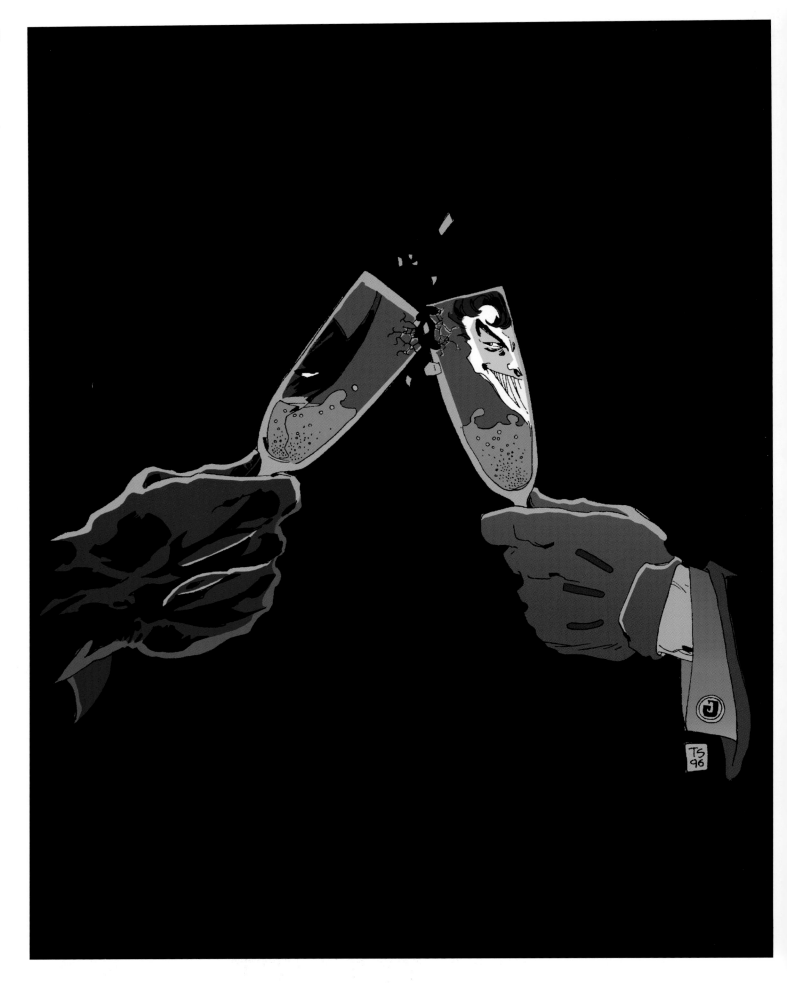

Previous spread: The Joker's "A Death in the Family" sin catches up to him in this
illustration by Jim Aparo and Mike DeCarlo from *Batman* #429 (January 1989).

Above: In a stylish Tim Sale cover from *Batman: The Long Halloween* (1997),
Batman and the Joker are reflected in shattering champagne glasses.

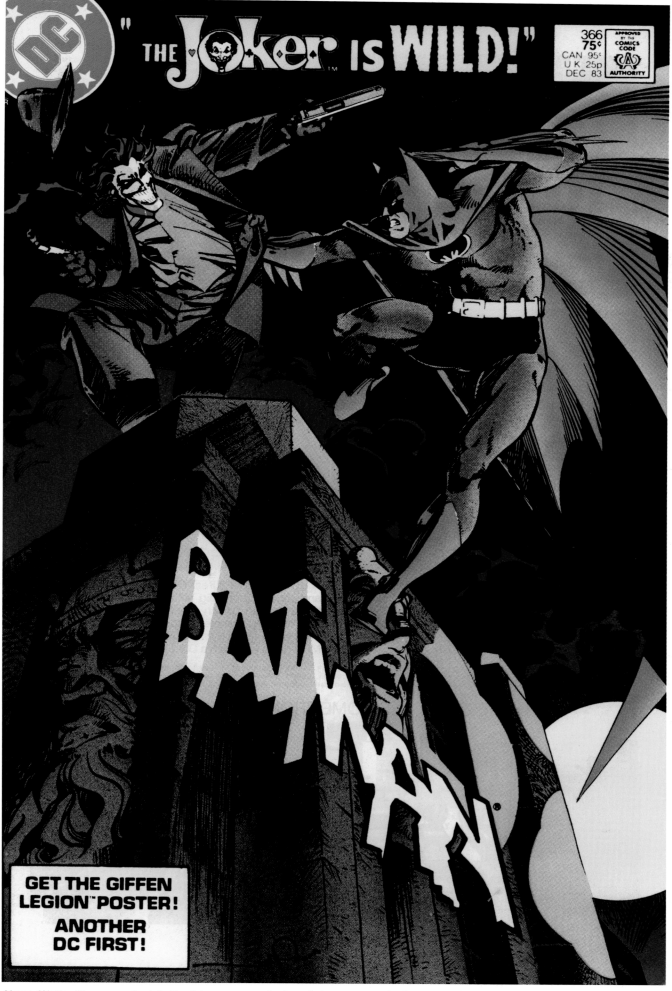

Above: Walter Simonson depicts the Joker as an explosion of zigzag energy in the cover of *Batman* #366 (December 1983).

Overleaf: The Joker takes his final bow in the *Dark Knight Returns* (1986), illustrated by Frank Miller and inked by Klaus Janson.

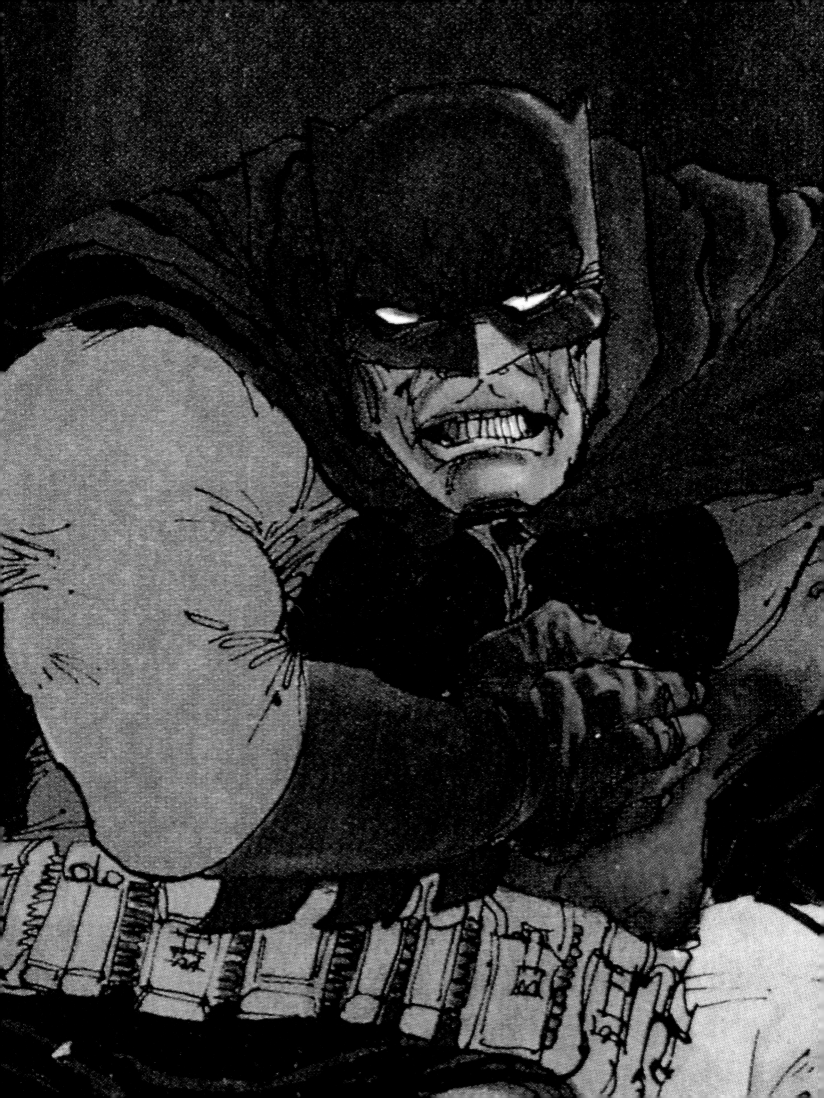

SPOTLIGHT ON:
Frank Miller

Writer/artist Frank Miller brought a film noir sensibility to comics in the 1980s, proving that superheroes could be surrogates for hard-boiled detectives in his explorations of crime and punishment. Miller made his first splash at Marvel, reinventing Daredevil with inker Klaus Janson. In 1983 DC released Miller's cyberpunk epic *Ronin*, and three years later Miller reteamed with Janson on *The Dark Knight Returns*. This grim story of an aging Batman in dystopian Gotham was soon followed by the origin story *Batman: Year One*. Both proved hugely influential. "The way I like to work is to have the image and the words carry as much impact as possible," said Miller, who later crafted *Sin City* and *300* at Dark Horse before returning to DC on the series *The Dark Knight Strikes Again* and (with artist Jim Lee) *All Star Batman and Robin the Boy Wonder*.

Arkham ASYLUM

Above: Arkham becomes a living thing in this Sam Kieth rendition from *Arkham Asylum: Madness* (2011).

"Don't forget, if it ever gets too tough, there's always a place for you here."
—*Arkham Asylum: A Serious House on Serious Earth* (1989)

When the Joker needs a base from which to launch an assault against normalcy, he'll probably pick a dilapidated amusement park or an abandoned playing card factory. Yet these eerie outposts are just layovers. When Batman inevitably sends him back to Arkham Asylum, he is only sending him home.

The Arkham Asylum for the Criminally Insane houses the Gotham City villains who are considered mentally unfit to be incarcerated alongside run-of-the-mill jailbirds in a standard penitentiary. Founded by Amadeus Arkham more than a century ago, the sanitarium has a notorious reputation, and deservedly so. Its inmates escape with scandalous frequency, and the grounds give off a palpable vibe of Gothic horror. In fact, Amadeus Arkham eventually succumbed to the madness that seemingly leaches from its walls, turning Arkham's administrator into its first patient.

Introduced into comics continuity in 1974, Arkham Asylum was a comparatively late addition to the Joker's mythology that felt as if it had belonged there all along. It shares a name with the Arkham, Massachusetts, setting of H. P. Lovecraft's horror tales, and often draws from a similar well of eldritch evil. The facility has been destroyed twice, once in the 1992 storyline "The Last Arkham" and again during the *Knightfall* crossover that ended with Batman's broken back. But the asylum always reappears, sprouting again from the tainted soil with as much malevolence as ever.

The hardcover graphic novel *Arkham Asylum: A Serious House on Serious Earth* explored the origins of the madhouse and the sad fate of its founder. Paintings by Dave McKean captured Batman's dreamlike exploration of the building, intercut with flashbacks of Amadeus Arkham as he treated the man who killed his wife and daughter before frying him to a crisp on an electro-shock couch. The incident pushed Arkham farther into insanity, and he scratched occult runes into the walls and ceilings with his bloody fingernails. In the main narrative, the Joker sent Killer Croc, the Mad Hatter, and other inmates on a haunted-house hunt for the Batman. Writer Grant Morrison strove for a stream-of-consciousness narrative and wove in thematic elements

Right: The asylum, as provided for reference in an internal DC Comics style guide.
Previous spread: Arkham Asylum as depicted in *Batman: The Animated Series*.

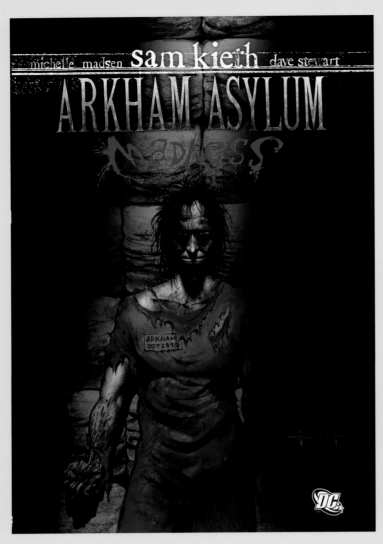

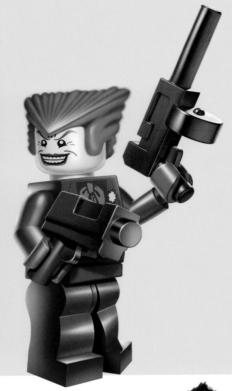

from Carl Jung, Lewis Carroll, and Aleister Crowley. The free flow washed around Batman, who stood alone as an island of emotional rigidity.

If reading about Arkham Asylum was disturbing, a 2009 game let players explore it at their own pace. The critically acclaimed *Batman: Arkham Asylum*, developed by Rocksteady Studios, restored the respectability of superhero video games after too many rushed movie tie-ins and cheaply developed shovelware releases. In *Arkham Asylum*, players controlled Batman during a riot that had freed the inmates and turned the administrators into hostages. The Joker delivered a mocking commentary as the player progressed through moody, expansive environments, adding more impact to the final showdown.

The game featured voice talents from *Batman: The Animated Series* including Kevin Conroy as Batman, Mark Hamill as the Joker, and Arleen Sorkin as Harley Quinn, and writer Paul Dini scripted the overarching story. A sequel, *Batman: Arkham City*, followed in 2011.

Top: Sam Kieth's cover to *Arkham Asylum: Madness*.
Above right: The Joker becomes a LEGO minifig in *LEGO Batman: The Videogame* (2008).
Right: In the game *Batman: Arkham Asylum*, the Joker is a manipulative mastermind.
Opposite: Batman enters the mouth of madness in this Dave McKean painting from *Arkham Asylum: A Serious House on Serious Earth*.

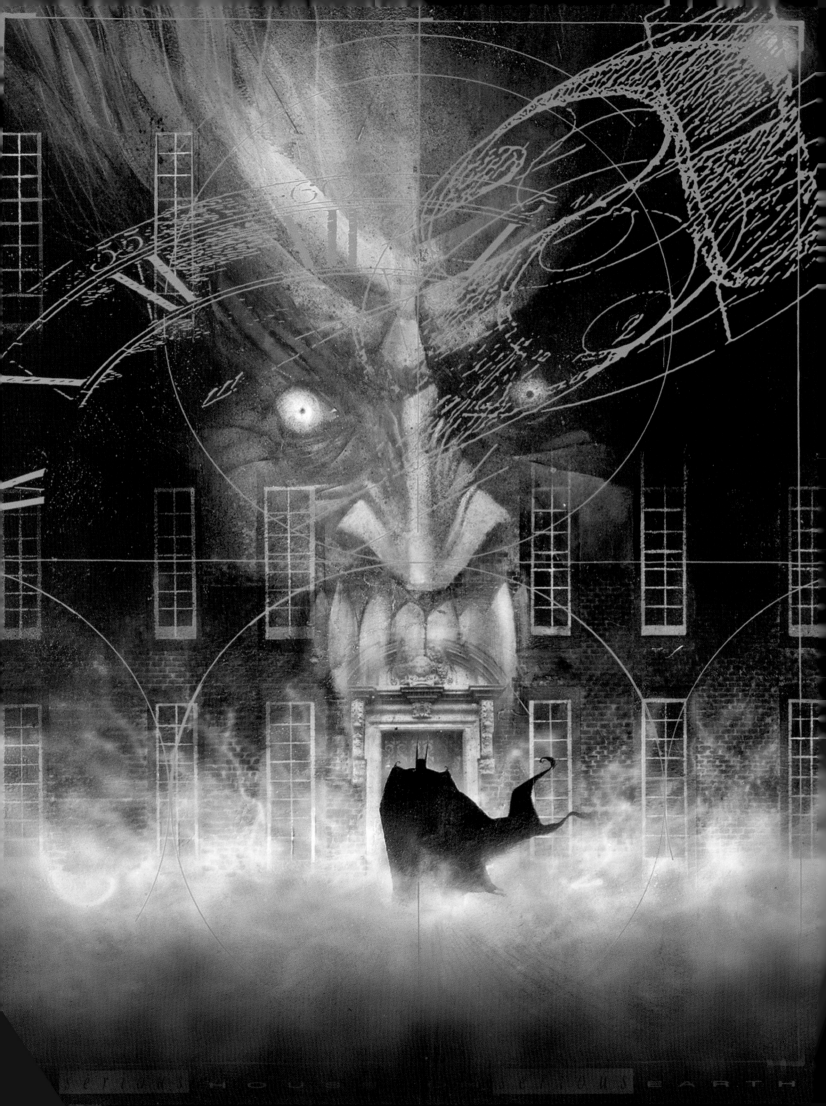

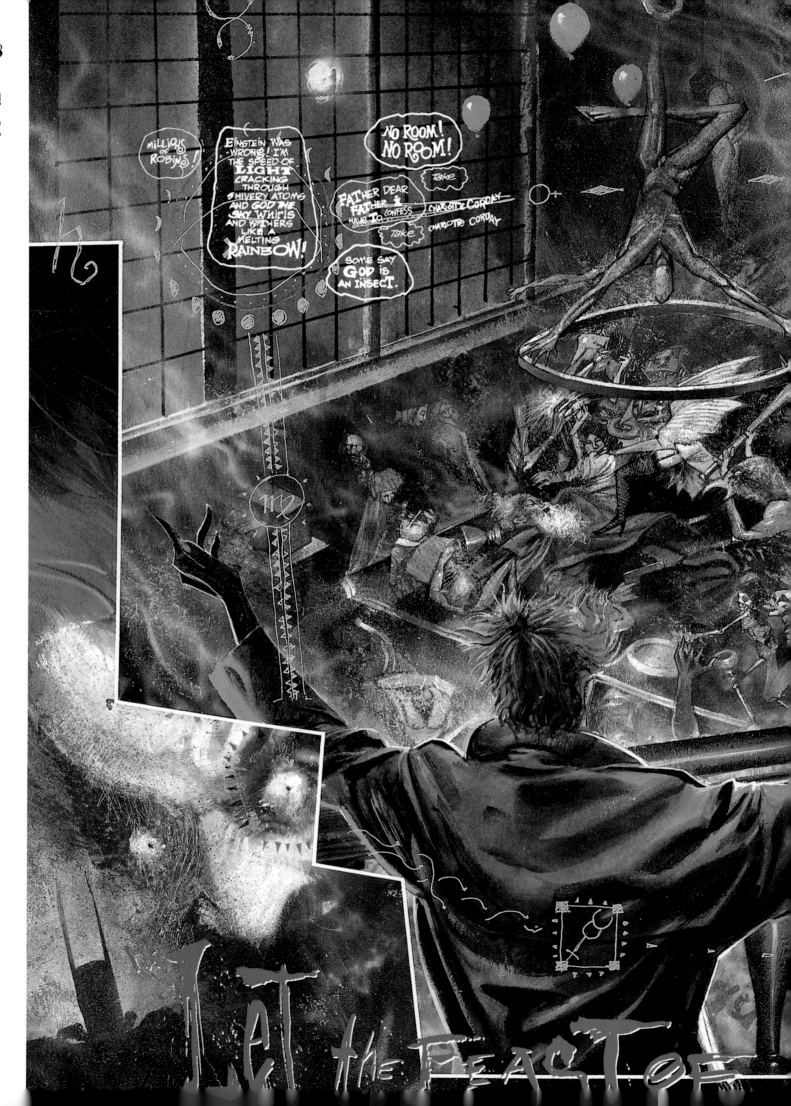

JOKER think Mick Jagger/ David Bowie body structure and even fashion, tall and lanky. wearing 'skinny jeans' and tight sport coats (or is that EMO nowadays :))

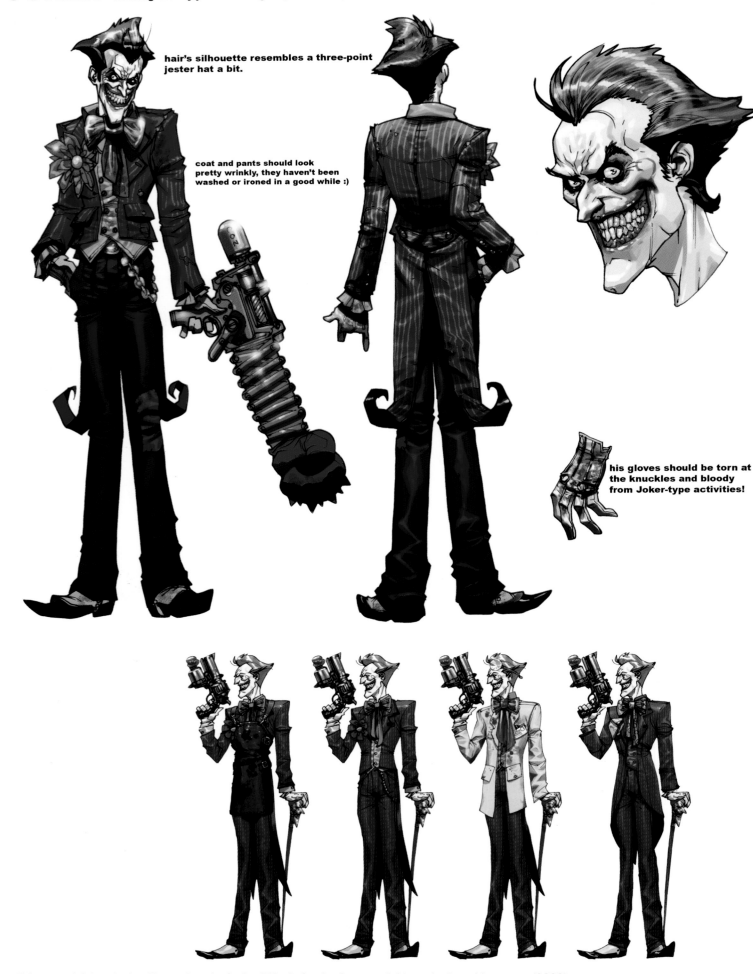

hair's silhouette resembles a three-point jester hat a bit.

coat and pants should look pretty wrinkly, they haven't been washed or ironed in a good while :)

his gloves should be torn at the knuckles and bloody from Joker-type activities!

This spread: Joker design illustrations by Carlos D'Anda for the *Batman: Arkham Asylum* video game (2009).
Previous spread: Each inmate speaks through a different lettering style in Grant Morrison's *Arkham Asylum: A Serious House on Serious Earth*.

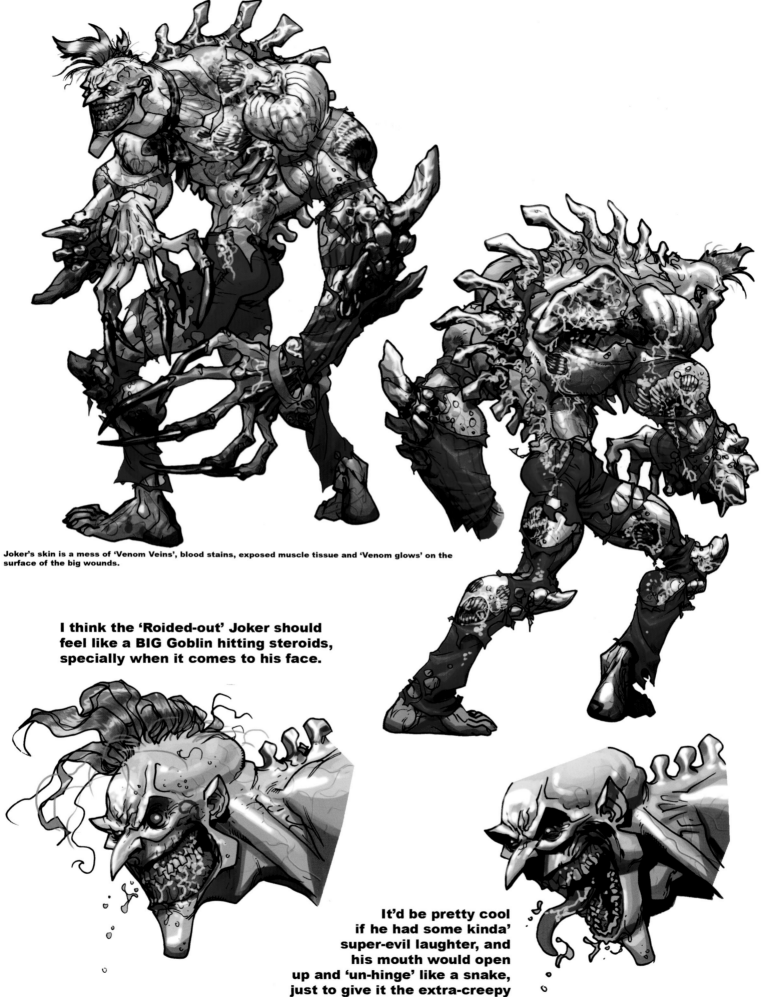

Joker's skin is a mess of 'Venom Veins', blood stains, exposed muscle tissue and 'Venom glows' on the surface of the big wounds.

I think the 'Roided-out' Joker should feel like a BIG Goblin hitting steroids, specially when it comes to his face.

It'd be pretty cool if he had some kinda' super-evil laughter, and his mouth would open up and 'un-hinge' like a snake, just to give it the extra-creepy factor?

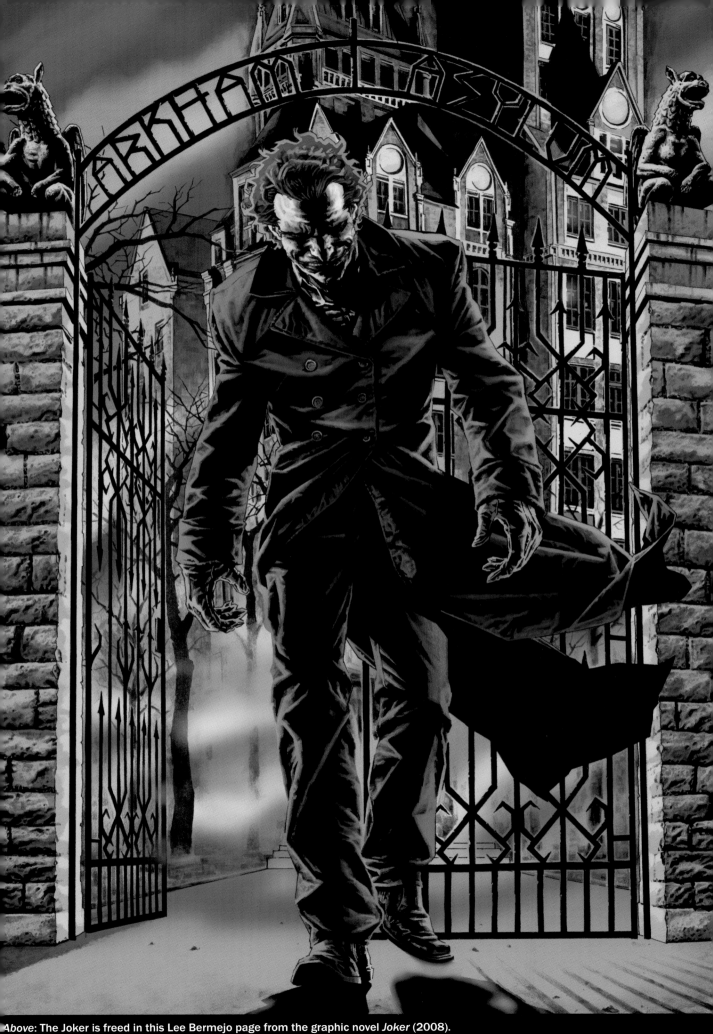

Above: The Joker is freed in this Lee Bermejo page from the graphic novel *Joker* (2008).

Opposite: Cliff Chiang drew the cover of *Batman: Arkham Reborn* (2010).

Overleaf: A sadistic Joker invites Batman to share the insanity in Grant Morrison and Dave McKean's *Arkham Asylum* (1989).

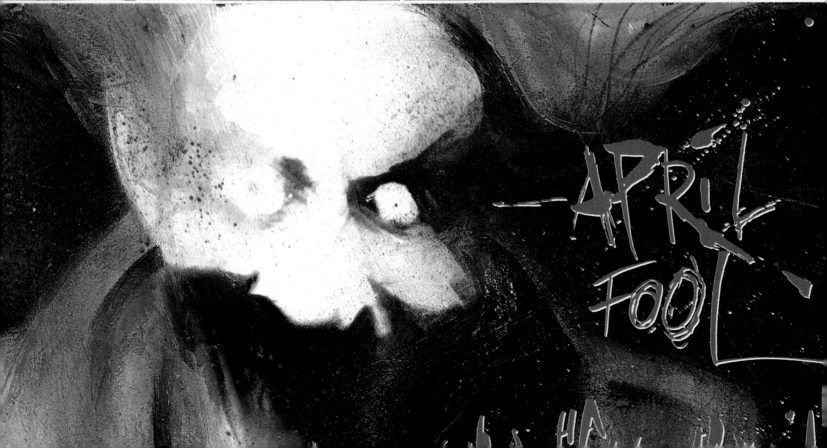

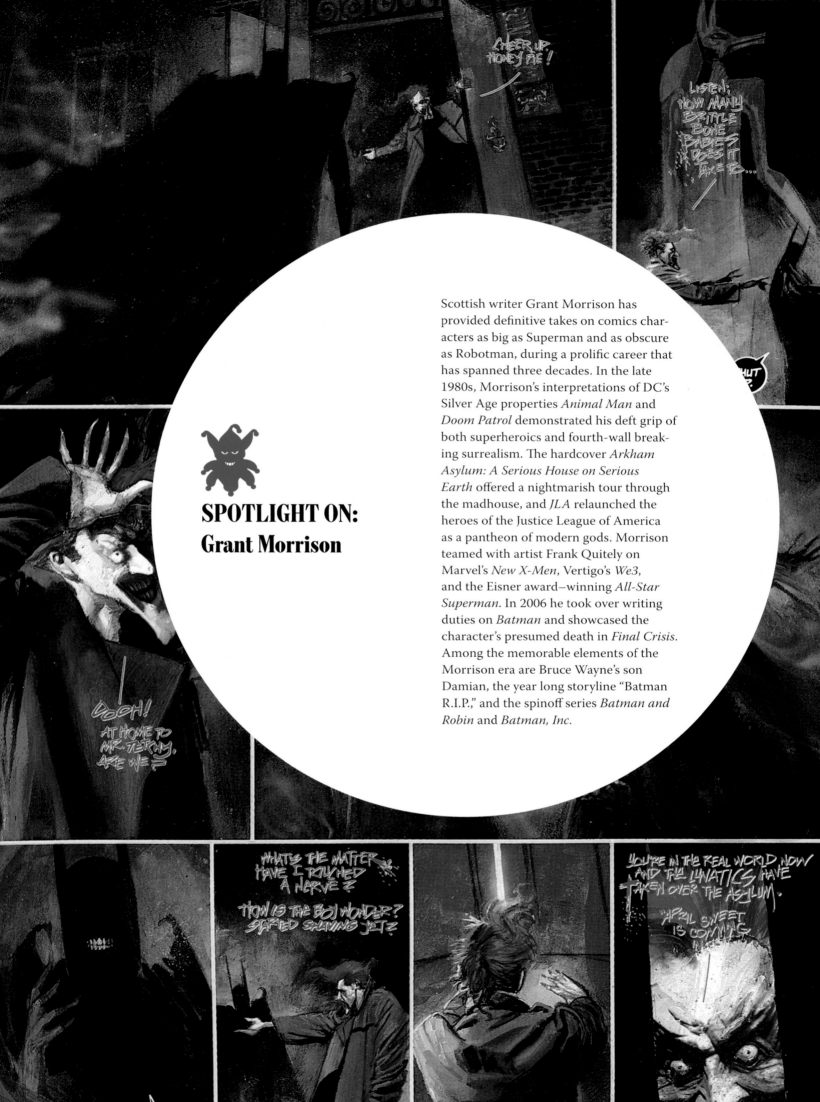

SPOTLIGHT ON:
Grant Morrison

Scottish writer Grant Morrison has provided definitive takes on comics characters as big as Superman and as obscure as Robotman, during a prolific career that has spanned three decades. In the late 1980s, Morrison's interpretations of DC's Silver Age properties *Animal Man* and *Doom Patrol* demonstrated his deft grip of both superheroics and fourth-wall breaking surrealism. The hardcover *Arkham Asylum: A Serious House on Serious Earth* offered a nightmarish tour through the madhouse, and *JLA* relaunched the heroes of the Justice League of America as a pantheon of modern gods. Morrison teamed with artist Frank Quitely on Marvel's *New X-Men*, Vertigo's *We3*, and the Eisner award–winning *All-Star Superman*. In 2006 he took over writing duties on *Batman* and showcased the character's presumed death in *Final Crisis*. Among the memorable elements of the Morrison era are Bruce Wayne's son Damian, the year long storyline "Batman R.I.P.," and the spinoff series *Batman and Robin* and *Batman, Inc.*

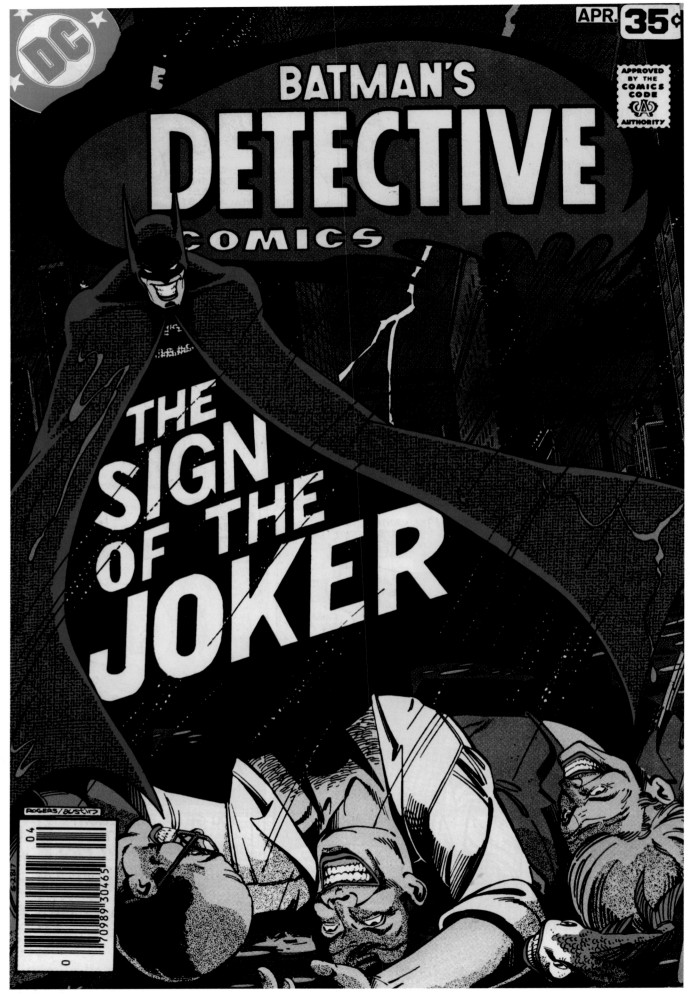

Above: Even Batman seems to have fallen victim to the Joker's Smile Venom in this Marshall Rogers and Terry Austin cover for *Detective Comics* #476 (March/April 1978).

"Where does he get those wonderful toys?"
—*Batman* (1989)

When it comes down to it, the Joker is a prop comic. He might enjoy a bit of clever wordplay, but nothing seems more natural to him than hauling a rubber chicken from beneath his coat or producing a pair of chattering teeth from a pocket. Those kinds of broad gags haven't been funny since Henny Youngman opened at the Catskills, but reality never enters into his calculus. It is enough that *he* finds them funny, and if the rest of the world isn't yet in on the joke—well, just give them time.

Like all performers, the Joker has a carefully crafted look which has gone virtually unchanged since 1940. He isn't properly dressed until he's wearing a purple suit with a long-tailed, padded-shoulder jacket, accented with a string tie. His striped pants are matched with spats and pointed-toe boots. A wide-brimmed hat has come and gone, but the Joker is never seen without a pair of gloves.

The ensemble conveys a whiff of Jazz Age elegance, but in the 2008 film *The Dark Knight*, Heath Ledger wore a shabby take on the suit that looked as if the Joker had slept in it for a week. This get-up is so identified with the character that, when the animated series *The Batman* outfitted its Joker with a straight-jacket, it quickly backtracked and restored his sense of style.

The suit's pockets can be as bottomless as the situation requires. Here is where the Joker conceals the gags he uses to kill and amuse, and in his case the second often follows from the first. The heavy hitter in the Joker's arsenal is Joker Venom—a toxin delivered in liquid or gaseous form that sends its victims into mirthful hysterics. In more potent doses, it leaves a death-rictus resembling a pained grin plastered on the faces of the dead. Joker Venom has been claiming lives since *Batman* #1 in 1940, and subsequent stories have established that the Joker is the only one who knows its secret formula. In fact, the Joker is immune to most poisons and has such a gift for chemistry that he has been known to whip up a batch of Joker Venom using handy household materials.

Previous spread: The Joker takes to the skies in this Tim Sale composition from *Batman: The Long Halloween* (1997).

Right: The Joker's distinctive costume, from a DC Comics style guide.

Joker Venom is a killer way to end a set, but the Joker is a versatile comic. He keeps things fresh with gags like razor-tipped playing cards, rolling marbles, and jack-in-the-boxes containing unpleasant surprises. It's never a good idea to shake the Joker's hand, since his palm is likely to conceal a joy buzzer pumping out a million volts of electricity. That colorful flower in his lapel? Stand back—anyone foolish enough to take a sniff will get a squirt of skin-burning acid. Above all, *never* accept one of the Joker's congratulatory cigars. The explosion can level an entire building.

The Joker is skilled with firearms and has been seen shooting a vase off Batman's head from fifty paces. Yet more often than not, the trigger of the Joker's long-barreled revolver releases a colorful flag bearing an onomatopoeic message: "BANG!" If that fails to get a laugh, a second trigger pull will turn the gun into a harpoon launcher, literally skewering the victim with the punchline.

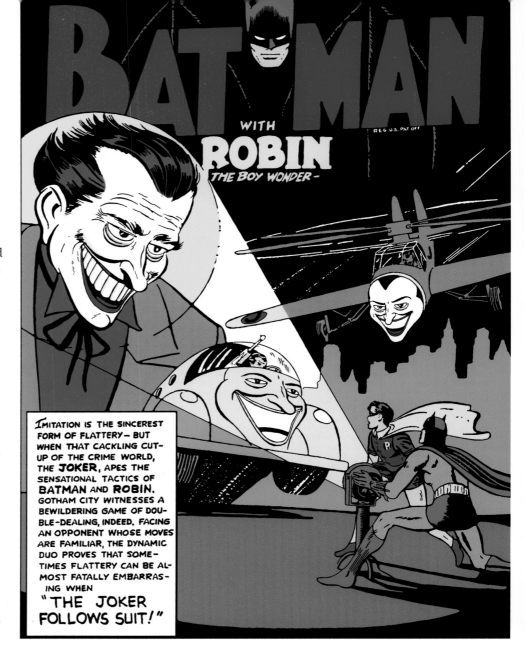

The Joker's love of gadgets is at least partially inspired by his nemesis' reliance on smoke pellets and Batarangs. In "The Joker's Utility Belt" (*Batman* #73), the Clown Prince of Crime stole a page from Batman's playbook by making his own copycat yellow belt, but this one was stocked with sneezing powder, Mexican jumping beans, and an item labeled "eyepiece which leaves viewer with a black eye." These gadgets were more annoying than lethal. At story's end the Joker was jailed and ironically appointed the foreman of the prison's belt factory, but his reliance on gags in the future remained undiminished.

No adventure better captured the Joker's reactionary Batman obsession than 1946's "The Joker Follows Suit" (*Batman* #37). Convinced that the Batmobile, Batplane, and Bat-Signal had given his enemy an unfair advantage, the Joker decreed, "The same weapons he has used against me, I can turn against him—with such improvements as only my genius could devise!" The result? A Jokermobile and a Jokergyro. Inverting the relationship

Top: The Joker one-ups the Caped Crusader in *Batman* #37 (October/November 1946). Art by Jerry Robinson.
Above: Hey, it's worth a try! Art by Jerry Ordway from the *Batman* movie comics adaptation (1989).
Opposite: Joker Venom in action, from *Detective Comics* #475 (February 1978). Art by Marshall Rogers and Terry Austin.

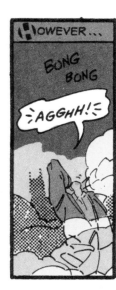

HOWEVER...

BONG
BONG

~AGGHH!~

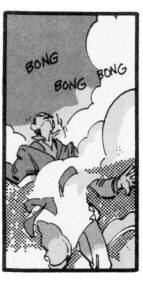

BONG
BONG BONG

BONG BONG
BONG BONG

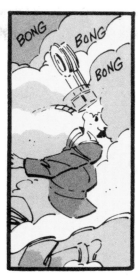

BONG
BONG
BONG

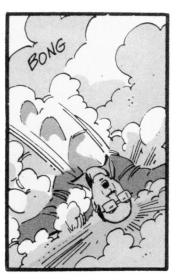

BONG

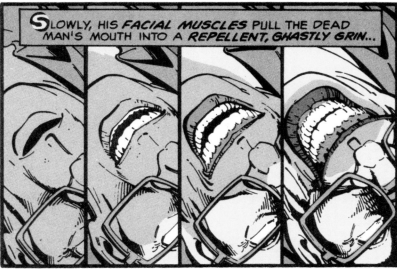

SLOWLY, HIS *FACIAL MUSCLES* PULL THE DEAD MAN'S MOUTH INTO A *REPELLENT, GHASTLY GRIN*...

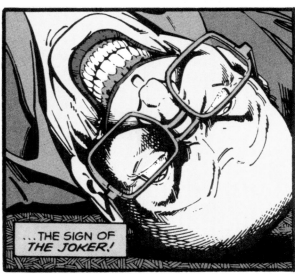

...THE SIGN OF *THE JOKER!*

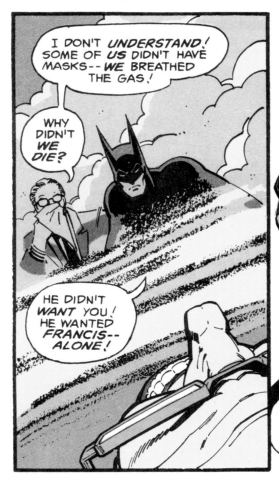

I DON'T *UNDERSTAND!* SOME OF *US* DIDN'T HAVE MASKS--*WE* BREATHED THE GAS!

WHY DIDN'T *WE* DIE?

HE DIDN'T *WANT* YOU! HE WANTED *FRANCIS*--ALONE!

NOW THAT I'VE BREATHED THE GAS *MYSELF*, I *RECOGNIZE* IT! IT'S ONE PART OF A *BINARY COMPOUND*--

--EACH PART *HARMLESS ITSELF*... BUT WHEN THEY'RE *MIXED*, THEY CREATE A *POISON!*

THE JOKER MUST HAVE SECRETLY SPRAYED HIM WITH THE *OTHER* GAS WHEN HE THREATENED HIM AT *NOON!*

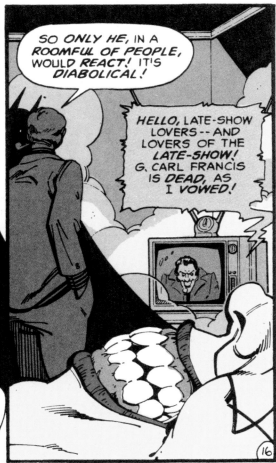

SO *ONLY HE*, IN A *ROOMFUL OF PEOPLE*, WOULD *REACT!* IT'S *DIABOLICAL!*

HELLO, LATE-SHOW LOVERS -- AND LOVERS OF THE *LATE-SHOW!* G. CARL FRANCIS IS *DEAD*, AS I *VOWED!*

16

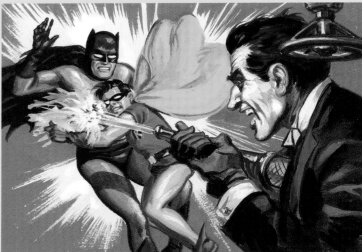

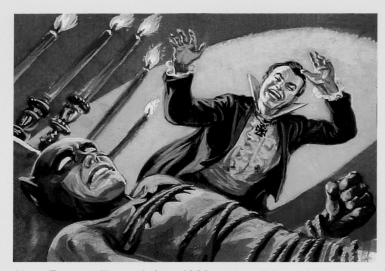

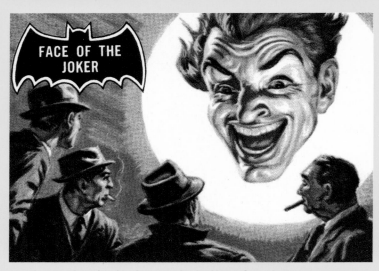

FACE OF THE JOKER

Above: Topps trading cards from 1966 portray a Joker with an odd appearance but a talent for death traps. Art by Norm Saunders.

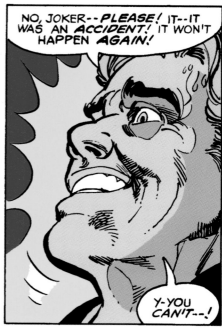

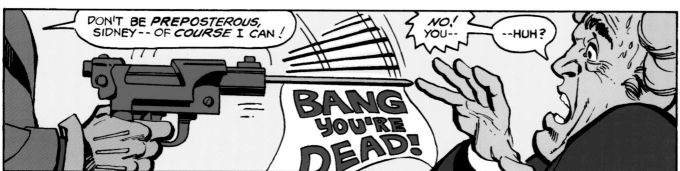

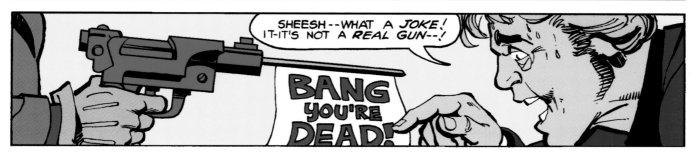

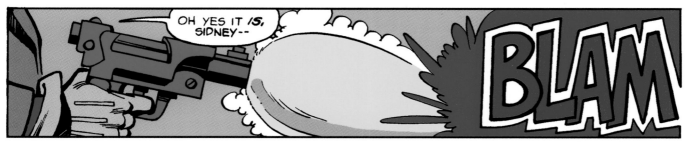

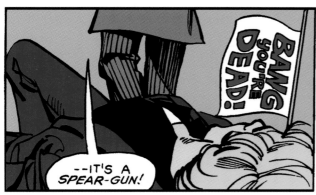

Above: Walter Simonson and Dick Giordano depict a henchman's demise in *Batman* #321 (March 1980).

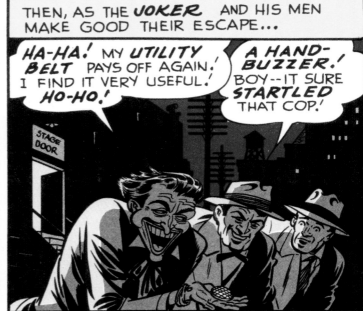

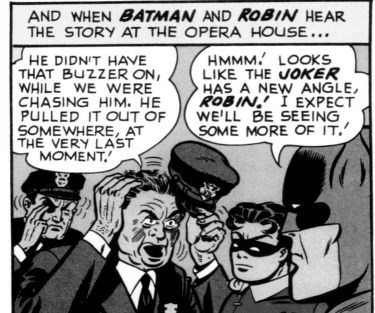

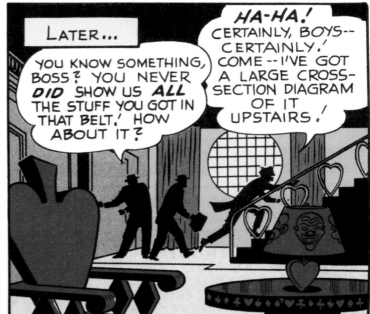

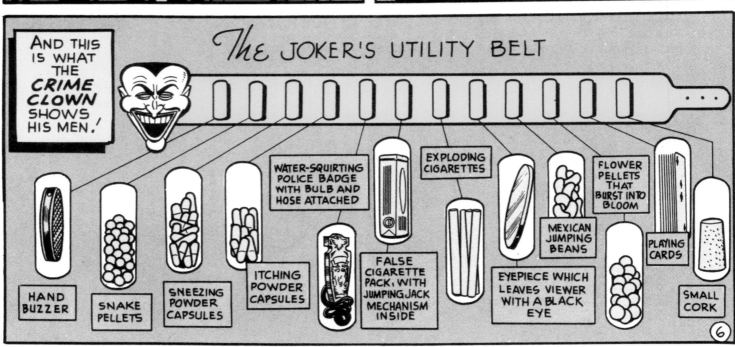

Above: Dick Sprang and Charles Paris catalog the Joker's exhaustive gag inventory in *Batman* #73 (October/November 1952).

of Batman to the Gotham City police department, the Joker also introduced a Joker Signal that crooks could use to summon him for post-heist getaways.

The Jokermobile had the most staying power. Like the Batmobile it evolved through the decades, but usually sported an oversized Joker's head on its hood which raised the question of how he managed to navigate rush hour traffic without getting stopped by the GCPD. The Jokermobile became a popular toy, appearing as a die-cast metal vehicle from Corgi during the 1950s and as a groovy VW microbus released by Mego at the tail end of the age of Flower Power.

The Joker's genius isn't limited by practicality. At any moment he might decide to gas Gotham City from a brightly colored dirigible, or transform an abandoned toy warehouse into a razor-filled deathtrap. His supply of cash seems somehow limitless, but even so he can't pull off his schemes without hired muscle. The Joker's henchmen are typically knuckle-cracking goons who would otherwise be collecting protection money for Gotham's traditional crime families. Money seems to provide the motivation for joining the Joker's team, and an unspoken rule seems to exist in the Gotham underworld that running with a costumed villain is a fast track to success.

The Joker, of course, is the biggest costume in town. His flunkies are too nervous to refuse indulging their boss's quirks, whether it's donning red clown noses or laughing with gusto at even the stalest jokes. Even so, the mortality rate among their ranks is frighteningly high. If one of them is captured by the Batman, the worst outcome is a prison term. The Joker, by contrast, will poison a henchman as a way to pass a rainy afternoon.

Batman has his bats, Catwoman her cats. Of all the members of the animal kingdom, the laughing hyena is the Joker's closest spiritual cousin. And while he has never patterned himself after one, he does see their value as pets. In the 1977 television cartoon *The New Adventures of Batman*, the Joker traveled with a hyena named Giggles who let loose with a chuckling, staccato bark whenever his master delivered a punchline. By the 1990s the Joker had expanded his menagerie, and in *Batman: The Animated Series* he often had a pair of scruffy-furred hyenas patrolling his hideout. These beasts, far less comical than Giggles, worked as watchdogs to keep out uninvited guests, especially ones with capes and pointed cowls. The only person other than their master who seemed capable of controlling the hyenas was the Joker's devoted gun moll, Harley Quinn.

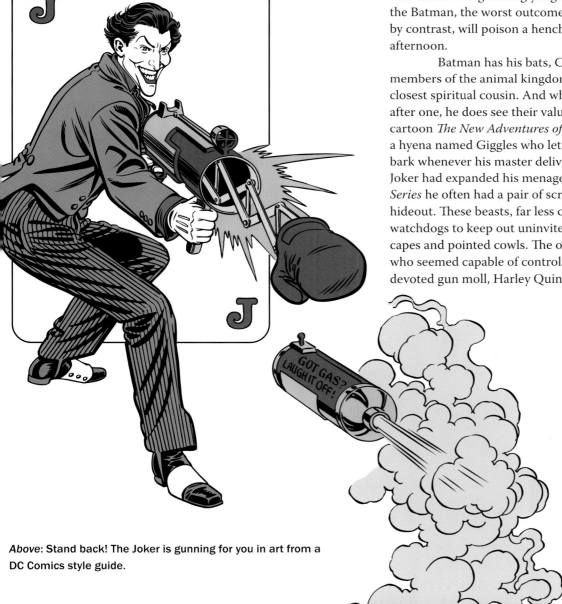

Above: Stand back! The Joker is gunning for you in art from a DC Comics style guide.

Above: It's curtains for the Caped Crusader in this page from
a 1966 Batman coloring book published by Whitman.

Opposite: A gruesome scene by Dustin Nguyen and Derek Fridolfs showcases one
use for the Joker's pet hyenas. From *Batman: Streets of Gotham* #19 (2011).

Above: In Dick Sprang's cover to *Detective Comics* #91 (September 1944), Robin beats the Joker at his own game.
Opposite: The Joker's balloon is as big as his ego in this George Perez poster from *The Batman Portfolio* (1990).

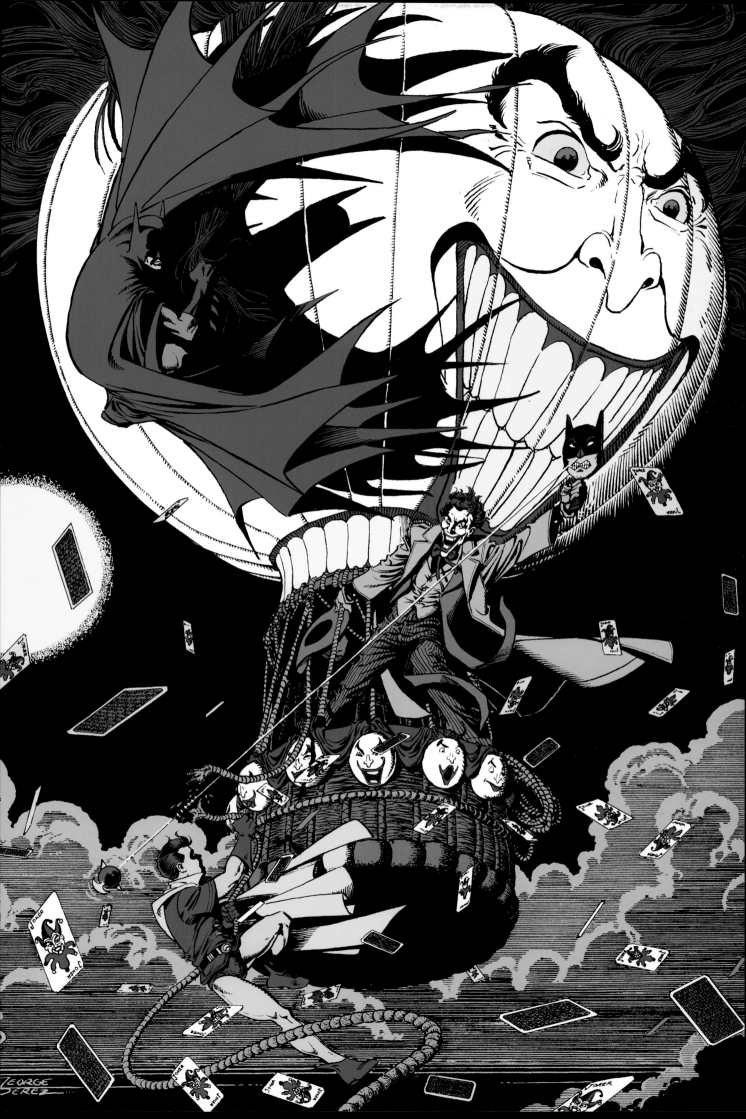

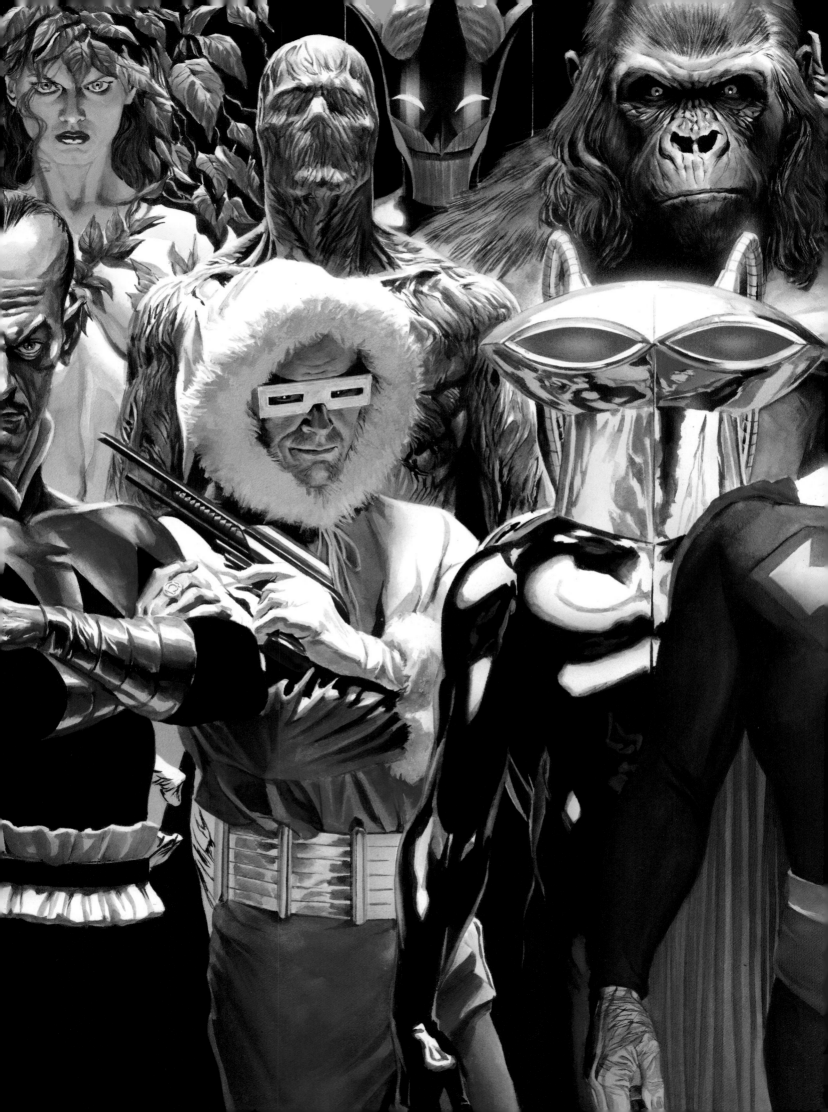

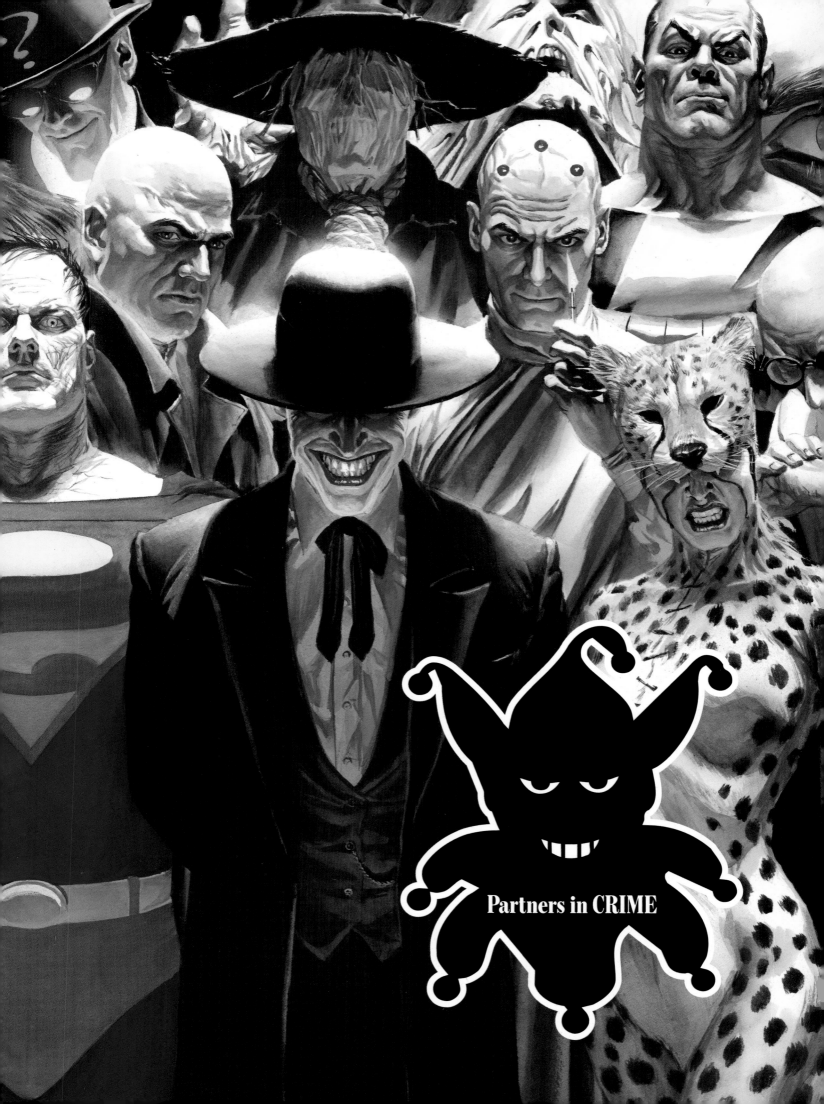

Partners in CRIME

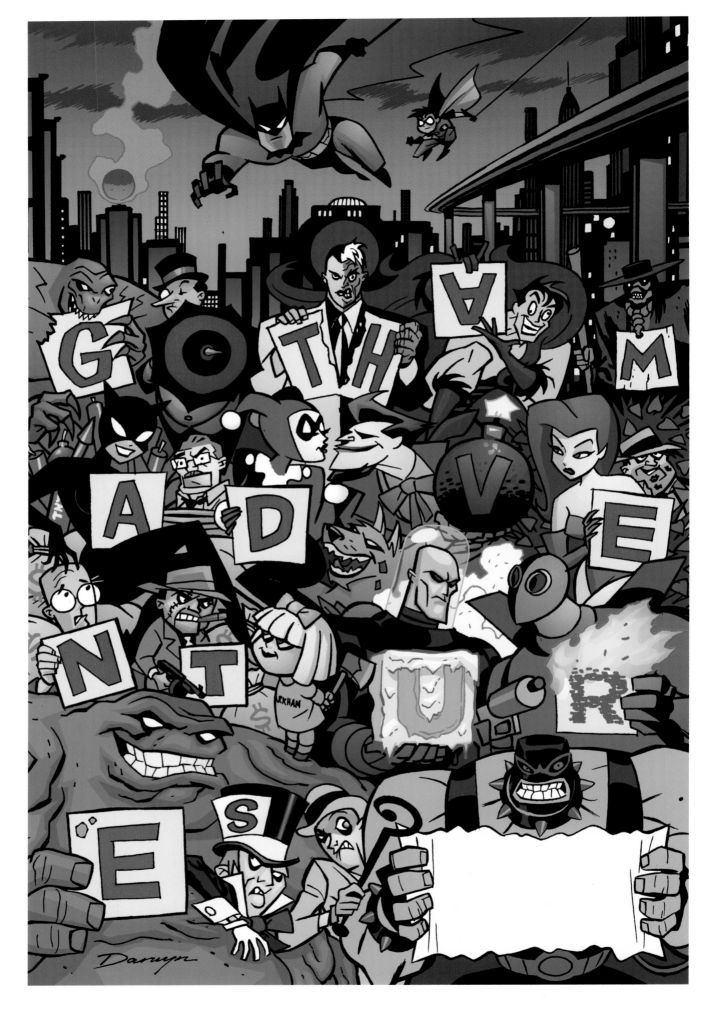

Above: Darwyn Cooke brings all of Gotham's baddies out to play in the cover to Batman: *Gotham Adventures* #45 (February 2002).

"Luthor wouldn't be a half-bad bird if he managed
to grow himself some kind of a sense of humor!"
— *The Joker* #7 (1976)

Gotham is the most dangerous city in the DC universe,
welcoming mafiosos and madmen alike. Arrayed against Batman
are insane obsessives like Two-Face, flamboyant but nominally
sane "themed villains" such as the Penguin, and traditional crime
families including the Falcones and the Maronis. But one thing
unites them—they all feel threatened by the Joker. When circum-
stances have forced his hand, the Joker has fought his rivals for
control of the city or teamed up with them to grab even bigger
slices of the pie.

Two-Face is one of Gotham's most powerful figures.
Formerly the handsome district attorney Harvey Dent, he
suffered a psychological split after acid scarred his left side.
Two-Face's insistence on basing his decisions on the outcome
of a coin flip has a binary simplicity that clashes with the Joker's
multifaceted madness.

It's an understatement to say the two get on each others'
nerves, and tensions came to a boil in the first issue of *The Joker*
(1975). Convinced that he could outthink Two-Face at nabbing
a museum's stash of gold doubloons, the Joker made a misstep
and wound up tied to a plank as Two-Face prepared to push him
into a circular saw. The Joker used his acid-spitting boutonniere
to escape his bonds and his near-bisection, but seemed rattled
by the thought that an enemy might be even more dedicated to
insanity than he.

Oswald Cobblepot is better known by the nom de guerre
of the Penguin. He's a criminal mastermind with his fingers in
scores of rackets, plus plenty of above-board businesses including
the chic nightclub the Iceberg Lounge. The Penguin has quirks
including his fixations on birds and umbrellas, but isn't so far
around the bend that he requires incarceration in Arkham
Asylum.

In 1944's *Batman* #25, the Penguin and the Joker united
for the first time. After the two got the drop on Batman and
Robin, they had the Dynamic Duo dead to rights under their
drawn guns. Yet Batman's simple play to vanity was enough to
undo the partnership. Goaded into target shooting to prove who
was the better marksman, the two villains bickered while Batman

Previous spread: Alex Ross's painted rogues' gallery from *Justice* vol. 2 (2007)
puts the Joker shoulder–to–shoulder with the DC Universe's villainous elite.

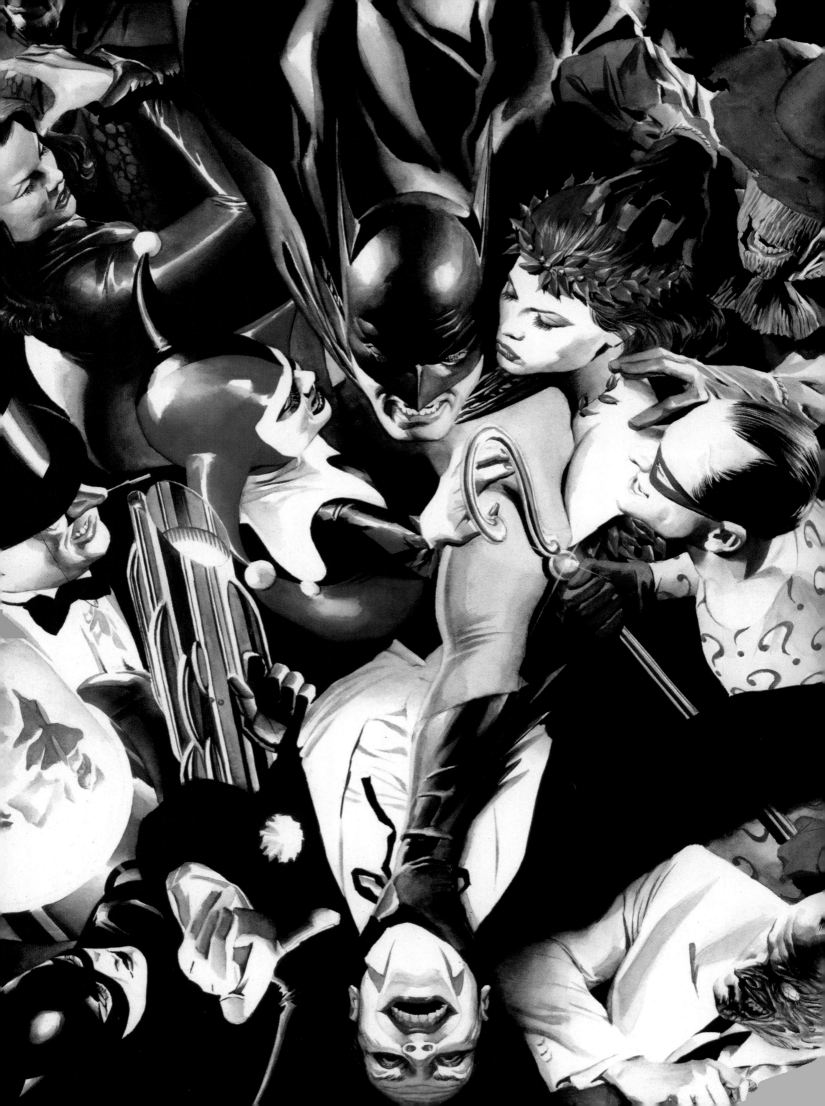

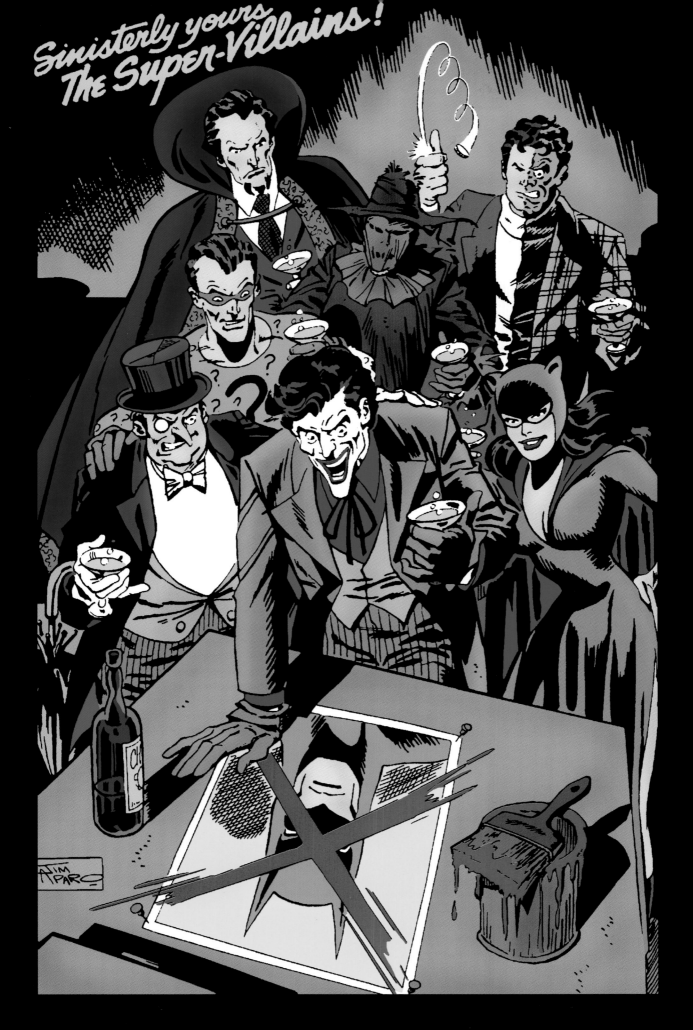

Above: A Jim Aparo pinup from *Detective Comics* #484 (June/July 1979), for fans who prefer cheering for the crooks.
Opposite: Hemmed in by foes, Batman keeps fighting in this Alex Ross cover to *Wizard* #99 (November 1999).

cut his bonds with a broken bit of crockery. Subsequent teamups between the Joker and the Penguin have been rare, for their aims are fundamentally incompatible. The Penguin wants to build up his piece of Gotham, but the Joker exists to tear everything down.

Selina Kyle, the Catwoman, prowls the thin band of twilight between good and evil. Her attraction to Batman pulls her to the side of the law, but her skill at cat burglary means that she's never far from a jewelry store or a museum's exhibit of priceless Egyptian cat statues. The Catwoman and the Joker both debuted in 1940's *Batman* #1, and their first direct meeting happened the very next issue. As Catwoman (at the time, known only as the Cat) moved in to nab a jewel, the Joker stopped her at gunpoint to claim the prize for himself. Batman and Robin's arrival turned the scene into a brawl, but the mistrust between villain and villainess has endured to this day.

Who is the smartest person in Gotham? Edward Nigma is quick to buzz in with an answer: it must be he, the city's perplexing Riddler. This puzzle maven and self-styled detective can't beat Batman in the brains department, but he enjoys leading the Caped Crusader on a merry chase through the alleyways of the intellect. Despite their mutual love of games, the Joker seems to have little patience for Eddie, and on closer examination it seems clear that the Riddler's crossword-style meticulousness is a poor fit for the Joker's wild bedlam.

Other figures in Gotham's crime structure include the Scarecrow, Mister Freeze, the Mad Hatter, Killer Croc, and the Ventriloquist, and most of them spend their downtime locked up in Arkham. Because the Joker is the asylum's unofficial boss, he enjoys a corresponding position of power over the "little fish" whenever the inmates escape, which is often. Someone like Croc will be exploited as dumb brawn, or Scarecrow might fill a niche as a dreamscape terrorist. In general the Joker doesn't mind if others take a spin with the Batman, just as long as they save the last dance for him.

The Joker's greatest rival is the smartest man in the world. Lex Luthor has dedicated his genius and his fortune to killing Superman, and that's the kind of tenacity that the Joker can't help but admire. Both men have no special powers but are among the most feared figures on the planet. And though their philosophies couldn't be farther apart—Lex is disciplined and process driven, the Joker is brilliantly scattershot—both would agree that their minds are in top form for their chosen missions.

Despite the best-selling popularity of both Batman and Superman, the two heroes didn't team up until the early 1950s in the pages of *World's Finest Comics*. It wasn't long before their archenemies took the hint. In *World's Finest Comics* #88 Edmond Hamilton and Dick Sprang presented the spectacle of a formal business partnership between Lex Luthor and the Joker. The pair manufactured a line of lifelike robots called Mechano-Men. The Man of Steel and the Caped Crusader remained

Above: Detail from the Jim Lee covers of the volume 1 and 2 hardcover collections of *Batman: Hush* (2003).

Opposite: Poison Ivy, Harley Quinn, and Catwoman balance Guillem March's cover composition for issue #11 of *Gotham City Sirens* (June 2010).

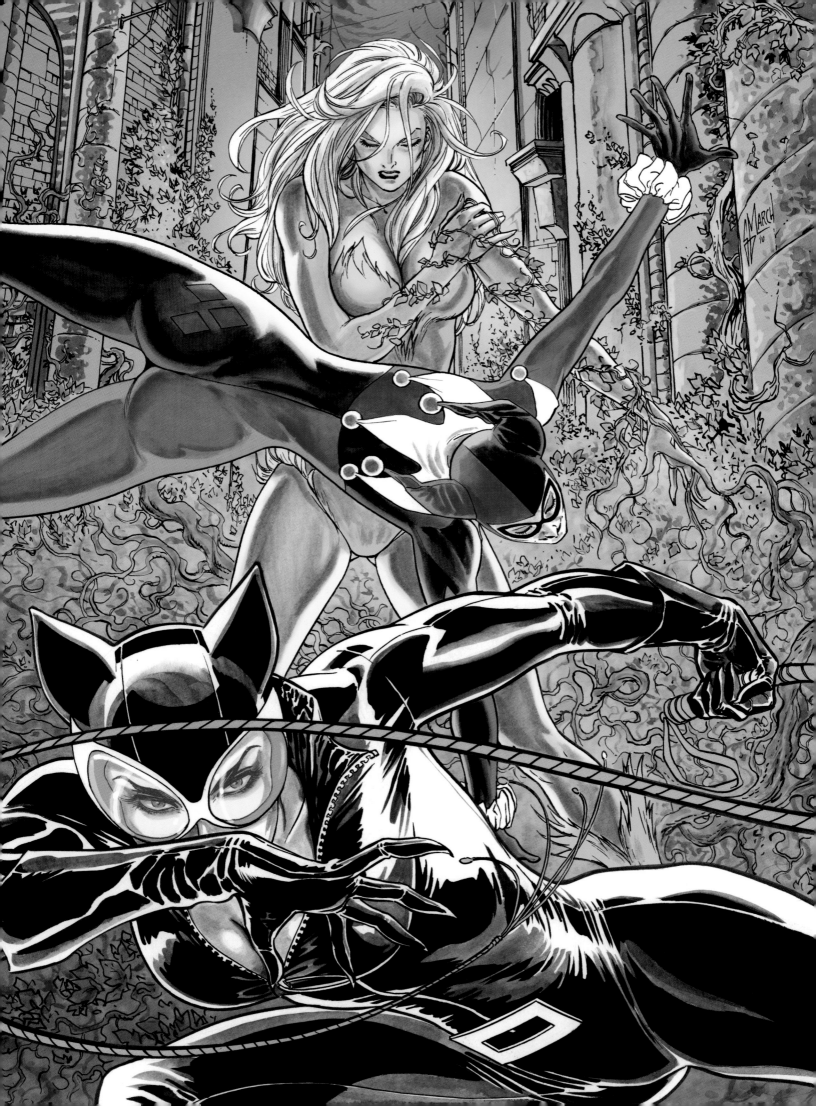

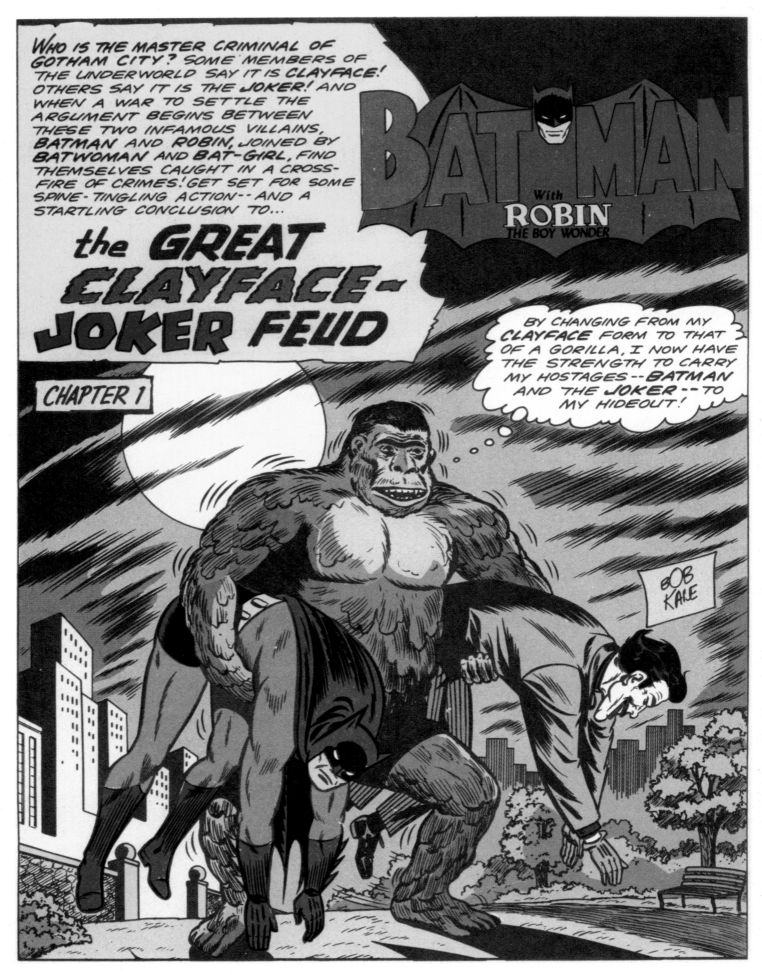

Above: You couldn't go wrong with giant gorillas during the Silver Age of comics, as Sheldon Moldoff and Charles Paris proved in this page from *Batman* #159 (November 1963).

Opposite: Bane cracks the Joker's spine in John Cassaday's cover to *Detective Comics* #740 (January 2000), a parody of the injury that sidelined Batman during 1993's *Knightfall*.

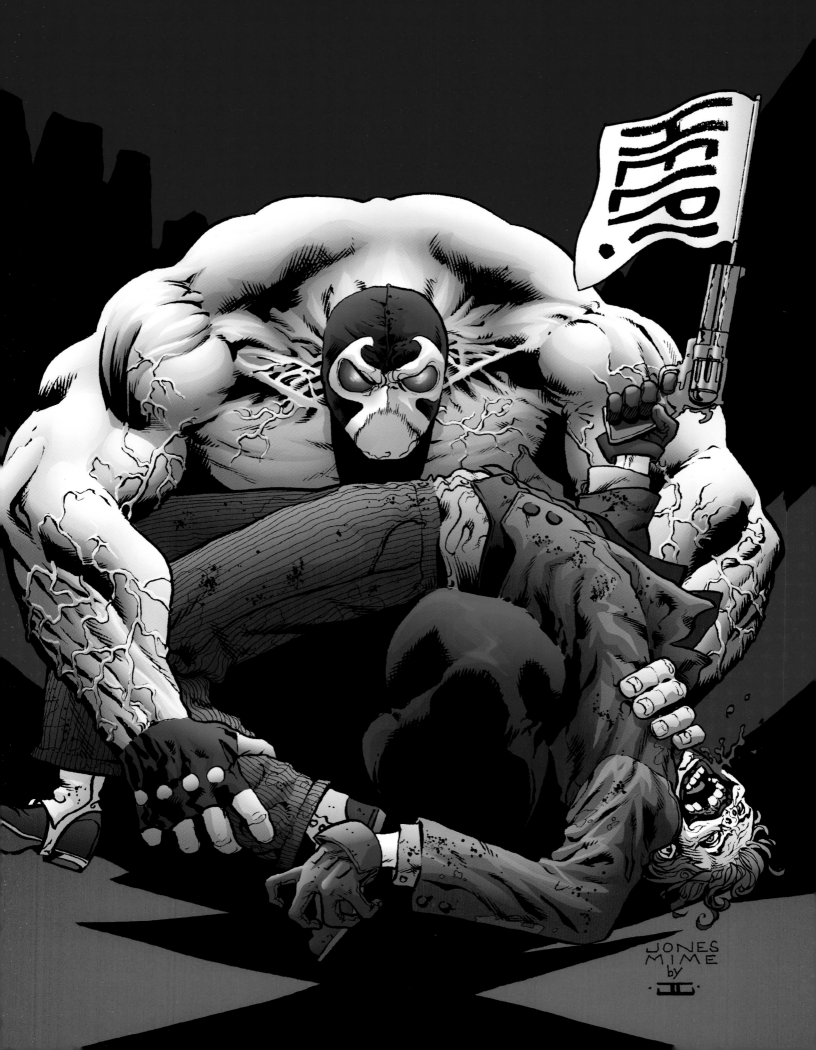

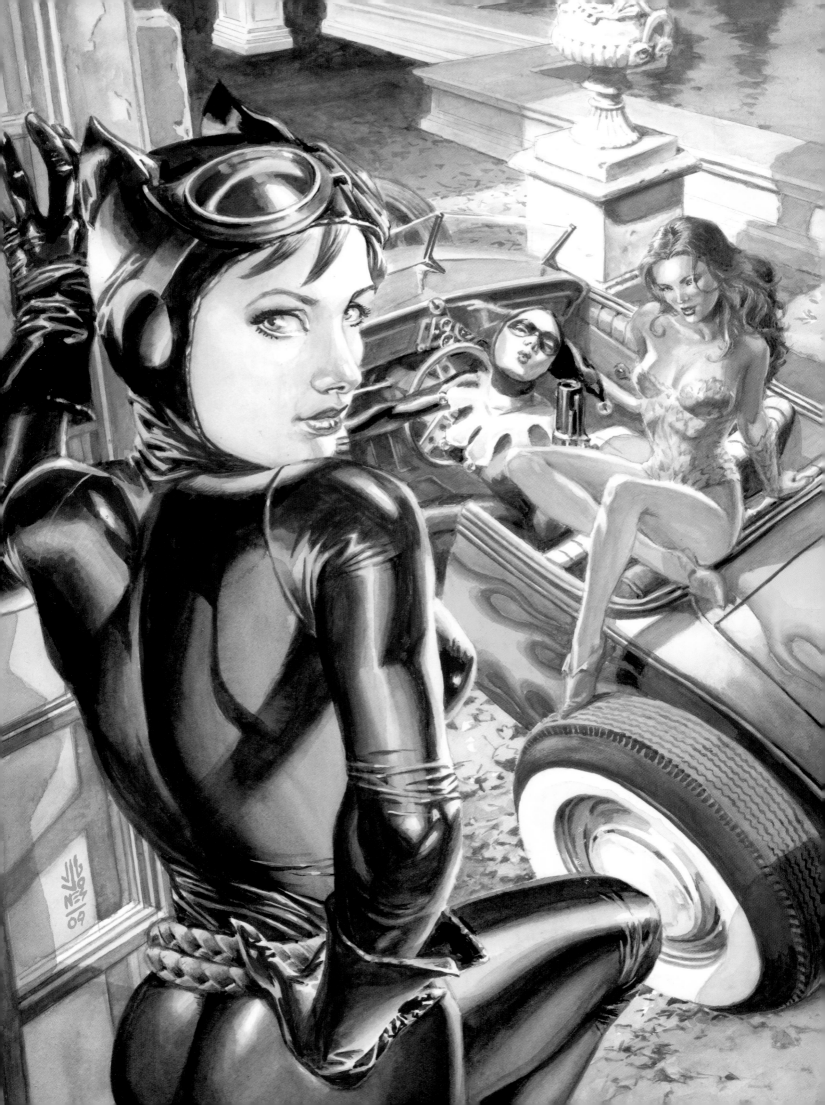

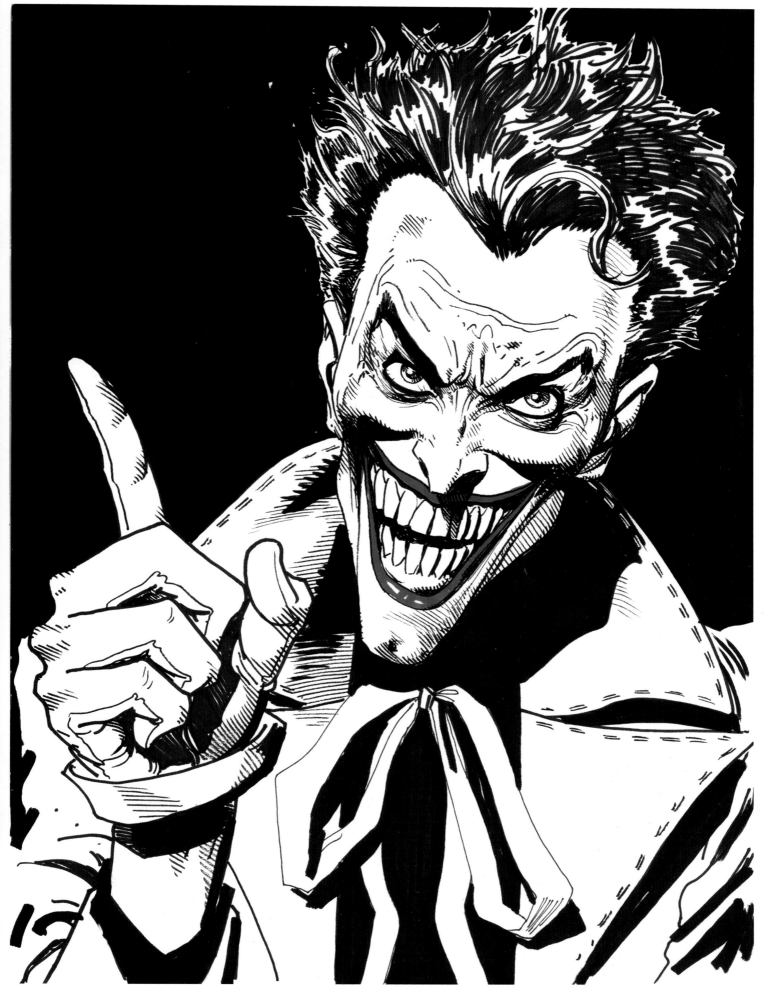

Above: *Batman: The Killing Joke* artist Brian Bolland drew this Joker portrait.
Opposite: Going for a spin? Guillem March's inviting cover for *Gotham City Sirens* #1 (August 2009).

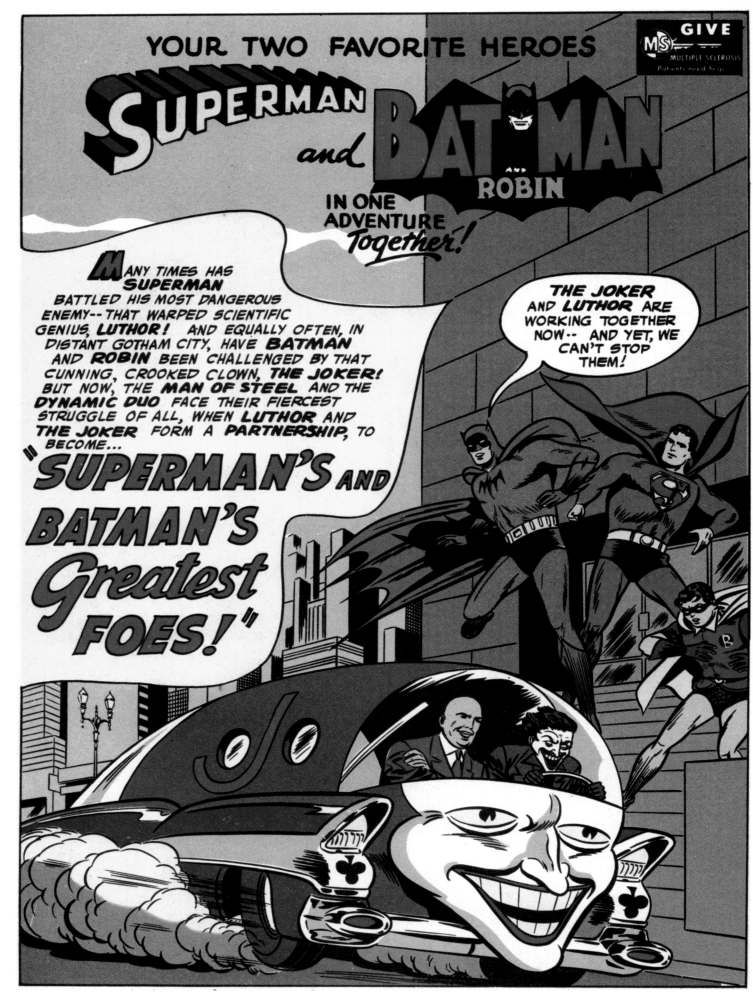

Above: Lex Luthor rides shotgun as the Jokermobile makes its getaway in *World's Finest Comics* #88 (May/June 1957). Art by Dick Sprang and Stan Kaye.

baffled by the move, unable to believe the crooks had gone straight. Their suspicions were vindicated when the Mechano-Men proved to be an elaborate distraction for a raid on the treasury.

Luthor and the Joker remained chummy right up until their arrest, but the Mechano-Men caper appears to be the sole product of Luthor's scientific acumen. The failure of the one-sided scheme was telling, for later pairings of the two villains were much more likely to emphasize their mutual hostility.

In a 1990 *World's Finest* miniseries by Dave Gibbons and Steve Rude, Luthor and the Joker swapped cities to cause maximum damage. Superman found himself frustrated by the Joker's pie-throwing unpredictability, while Batman couldn't make headway against a villain who used LexCorp to buy up Gotham city blocks through sketchy but ultimately legal means. Luckily for the heroes, their problem largely solved itself when Luthor and the Joker tore each other apart in their angry insistence on proving who was top dog.

That friction carried over into 1998's *The Batman/Superman Movie*, an animated feature that united the two criminals in a take-over plot involving a chunk of kryptonite and plenty of killer robots. Luthor and the Joker clashed with more hate-fueled spite than either showed toward his costumed counterpart, yet each recognized the value of an alliance—as long as it remained temporary.

In a 2003 issue of *The Outsiders*, writer Judd Winick included a standoff between the Joker and Luthor, who at the time was serving a term as president of the United States. President Luthor withstood the Joker's electroshock torture, and crushed his rival with a single, needling taunt: "Does it bother you that Batman likes Catwoman better?"

A 2011 issue of *Action Comics* proved that the Joker and Lex Luthor are still one of the most dangerous and fascinating pairings in fiction. Paul Cornell and Pete Woods detailed Luthor's visit to Arkham Asylum to locate a cosmic anomaly. Mocking Lex's goal of improving the world through scientific genius, the Joker sneered, "My only 'freedom' would be to feel like you. Like the world could be made right." In what was basically an issue-length locked-cell conversation, each villain demonstrated his driving motivation and never gave the other an inch.

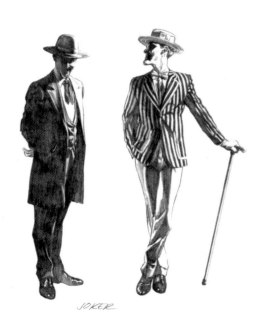

Top: Evil doesn't have a prayer in Dave Taylor and Robert Campanella's cover to *Batman/Superman: World's Finest* (2003).
Above: Alex Ross drew these pencil studies of the Joker for *Justice* (2005).
Overleaf: Lex Luthor and the Joker plan to take over the world—if they don't kill each other first—in *The Batman Superman Movie: World's Finest* (1996).

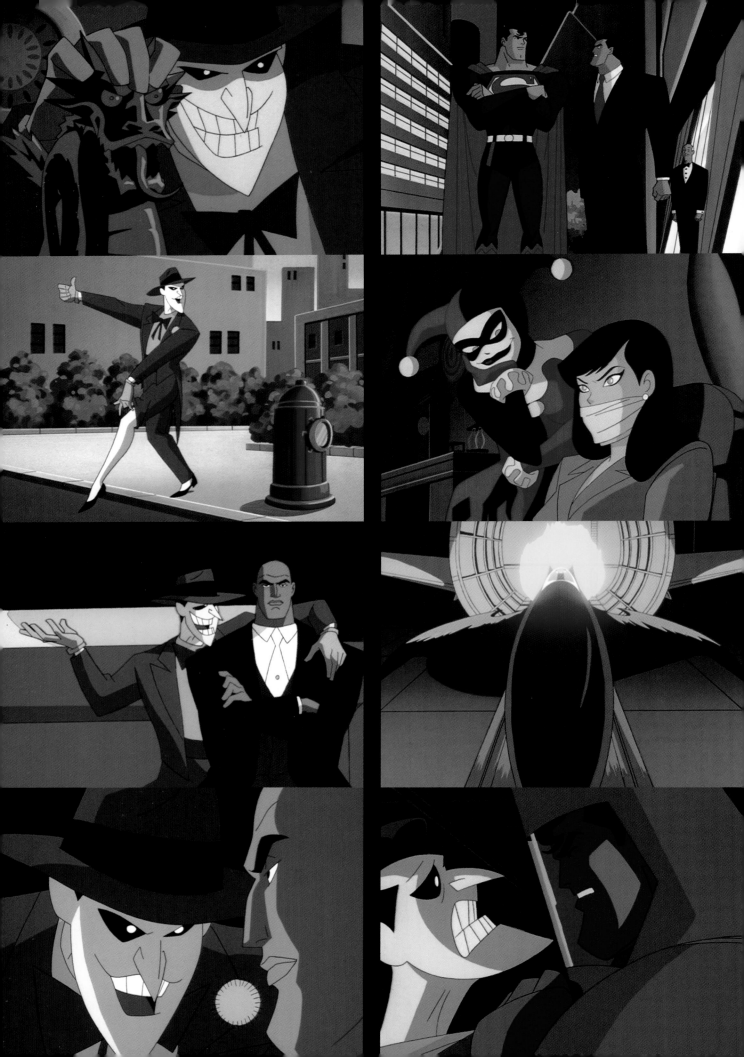

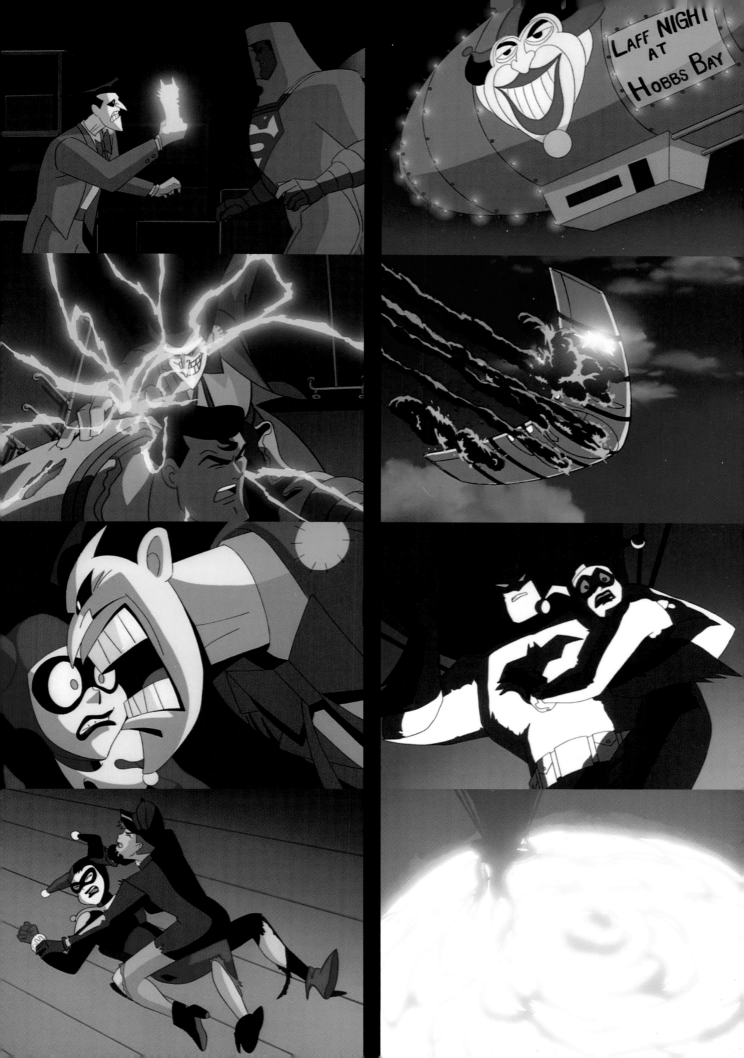

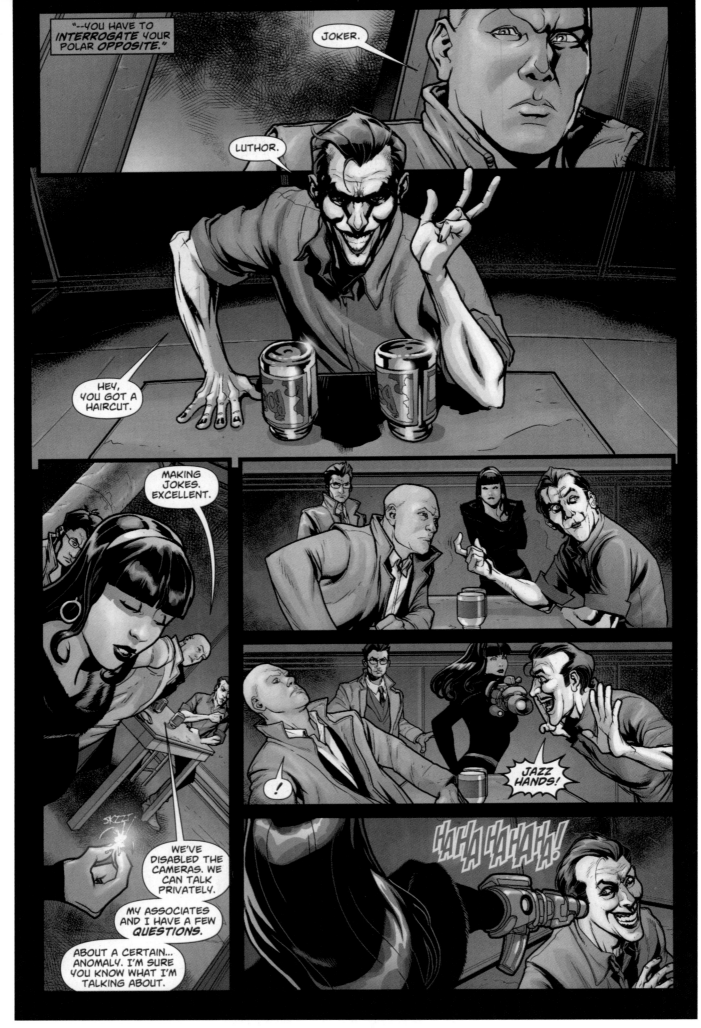

This spread: Even in a locked cell, the Joker knows how to outmatch the world's smartest man.
Art by Pete Woods from *Action Comics* #897 (March 2011).

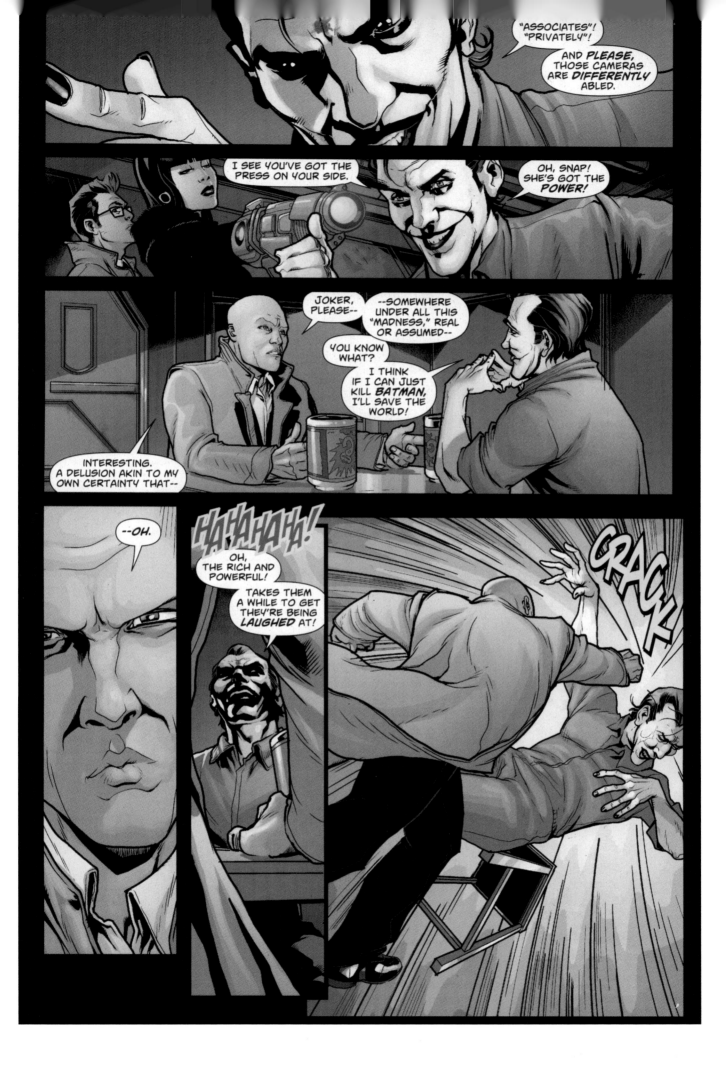

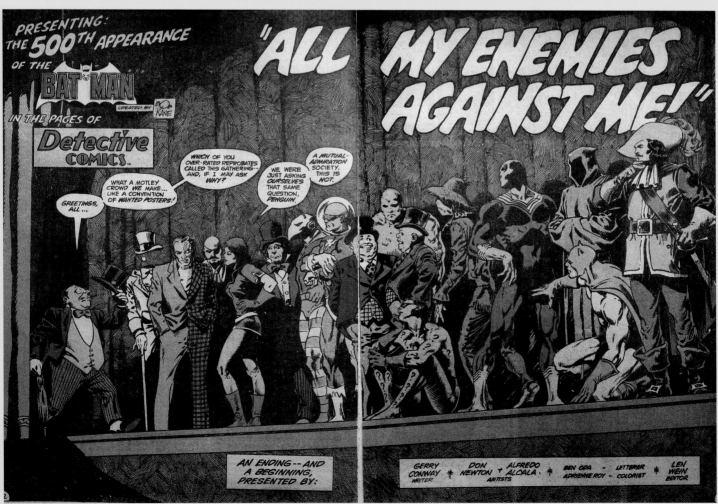

Top: In 1966, Bat-Fans could get these posters as mail-in premiums from Fact toothpaste.

Above: A host of enemies from superstars to bit players fills the stage in *Detective Comics* #526 (May 1983). Art by Don Newton and Alfredo Alcala.

Opposite: The Dark Knight's foes are never far from his mind in this Michael Golden and Mike DeCarlo page from 1984's *Batman Special*.

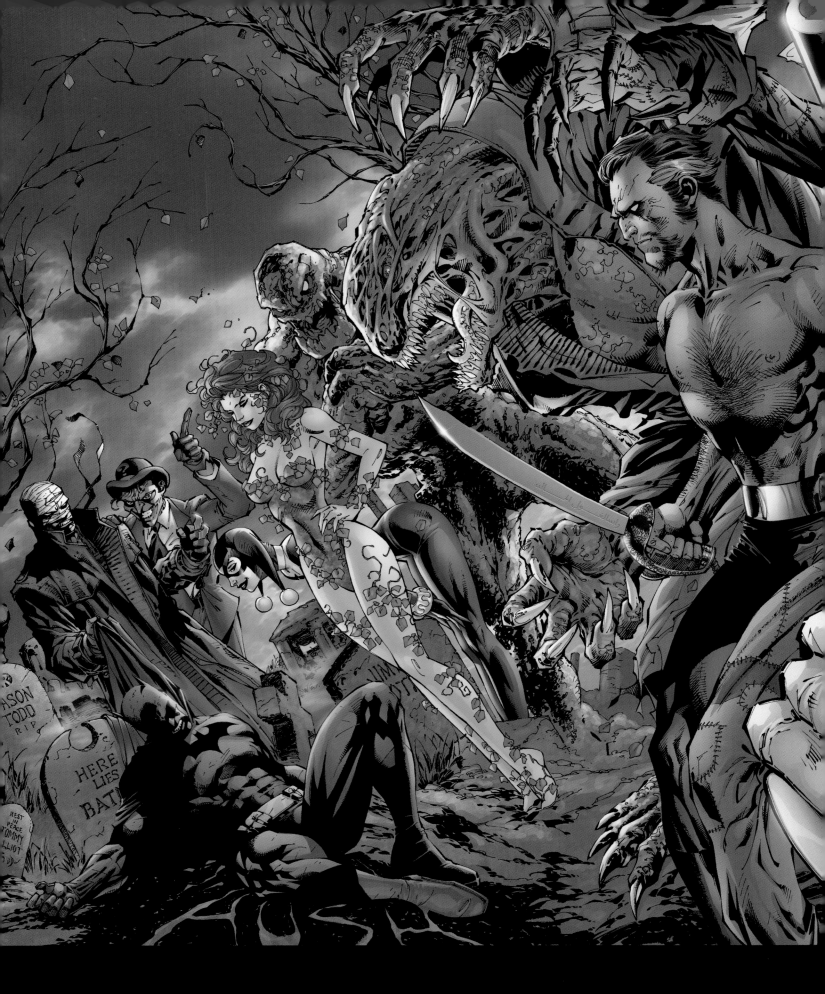

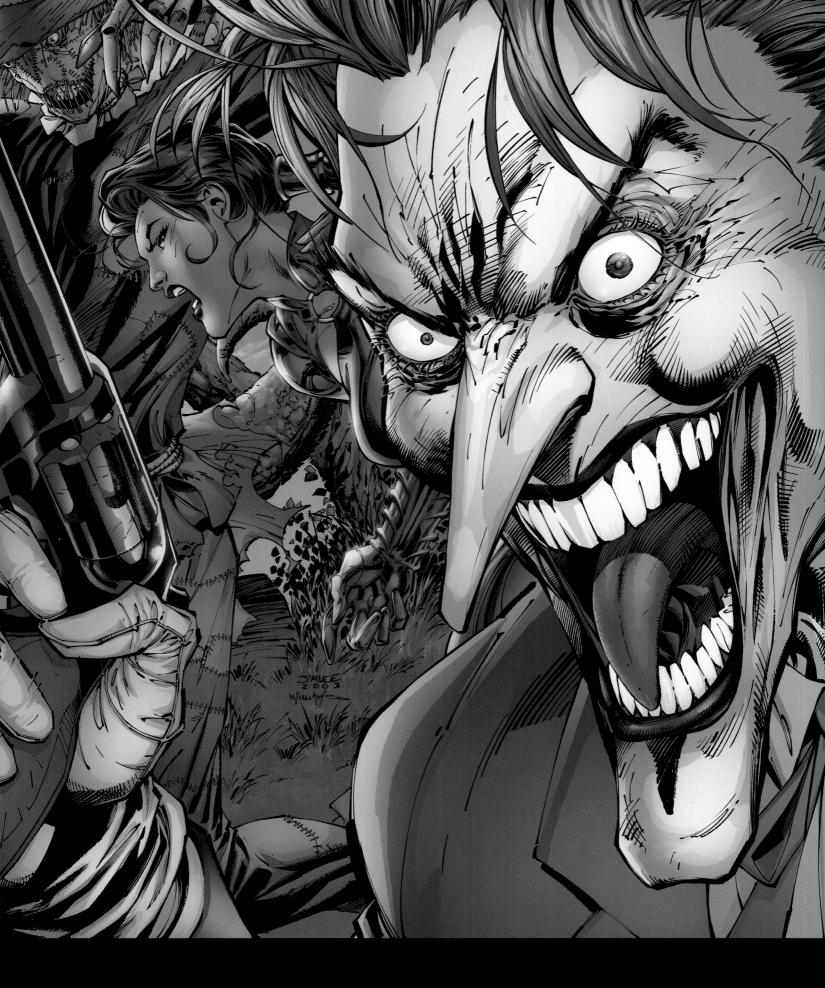

Overleaf: Batman cradles the lifeless body of Jason Todd, the second Robin. Jim Aparo and Mike DeCarlo interpret Michelangelo Pieta for
Batman: A Death in the Family.

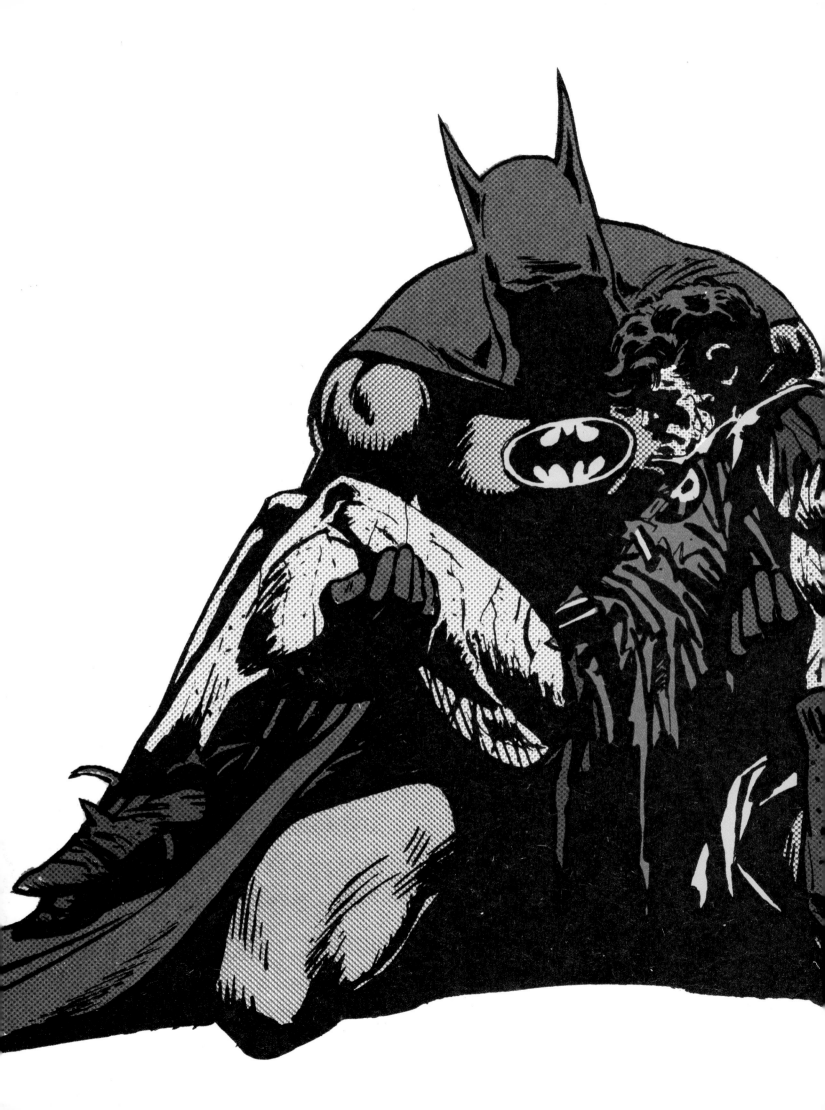

Crimes and CAPERS

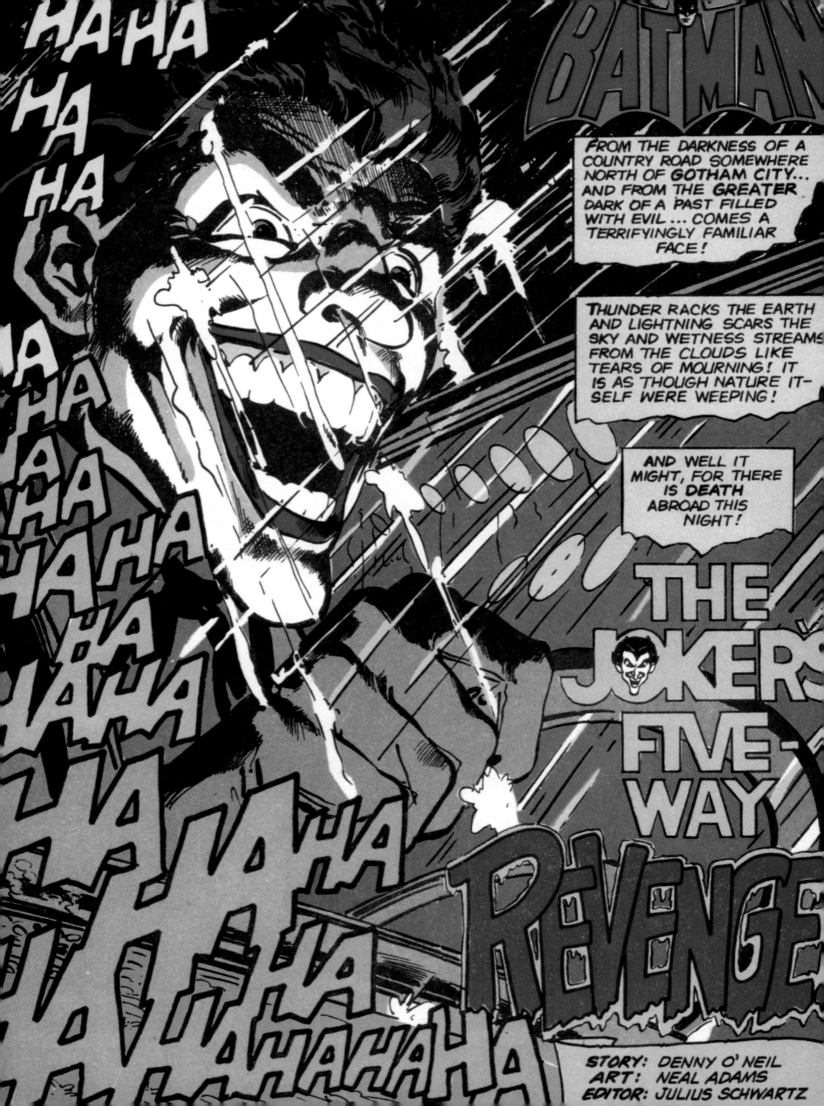

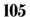

"Come now, birdboy! You're not going to sleep on me already, are you? The party's just got started!"
—*Batman* #427 (1988)

He's the most outsized criminal in the big city of Gotham, and his exploits are always larger than life. For the Joker, crime is performance art. If it's not spectacularly theatrical, it's boring, and his audience might fail to see the humor in the horror. Like all actors, the Joker claims not to care what the reviewers think, but secretly craves critical validation. And there's only one critic who matters: Batman.

"The Joker's Five-Way Revenge" in *Batman* #251 is a definitive take on the Joker's modus operandi. This story by writer Denny O'Neil and artist Neal Adams reset the Joker back to the homicidal circus freak introduced in 1940, after decades of lighthearted, cream-pie fare that included the satirical *Batman* live-action TV show. As the Joker moved against five ex-cons responsible for sending him up the river, he snuffed each one with an array of lethal novelties including Joker Venom and exploding cigars. Batman arrived too late to prevent each kill, and the Joker's signature playing card became a taunt and a challenge.

At one point this leaner, deadlier Joker overwhelmed the Dark Knight and had his enemy at his mercy. "I can crush the breath out of him effortlessly," he mused, his boot on Batman's trachea, before concluding that such a victory would be anticlimactic and hollow. "No! Without the game that the Batman and I have played for so many years, winning is nothing!" In the end Batman barely pulled out a victory, but only after going a round against a great white shark inside a saltwater tank.

In *Detective Comics* #475, the Joker attempted to execute a scheme that seemed almost plausible if one overlooked its intentionally absurd premise. "The Laughing Fish" by Steve Englehart and Marshall Rogers began with the wholesale poisoning of every fish on the Eastern Seaboard—not to turn their meat toxic, but to stick bizarre grins on their lipless faces. The Joker's next step was hilariously mundane. Bursting into a patent office, he demanded that the terrified clerk grant a copyright on these "Joker-fish" which would guarantee him a royalty payment every time someone ordered a seafood dinner. Given the news that fish are a natural resource that cannot be trademarked, the Joker threatened murder to jumpstart the government's bureaucracy. "The Laughing Fish" was later adapted as an episode of *Batman: The Animated Series*, and the script also incorporated the shark fight from "The Joker's Five-Way Revenge."

Above: The Joker is a cruel predator in this study by Alex Ross for *Justice* #3 (February 2006).
Opposite: Do you hear laughter in the rain? Neal Adams and Dick Giordano welcome the Joker back to Gotham in *Batman* #251 (September 1973).

Above: Something's fishy in Brian Bolland's cover for this 1988 collection of Joker tales.

Left: *Batman: The Animated Series* offered its own take on the Joker's marine menace with "The Laughing Fish," which aired on January 10, 1993.

Opposite: Marshall Rogers and Terry Austin serve up an iconic cover image with *Detective Comics* #475 (February 1978).

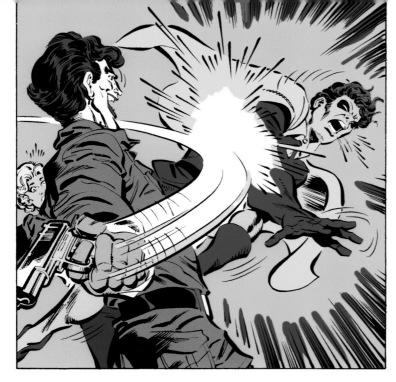

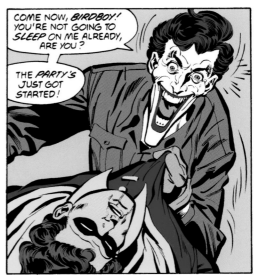

By the late 1980s, Batman's original Robin, Dick Grayson, had left the nest to become the costumed hero Nightwing. His replacement was Jason Todd, but the second Robin never clicked with fans. "I had a Robin problem," admitted editor Denny O'Neil. "We could have simply lightened his character, or had some event happen to him that made him change his act. That certainly would have been a way to go."

Instead, like Caesar at the Colosseum, the fans received the power to decide Robin's fate. The "Death in the Family" storyline was plotted for *Batman* issues #426–429. The Joker would be the instrument of Robin's ruination, with the outcome decided by reader vote determined through calls to a pay telephone service. At the conclusion of issue #427, Robin suffered a crowbar beatdown at the Joker's hands, and a bomb leveled the warehouse in which he lay. "Robin will die because the Joker wants revenge," urged the final page. "But you can prevent it with a telephone call." Fans dialed one number if they wanted Robin to pull through, and another if they wanted the Joker's punishment to become a death sentence.

By a 28-vote margin, Jason Todd became the first Robin killed in the line of duty. But even more lasting was the obliteration of a line in the sand that had kept the Joker in

check. No longer was he merely a killer of anonymous thugs and random bystanders, which by then was entry-level mayhem for a comic book villain. Now he could murder characters who were important to the legend's core narrative. His menace had become metafictional.

The Joker's killing of Jason reshaped the Bat-Universe. Batman became even more committed to his cause, putting Jason's costume on display in the Batcave as a memorial and a reminder: *never again.* The Dark Knight played solo for a while, but Batman needs a Robin. Tim Drake soon joined the cast as Robin #3. And, because death seldom sticks in the world of comics, Jason Todd came back to life many years later, but this time as an enemy. That his former sidekick wasn't allowed to rest in peace made the whole ordeal even more excruciating for Batman.

This spread: Though it was a bomb that supplied the coup de grace, the Joker's crowbar pummeling is what readers remember. Panels by Jim Aparo and Mike DeCarlo from *Batman* #427 (December 1988).

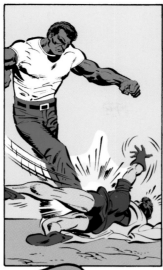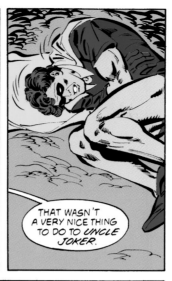

THAT WASN'T A VERY NICE THING TO DO TO *UNCLE JOKER*.

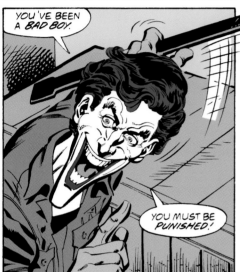

YOU'VE BEEN A *BAD BOY*.

YOU MUST BE *PUNISHED!*

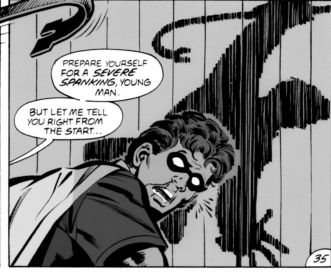

PREPARE YOURSELF FOR A *SEVERE SPANKING*, YOUNG MAN.

BUT LET ME TELL YOU RIGHT FROM THE START...

35

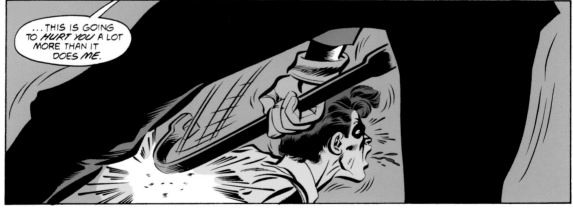

...THIS IS GOING TO *HURT YOU* A LOT MORE THAN IT DOES *ME*.

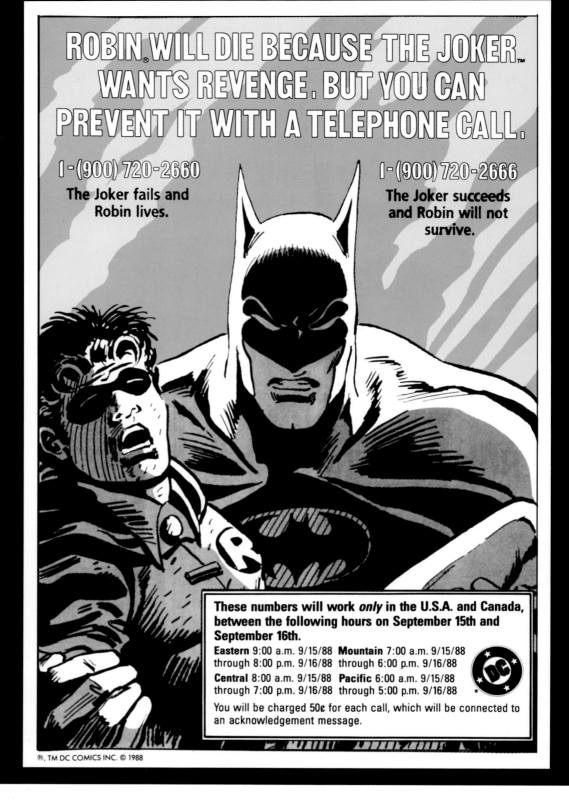

The 2010 animated movie *Batman: Under the Red Hood* retold the story of Jason's death and return, and starred a Joker who was all business. With a heavier frame, dark, sunken eyes, and a gravelly voice provided by John Di Maggio, this Joker could kill a room full of people with a broken bottle and loved rubbing salt in Batman's wounds. He showed smug satisfaction in killing Jason, and amusement that Jason's resurrection could cause even more pain. Jason, for his part, couldn't believe that Batman had let the Joker get away with murder. "Blindly, stupidly disregarding the entire graveyards he's filled, the thousands who have suffered, the friends he's crippled?" he said. "And I thought I'd be the last person you'd ever let him hurt." Far from being an isolated incident, the Joker's role in the death and life of Jason Todd has cast a long shadow.

Above: Fans cast more than 10,000 votes in the life-or-death telephone poll.
Opposite: Back from the dead, an older and grittier Jason Todd has murderous intentions for the villain who sent him to the grave in 2010's *Batman: Under the Red Hood*.

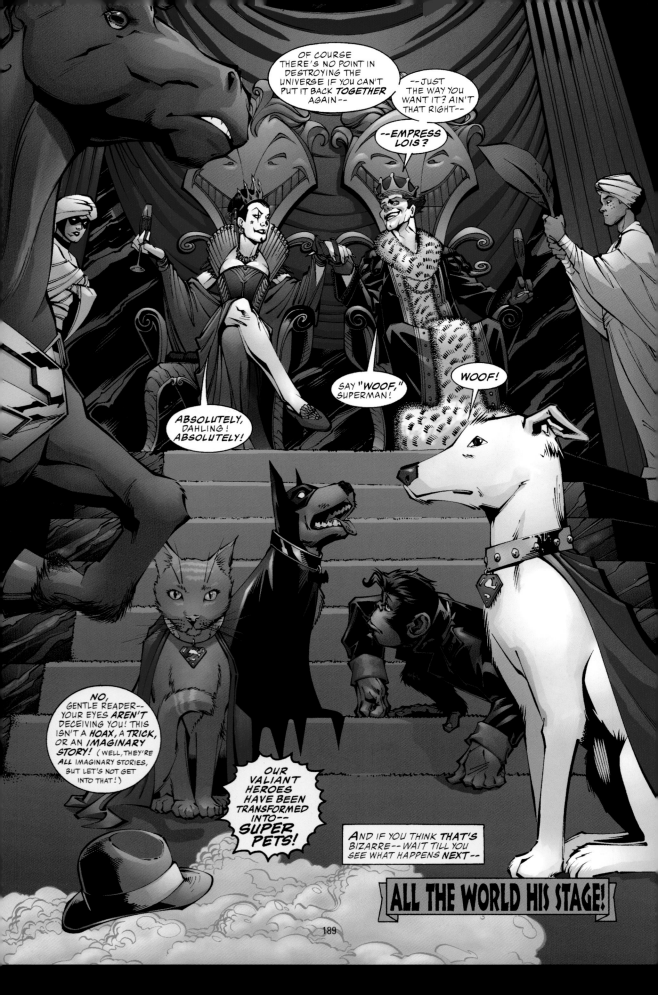

189

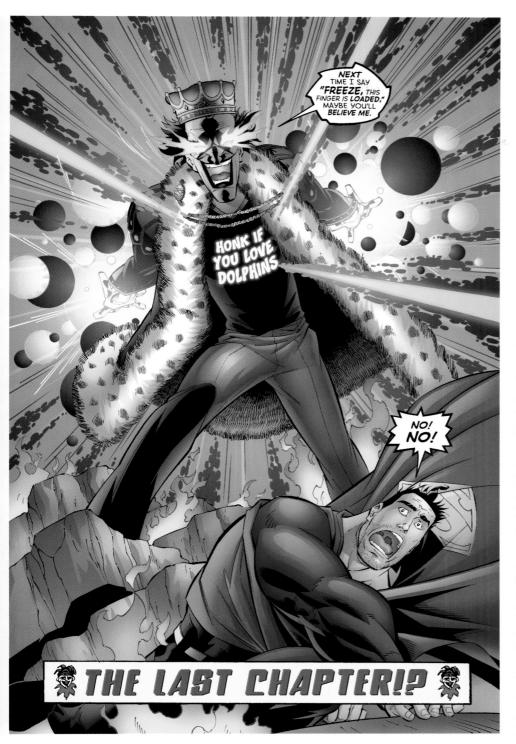

So what would happen if the amped-up threat represented by this new and deadly Joker were to suddenly gain all the power in the universe? The nine-part "Emperor Joker" explored the intersection of omnipotence and insanity in a storyline that run through the Superman titles during 2000. Mister Mxyzptlk, the fifth-dimensional prankster who has vexed Superman since the 1940s, possesses such control over reality that he can reshape his surroundings with a thought. Only his obsession with innocent game-playing keeps him from becoming the most dangerous foe in the DC universe.

But the instant the Joker stole Mxyzptlk's powers, the planet became a madman's playground. Presiding over a cube-shaped Earth emblazoned with his own face, Emperor Joker drafted Lex Luthor as his court jester, turned Earth's champions into pets, and executed Batman every night only to resurrect him the next morning. Organizing a resistance against an enemy who could weave atoms proved useless. Even cosmic power players like Darkseid and the Spectre fell under the Joker's spell.

It was left to Superman to find a crack in the Joker's armor. And one anomaly still existed in this brave new world—the continued existence of Batman. Even as a tortured toy, Batman remained the focus of the Joker's creations, and thus he still held sway over the Joker's imagination. If Batman couldn't be banished from his thoughts, then the Dark Knight had already won. A crestfallen Joker collapsed into catatonia.

"Emperor Joker" showed the character at his most powerful, but his ambition is a fickle thing. When offered his heart's desire by the Lord of Hell in exchange for his eternal soul (during *Underworld Unleashed*), the Joker readily agreed. His only demand? A box of Cuban cigars.

Above: The Joker becomes a literal god of chaos after stealing fifth-dimensional power.
Overleaf: Seen from the Justice League's lunar HQ, a Jokerized Earth fills this spread by Kano and Marlo Alquiza.

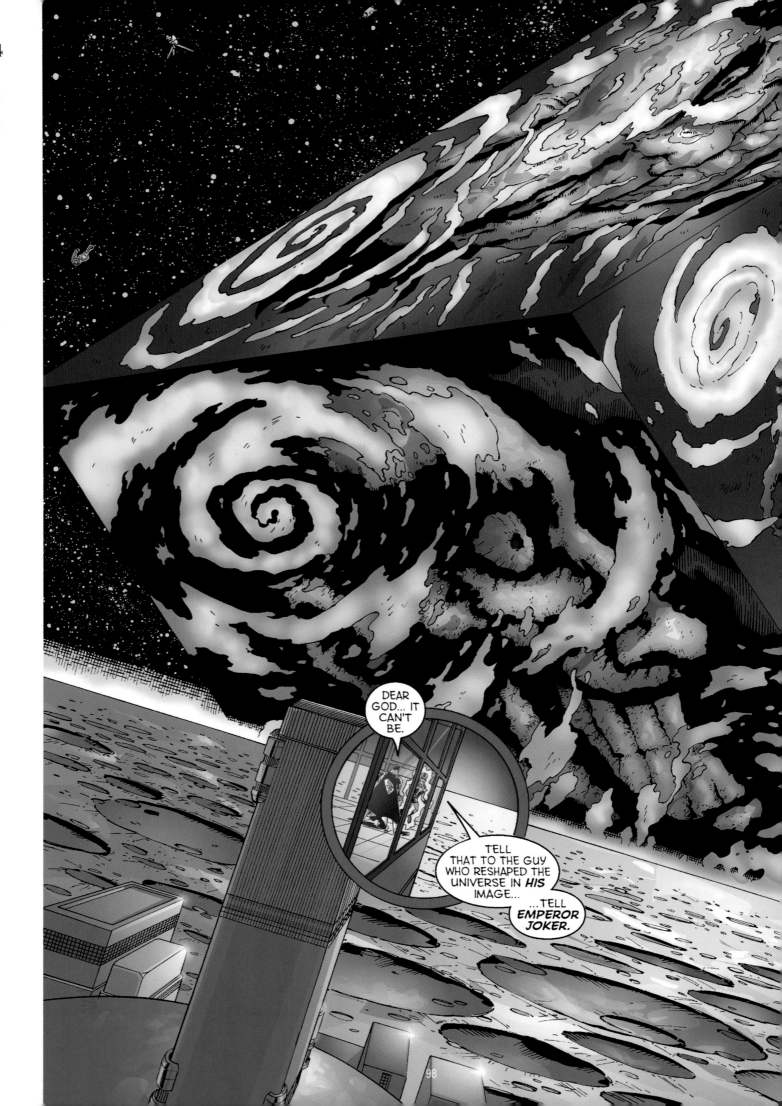

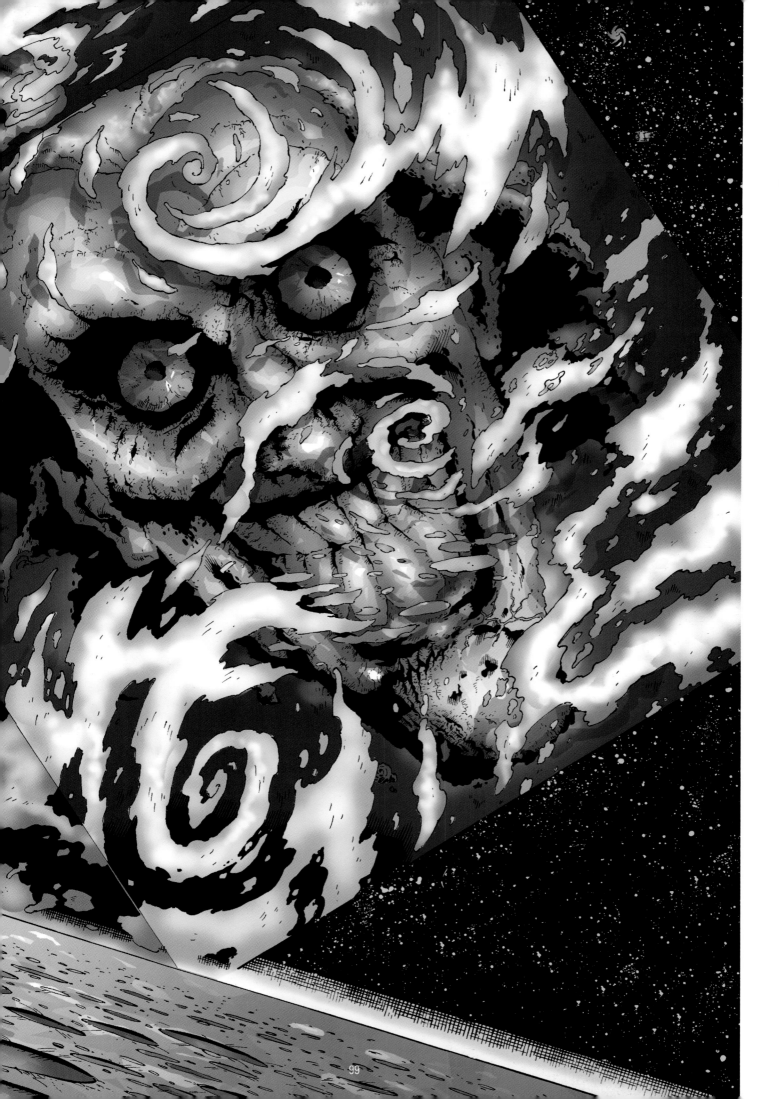

At other times, as if driven by the law of the jungle, the Joker made power grabs against his rivals to prevent from landing on the wrong side of the "eat or be eaten" equation. During the *No Man's Land* event that ran through the Batman comics in 1999, a one-two punch of plague and earthquake brought Gotham City to its knees. Cut off from the mainland, the city became a disaster zone where anyone with a gun could become a king. As Batman led a crusade to restore order, opportunists carved out their own fiefdoms from Gotham's city blocks, with the Penguin, Two-Face, and Mister Freeze all taking their cuts.

Faced with this territory scramble, the Joker vowed to show everyone that not even a magnitude 7.6 earthquake could unseat him as Gotham's supreme bringer of destruction. The

Joker seized a swath of the city's northern boroughs, but, as Christmas approached, citizens began to show hope that their home would see signs of recovery. The Joker soured that hope, first by kidnapping the No Man's Land post-quake newborns who symbolized Gotham's future, then by shooting their protector. The casualty was Sarah Essen Gordon, wife of police commissioner James Gordon. The cruel murder proved to be a spirit-crushing blow to Commissioner Gordon, who nearly killed the Joker in retaliation. Instead, he fired a bullet into his kneecap.

Lots of people want the Joker dead, but Batman pulls them back from the brink. Even though Batman operates as a vigilante, his rules dictate that final punishment be dished out by the legal system. In *The Joker: Devil's Advocate*, Chuck Dixon and Graham Nolan dared to present the Joker's court-ordered execution not as a cause for celebration, but as a miscarriage of justice. After citizens across the country dropped dead from licking poisoned postage stamps, the media was quick to single out the Joker as the culprit—after all, they were commemorative stamps depicting the world's greatest comedians. The Joker welcomed the attention of the network news and basked in his own notoriety. The jury found him guilty on nine counts of first-degree murder and sentenced him to death row. A prison barber shaved the Joker's scalp, leaving behind only green stubble.

Batman saw through the Joker's act of taking credit for a crime he didn't commit. Detective work uncovered the true culprit, and the Joker received a pardon just as a guard was about to throw the switch on the electric chair. Batman was left with the agonizing knowledge that the Joker would almost certainly commit more crimes. When the Joker asked him to explain his motivation, Batman responded with a curt summation of his life's mission. "I don't care about you," he said. "I care about justice."

Top: In Greg Land and Drew Geraci's cover to vol. 5 of the collected *No Man's Land*,
the Joker is a looming menace for Batgirl, Batman, and the Huntress.
Above, opposite: In *Batman* #574 (February 2000), the Joker murders Sarah Essen-Gordon and
is the victim of Commissioner Gordon's retaliation. Art by Dale Eaglesham and John Floyd.

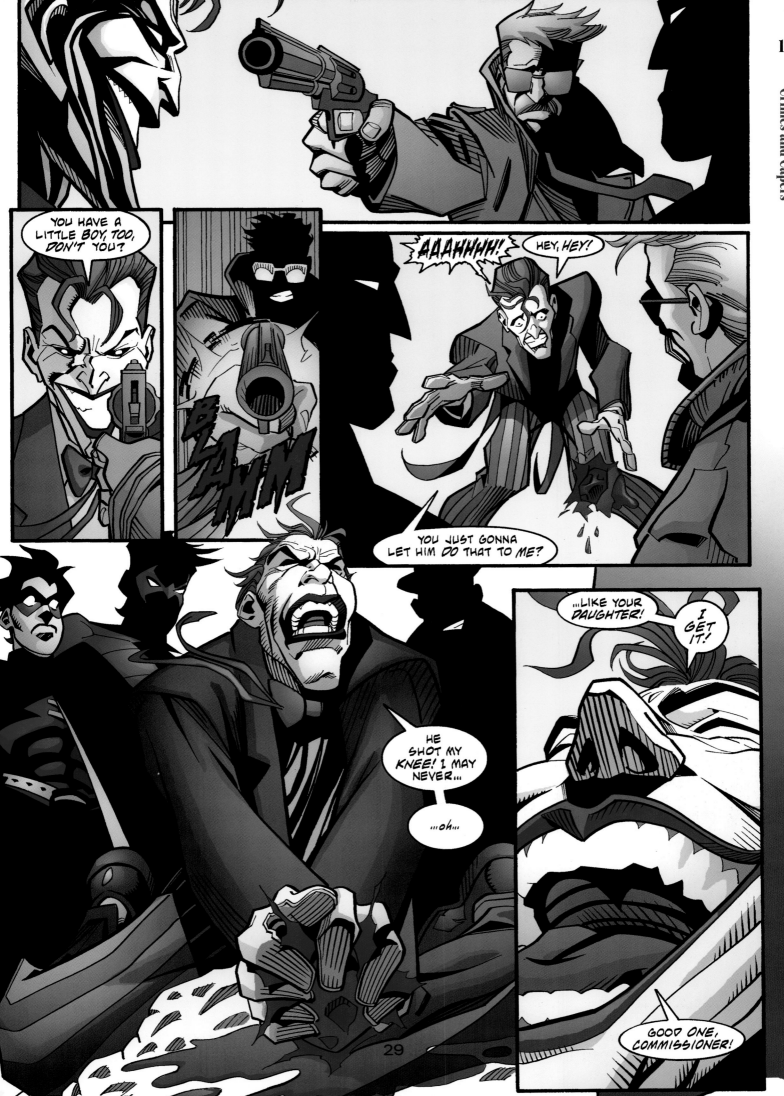

This spread: Batman is the Joker's reluctant savior in *The Joker: Devil's Advocate* (1996), but he still finds a way to twist the knife. Art by Graham Nolan and Scott Hanna.

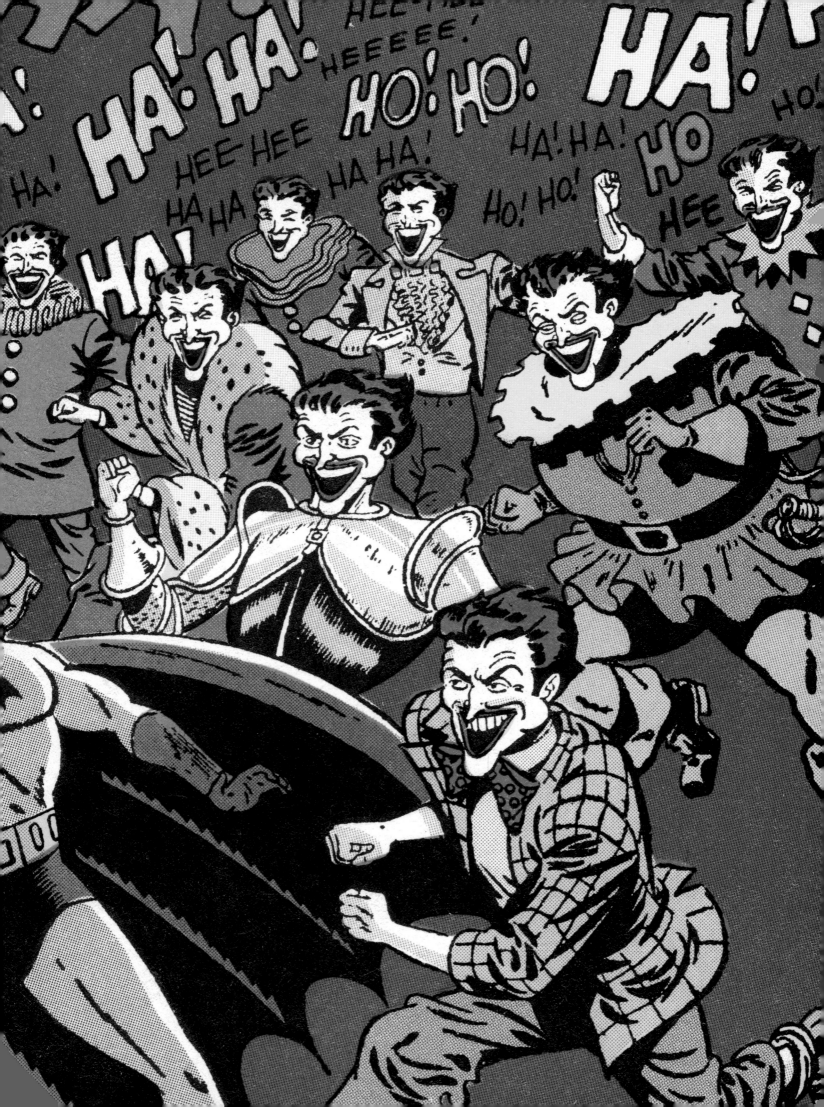

The Joker hangs his hat in Gotham City because it's Batman's home too. But even a lover of the spotlight can grow bored playing for the same audiences night after night. When he's not staying in Arkham Asylum, the Joker has sometimes ventured abroad in search of new targets to terrorize. And even in situations where the relocation has been imposed by force, the Joker always finds a way to turn the new settings to his advantage.

"To Laugh and Die in Metropolis" from *Superman* #9 (September 1987) was an expert example of the Joker's anything-goes motivation. Writer/artist John Byrne, during his 1980s Superman revamp, brought the Joker into Metropolis with a brazen scheme guaranteed to get him noticed by the city's favorite son.

The Joker initially distracted Superman with a robot packing a 40-megaton nuclear warhead. Superman safely rocketed the bomb into space, but returned to find that the Joker had kidnapped Lois Lane, Perry White, and Jimmy Olson and claimed to have sealed them in lead-lined coffins all across town. The chase ended on a clever superpowered technicality—because Superman can see through everything *except* lead, the coffins stood out in his X-ray vision like beacons and were a snap to find at super-speed. After only 17 pages, the Joker had been caught.

"To Laugh and Die in Metropolis" was notable not only for the creative way in which the Joker stepped up his game when facing a powerhouse like Superman (it didn't work, but deploying a tactical nuke certainly counted as giving it the old college try), but also for the relative ease with which Superman took him down anyway. In Byrne's telling the Joker had no hope of outmatching an earthbound god, but the outcome didn't seem to trouble him one whit. When asked why he came to Metropolis, the Joker grinned. "Oh, Superman, why not?"

In the DC universe, Batman, Superman, and Wonder Woman make up a core set of iconic heroes sometimes called the Trinity. And with two names off his list, it

Above: In this spectral sketch by Jim Lee, the Joker's head seems to be capped by flame.
Opposite: What's worse than one Joker? An entire deck! Dick Sprang and Charles Paris illustrate a scene from *Batman* #63 (February/March 1951).

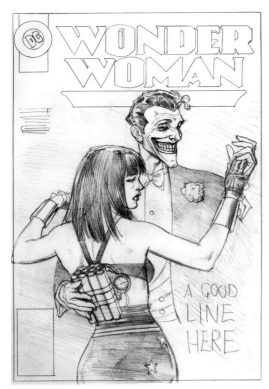

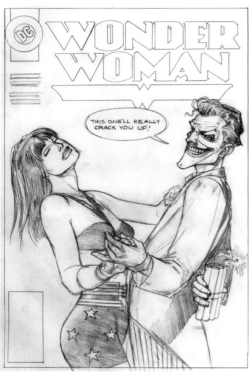

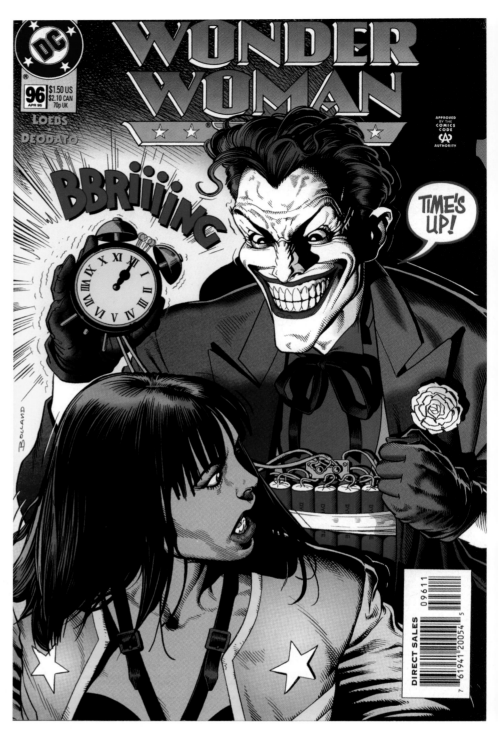

followed that the Joker would want to complete his tour of the Big Three. Wonder Woman, who hails from the Amazonian paradise of Themiscyra, operated for a time out of Boston, Massachusetts. "Joker's Holiday" in *Wonder Woman* (vol. 2) #96 saw Beantown receive an unwelcome guest.

Mob violence in Boston created an opportunity, and the Joker decided to grab his own piece of the action. Toy tanks firing smiling poison darts left little doubt that he had arrived. At one point the Joker threatened to blow up a building with the dynamite strapped to his chest. An unused Brian Bolland cover for the issue depicted the Joker displaying an open trench coat in Wonder Woman's direction, with the reverse angle suggesting that he was revealing something more intimate than a stick of TNT.

This spread: Brian Bolland's cover sketches and the final cover of *Wonder Woman* #96 (April 1995).

Wonder Woman scored a win by playing against type. The Amazon princess drew upon the primal trickery of the Greek god Pan, and told better jokes than the Joker's weak one-liners. Being bested at his own game cracked the Joker's confidence and he quietly slunk home.

A common factor in most of these tales was broad daylight. This might seem like a small thing, but Gotham seems perpetually nocturnal and overcast—all the better for projecting Bat-Signals on the underside of cloud banks. A brighter color palette can therefore act as visual shorthand for a change in locale. The effect can be jarring, even more so when the Joker changes his wardrobe. After the "Death in the Family" story arc, the Joker obtained a position with the Iranian government as Iran's ambassador to the United Nations. During his short career as diplomat he wore an Arab keffiyeh.

For a character defined by randomness, the Joker seems to have clear motivations for venturing out of his element, even if the reason is merely boredom. But when a terminal brain tumor threatened to cut his life short in *Joker: Last Laugh*, the Clown Prince decided that the world needed to go down with him. In this limited series by Chuck Dixon and Scott Beatty, a vengeful prison doctor tricked the Joker into believing he had only weeks to live. At the time, the Joker wasn't in Arkham Asylum, but rather the maximum-security Slabside Penitentiary.

The Slab housed the DC universe's most overpowered supervillains, but his fellow inmates proved to be the rungs of the Joker's escape ladder. Using the prison's own chemical deterrents, he brewed a batch of Joker Venom, then turned the prisoners— including some who could control the weather, bend the minds of others, and alter the molecular structure of the universe—into drooling, leering Jokerized goons. Enchanted by the notion of converting the other six billion residents of Earth, the Joker planted his flag amid the stone *moai* of Easter Island and dispatched his superpowered slaves to enforce his will. In the end Batman brought him in, and the Joker learned that the diagnosis that had triggered his rampage was a prank. The Joker failed to see the humor in being the butt of the joke.

It seems that the Joker has little tolerance for situations where he's not in complete control, which may be one reason why his non-Gotham adventures are so rare. But he didn't have much of a choice in 2008's *Salvation Run*, in which all of DC's supervillains were forced to relocate by editorial fiat. The seven-issue series by Bill Willingham and Matthew Sturges saw the Joker and hundreds of bad guys from Captain Cold to Cat-Man exiled to a jungle planet by a shadowy government agency.

Above: Not even a Cheshire cat can out-grin the Joker in this Wonderland-influenced cover by Brian Bolland and Rachel Birkett gracing issue #50 of *Batman: Legends of the Dark Knight* (Septempber 1993).
Opposite: The Joker's "A Death in the Family" saga takes a surreal turn in this page by Jim Aparo and Mike DeCarlo.

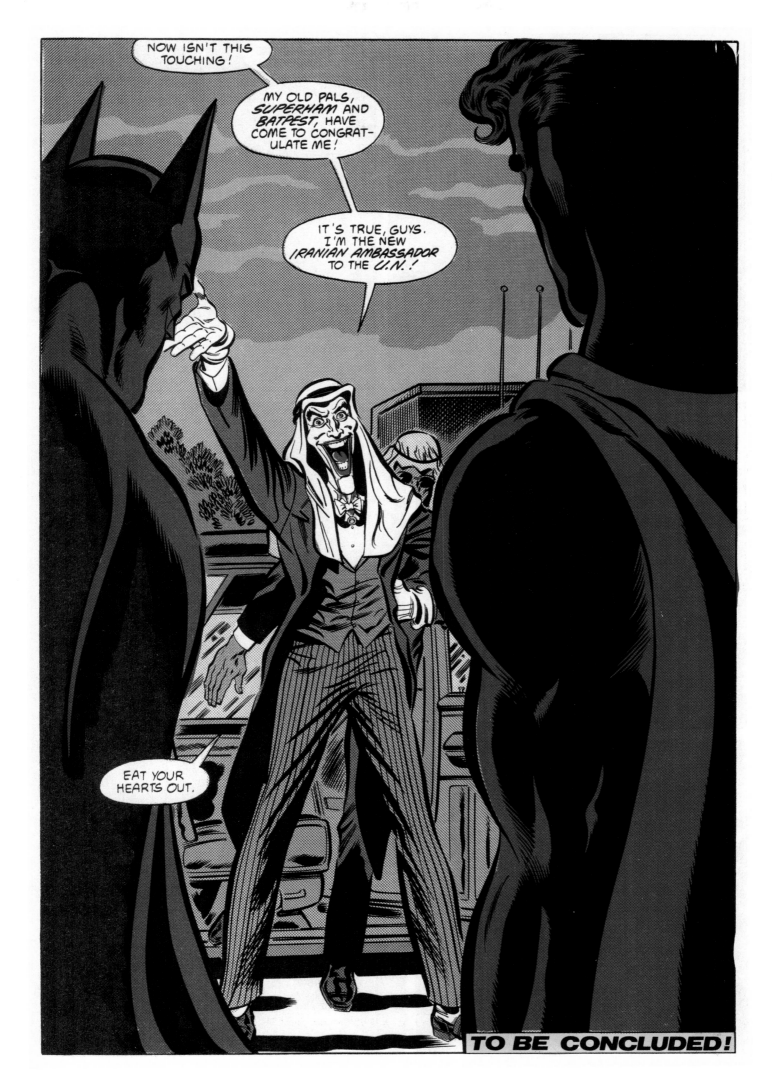

At first annoyed by his predicament ("I'm not dressed for the wilderness!" he groused), the Joker soon turned the situation to his advantage by murdering the mind-controlling Psimon and kicking the powerful Gorilla Grodd off a cliff. But this interplanetary pond had another big fish: Lex Luthor. The exiles soon grouped into two camps, one headed by Luthor and the other by the Joker, despite the fact that Lex was the only one with a plan for returning everyone to Earth.

The split proved just how much pull the Joker has within the DC universe. Every criminal on the prison planet remained perfectly aware that the Joker was off his rocker, but half of them decided to sign up for his team anyway. Fear was a big motivator. Lex can be a deadly enemy, but at least his actions have some logic. The fury of a spurned Joker was something that no one could predict and everyone wanted to avoid, and his killer charisma attracted lesser criminals like pack wolves rallying behind their alpha. In the end the Joker hitched a ride home using Luthor's invention, stalking shadowy Gotham once more without ever having compromised his principles during his time away.

This spread: Batman, Plastic Man, and the Martian Manhunter discover the Joker's pre-death checklist in *Joker: Last Laugh* #5 (December 2001). Art by Ron Randall.

Overleaf: The Joker studies his fragmented reflection in this Alex Ross illustration from *Batman: Black and White* vol. 2 (2001).

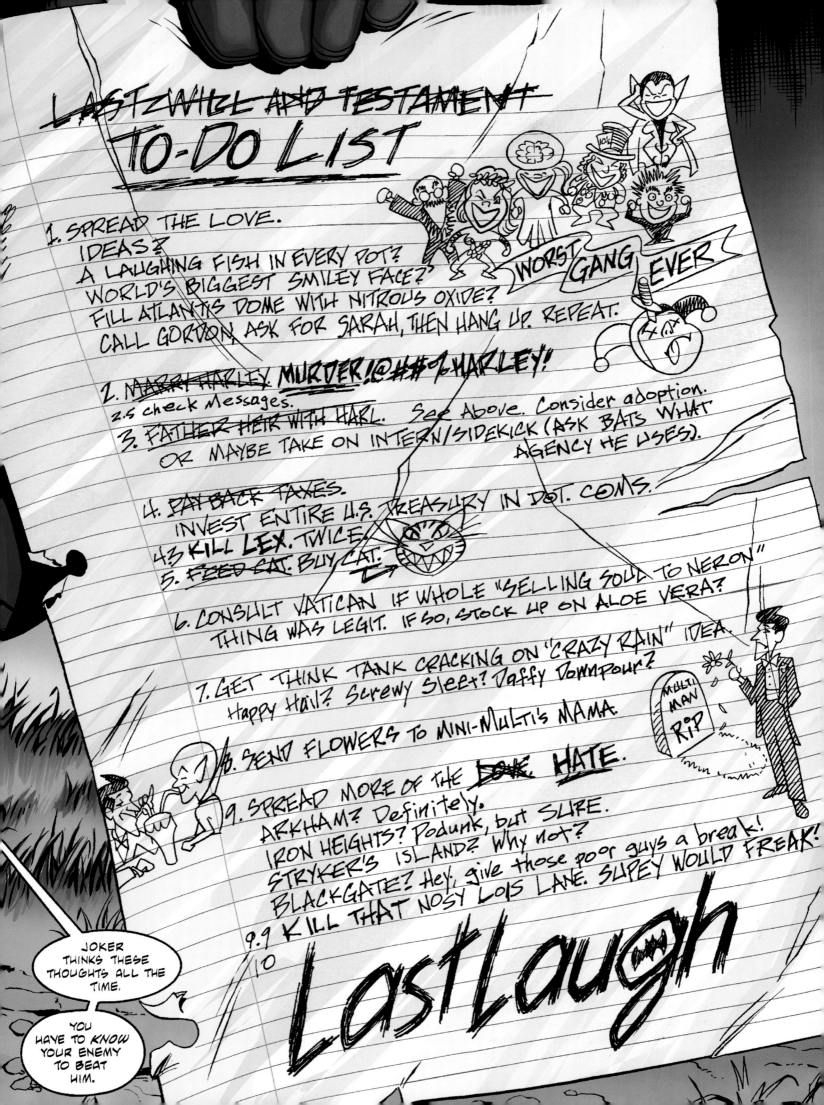

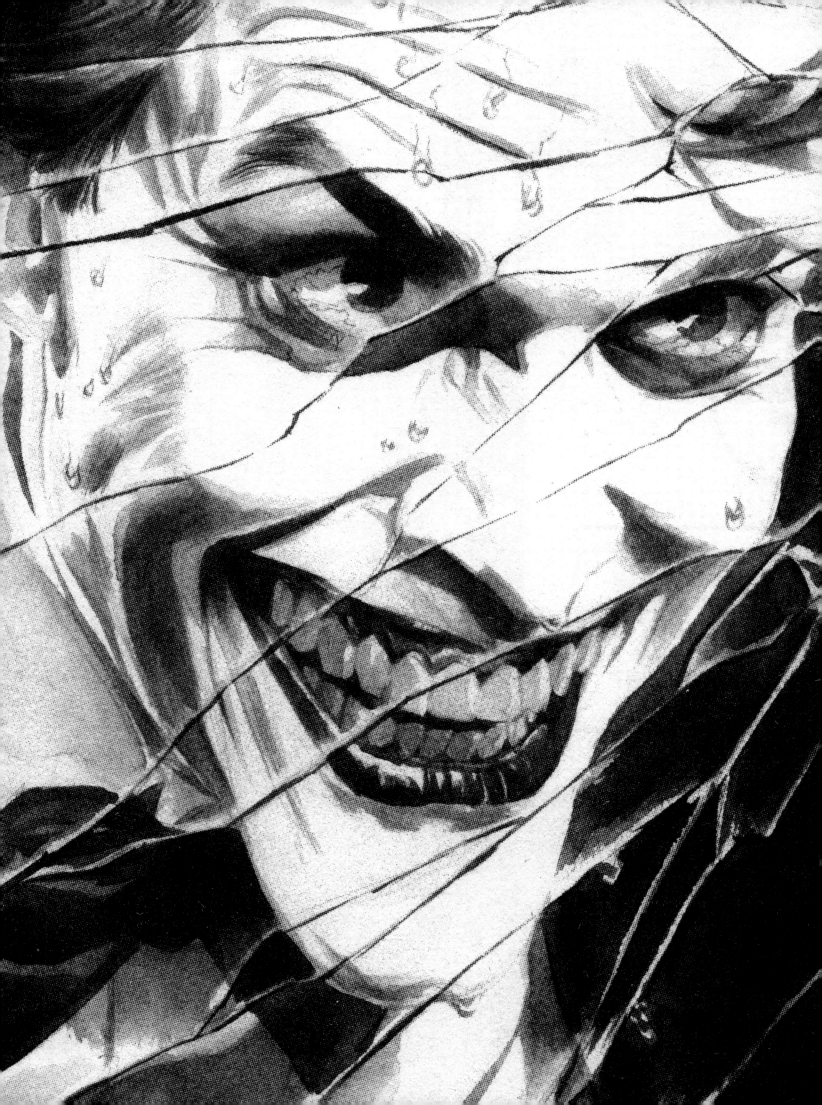

Shattered MIRROR

"If I'm going to have a past I prefer it to be
multiple choice."
—*Batman: The Killing Joke* (1988)

His 1940 debut didn't supply an origin. Like all clowns, the Joker stepped into
the lights ready to perform, his costume and his sinister shtick already rehearsed to
perfection. The mystery remained for over a decade, but in Batman's world, criminals
hardly needed justification to model themselves after playing cards. *That's just the way
things are in Gotham*, the stories seemed to shrug.

That changed in the 1950s, as superhero comics got more outlandish but some-
how more literal. "The Man Behind the Red Hood," in *Detective Comics* #168, opened
with Batman bizarrely agreeing to teach a course in criminology at a local university.
His students helped him crack a string of unsolved crimes by revealing that the Red
Hood—a crook who had vanished years before—and the Joker were one and the same.
The full story was told in flashback. When the man known as the Red Hood tumbled
into a chemical vat adjacent to the Monarch Playing Card factory, the bath bleached his
skin and dyed his hair a shocking green. The disfigurement tipped the failed burglar into
madness, and he chose to recast his role as Gotham's Clown Prince of Crime.

This origin became the foundation of Alan Moore and Brian Bolland's influential
1987 tale *The Killing Joke*. Here, the pre-accident Joker was a desperate, unfunny stand-
up comic press-ganged by thugs into posing as the Red Hood during the raid on a
chemical plant. A pregnant wife added to the tragedy. The news of her accidental
death, delivered just before the robbery, arguably served as the incident that snapped
the Joker's sanity, with the chemical dip merely a matter of cosmetics. Years later, in
Batman: Gotham Knights, the Riddler uncovered proof that a crooked cop had mur-
dered the Joker's wife. The Joker's name in those earlier, happier days was Jack, and his
hopeful, doomed wife, Jeannie.

Sad? Certainly. Straightforward? Not so fast. Depictions
of the Joker as a hardworking father-to-be are outnumbered by
stories in which he remains an unrepentant crook. In a tale from
Batman Confidential, the young Joker was an expert at defeating
bank security systems—so skilled, in fact, that he yawned his way
through his crimes until he witnessed the costumed theatricality
of Batman. Fascinated by this "ridiculous" vigilante, he goaded
Batman into a series of confrontations and gained his leering
grin when a Batarang sliced his face. Ultimately, this Joker also
fell into a tank. In this ironic retelling, it brimmed with anti-
psychotic medication.

Opposite: Brian Bolland's artwork in **1988**'s *The Killing Joke* received a more
muted coloring treatment, reflected here, in the **2008** hardcover deluxe edition.

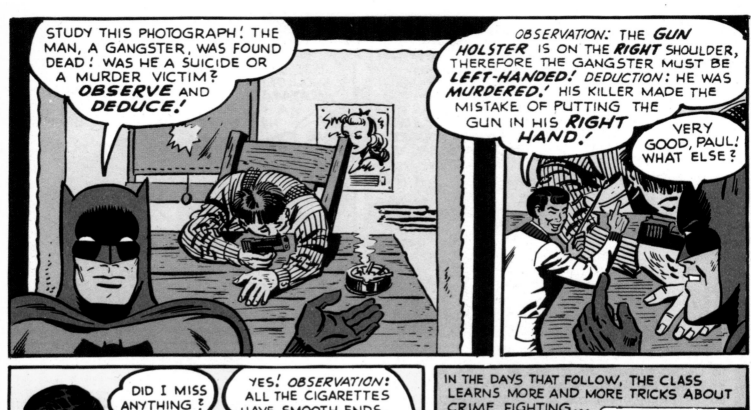

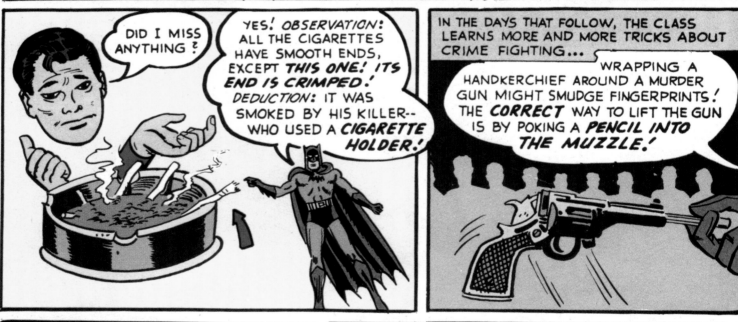

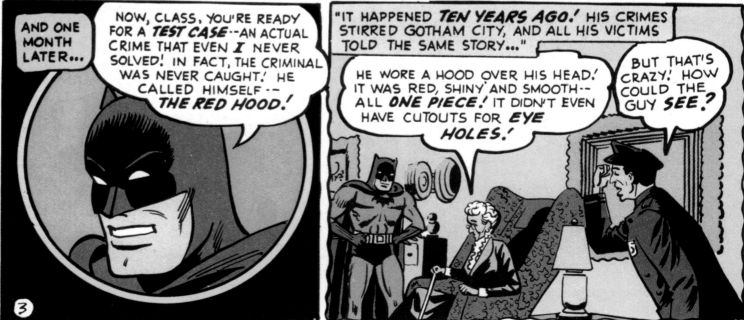

This spread: Batman's pupils try to emulate the Dark Knight Detective by studying the mystery of the Red Hood in *Detective Comics* #168 (February 1951). Art by Sheldon Moldoff and George Roussos.

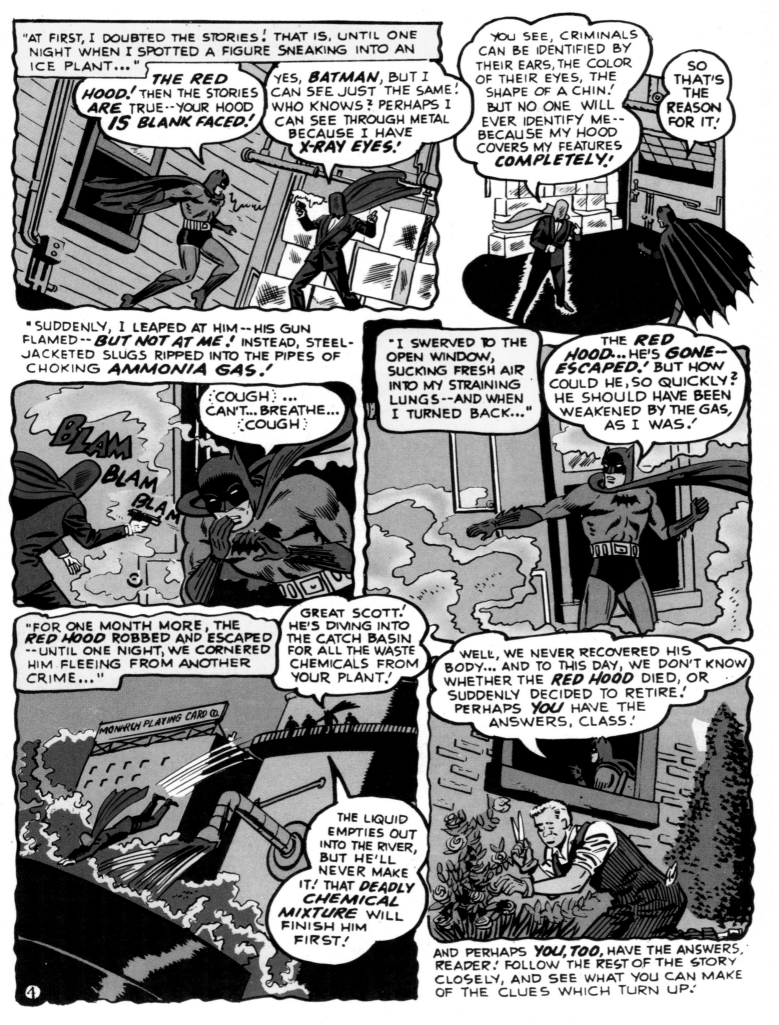

134

The Joker

This spread: Darwyn Cooke retells the Joker's most enduring origin in *Batman: Ego* (2000).

Writer J. Michael Straczynski reinforced the "bad seed" origin in a 2010 issue of *Brave and the Bold*. The story required the size-changing Atom to go microscopic and enter the Joker's brain, where he relived a memory of the Joker as a child, burning down his house with his parents still inside. Legendary Batman scribe Denny O'Neil offered his own take in *Legends of the Dark Knight* #50. Here, the Joker received aid from his cousin Melvin Reipan, an idiot savant whose talent for toxicology resulted in Joker Venom, version 1.0.

Of course, the Joker's origin is the tale of a trickster, and there's no reason to expect that a single story will ever be enshrined as truth. Just ask the Joker himself—he's got a million of 'em! In *Batman: It's Joker Time*, the villain regaled the audience of a TV talk show with the details of his life as a jester for an Egyptian pharaoh and the insubordination that led to him submerged in embalming fluid for thousands of years. In *Mad Love*, the Joker opened up about his abusive father, who broke his nose after a clownish pratfall failed to get a smile. His sidekick Harley Quinn was taken in by the sob story until Batman dashed her sympathies by pointing out that the Joker was a serial liar. "Like any other comedian, he uses whatever material will work," he said.

The pattern has continued up on the big screen. Tim Burton's *Batman* introduced the Joker as mob gunman Jack Napier, adding the wrinkle that Napier had murdered Thomas and Martha Wayne twenty years prior and caused the event that birthed the Bat. Christopher Nolan's *The Dark Knight* side-stepped an origin story by providing more than one. When *The Dark Knight*'s Joker asked, "Wanna know how I got these scars?" he followed up with different answer each time. The colorful, contradictory act is fitting for a villain who relishes playing the role of the Man with a Thousand Faces.

Above: "Why so serious?" Heath Ledger as the Joker in *The Dark Knight* (2008).

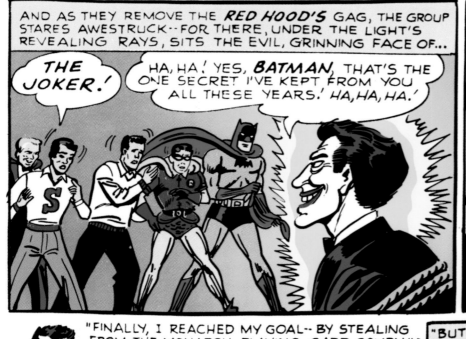

AND AS THEY REMOVE THE *RED HOOD'S* GAG, THE GROUP STARES AWESTRUCK--FOR THERE, UNDER THE LIGHT'S REVEALING RAYS, SITS THE EVIL, GRINNING FACE OF...

THE JOKER!

HA, HA! YES, *BATMAN*, THAT'S THE ONE SECRET I'VE KEPT FROM YOU ALL THESE YEARS! *HA, HA, HA!*

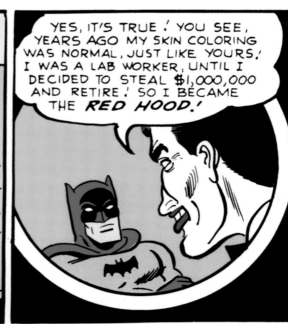

YES, IT'S TRUE! YOU SEE, YEARS AGO MY SKIN COLORING WAS NORMAL, JUST LIKE YOURS! I WAS A LAB WORKER, UNTIL I DECIDED TO STEAL $1,000,000 AND RETIRE! SO I BECAME THE *RED HOOD!*

"FINALLY, I REACHED MY GOAL-- BY STEALING FROM THE MONARCH PLAYING CARD COMPANY! MY HOOD'S OXYGEN TUBE ENABLED ME TO ESCAPE BY SWIMMING UNDER THE SURFACE OF THE POOL OF *CHEMICAL WASTES...*"

"BUT AT HOME I LOOKED AT MYSELF WITH GROWING HORROR..."

THAT CHEMICAL VAPOR-- IT TURNED MY HAIR *GREEN*, MY LIPS *ROUGE-RED*, MY SKIN *CHALK-WHITE!* I LOOK LIKE AN *EVIL CLOWN!* WHAT A JOKE ON ME!

"THEN, I REALIZED MY NEW FACE COULD TERRIFY PEOPLE! AND BECAUSE THE PLAYING CARD COMPANY MADE MY NEW FACE I NAMED MYSELF AFTER THE CARD WITH THE FACE OF A CLOWN-- *THE JOKER!*"

HA! HA! HA!

AND ALL THESE YEARS I'VE BEEN LAUGING AT YOU! HA, HA! YOU NEVER EVEN KNEW MY IDENTITY TILL NOW!

HA! HA! HA!

YOU'RE *WRONG*, JOKER.... I KNEW YOUR IDENTITY *BEFORE* WE OPENED THE SHACK! *ROBIN* AND A *GREEN HAIR* CAN VOUCH FOR THAT! SO YOU SEE, THE JOKE'S BEEN ON YOU ALL ALONG!

HA, HA... THAT'S RIGHT, JOKER...NOW IT'S OUR TURN TO LAUGH! HA, HA!

THE END

⑬

Above: The Joker is revealed as the Red Hood in *Detective Comics* #168 (February 1951), inspiring a host of tales to come. Art by Sheldon Moldoff and George Roussos.

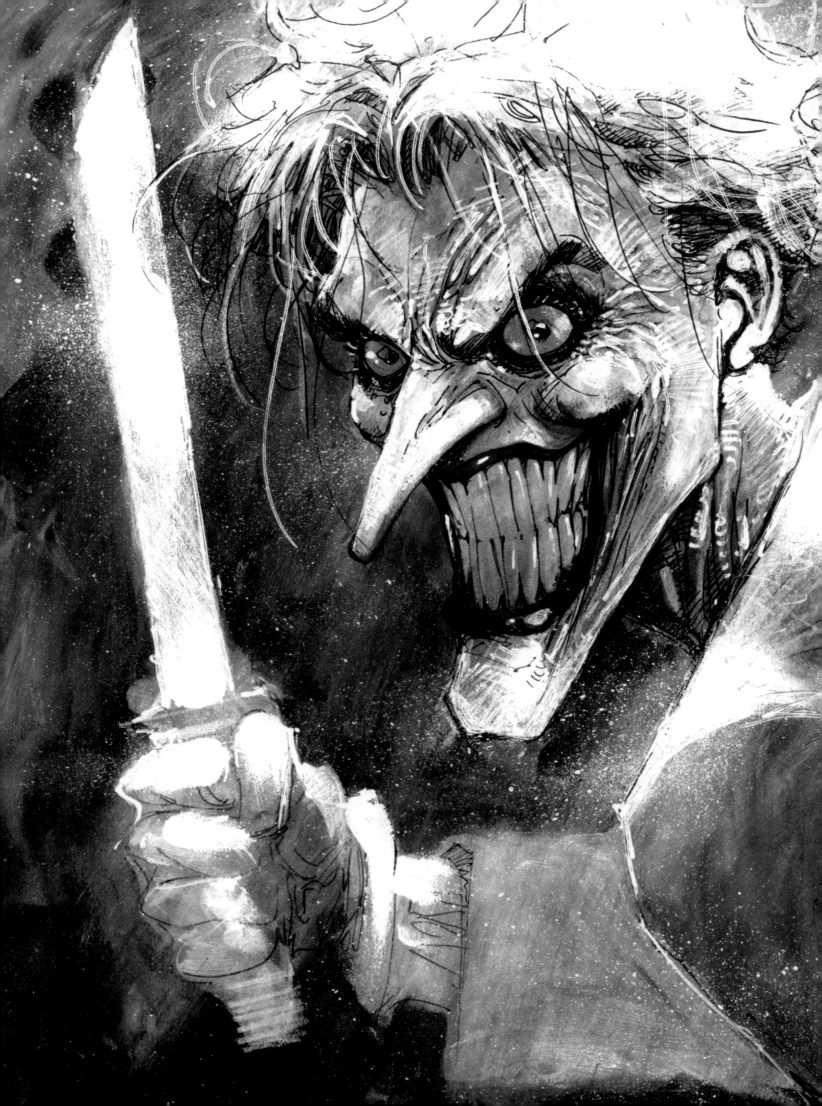

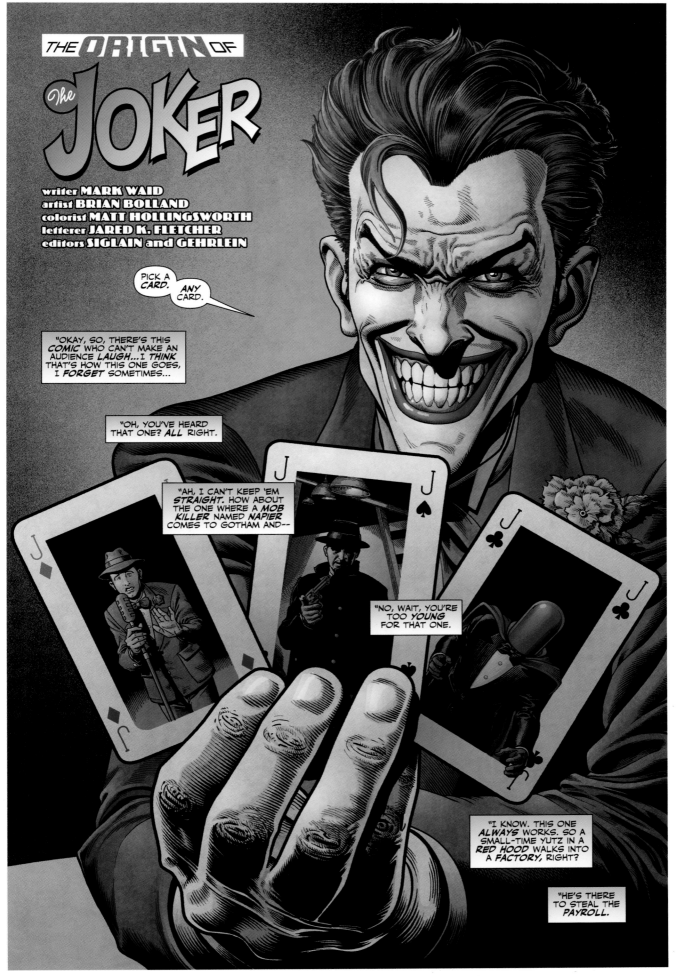

THE ORIGIN OF THE JOKER

writer **MARK WAID**
artist **BRIAN BOLLAND**
colorist **MATT HOLLINGSWORTH**
letterer **JARED K. FLETCHER**
editors **SIGLAIN** and **GEHRLEIN**

PICK A CARD. ANY CARD.

"OKAY, SO, THERE'S THIS *COMIC* WHO CAN'T MAKE AN AUDIENCE *LAUGH*...I *THINK* THAT'S HOW THIS ONE GOES, I *FORGET* SOMETIMES..."

"OH, YOU'VE HEARD THAT ONE? *ALL* RIGHT."

"AH, I CAN'T KEEP 'EM *STRAIGHT.* HOW ABOUT THE ONE WHERE A *MOB KILLER* NAMED *NAPIER* COMES TO GOTHAM AND—"

"NO, WAIT, YOU'RE TOO *YOUNG* FOR THAT ONE."

"I KNOW. THIS ONE *ALWAYS* WORKS. SO A SMALL-TIME *YUTZ* IN A *RED HOOD* WALKS INTO A *FACTORY*, RIGHT?"

"HE'S THERE TO STEAL THE *PAYROLL.*"

Above: To the Joker, one origin is as good as the next. Brian Bolland illustrated "The Origin of the Joker" in *Countdown* #31 (November 2007).

Opposite: In Jim Lee's drawing, the contours of the Joker's face are as sharp as the knife in his fist.

Overleaf: A Harley Quinn model sheet reflecting the style of *Batman: The Animated Series*.

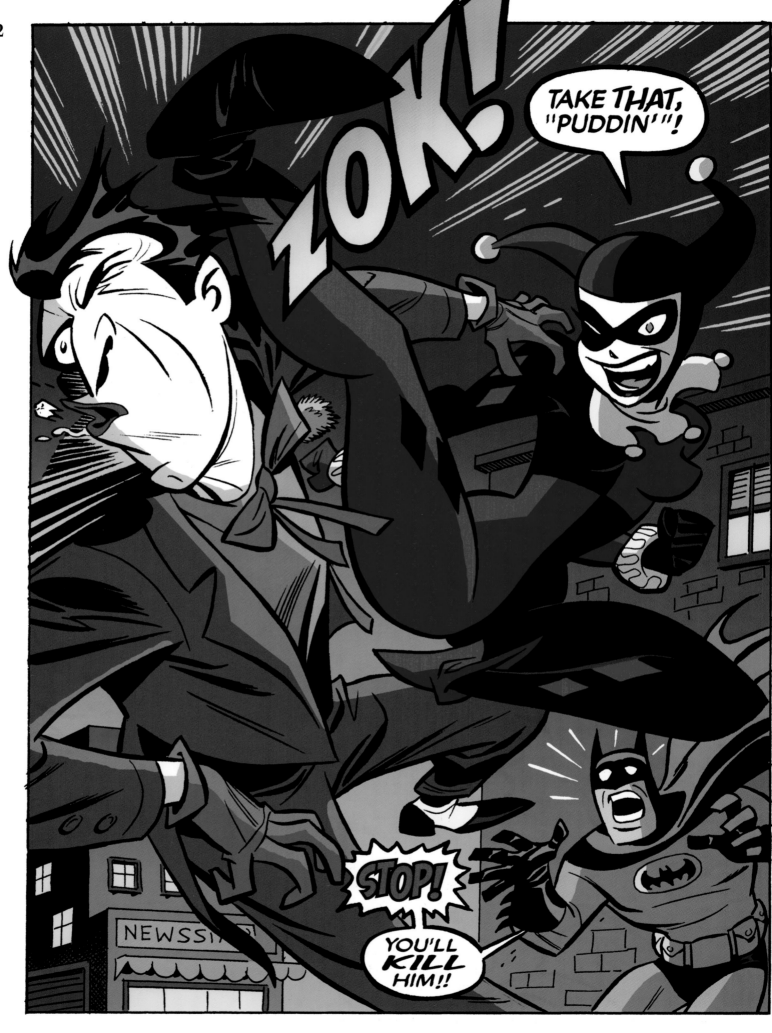

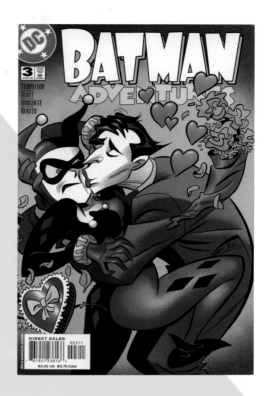

"Harley? Honey, baby, pumpkin pie. You know I can't hold a grudge."
—"Harley and Ivy," *Batman: The Animated Series* (1993)

Villains don't get love interests. That storytelling rule of thumb would seem to go double for the Joker, whose obsession with besting Batman seems to leave little time for a split focus.

The introduction of Harley Quinn in the 1990s brought about a clever solution, since the romance between her and the Joker remained mostly a one-way street. The lovesick jester proved to be a hugely popular character, and a cornerstone of a vibrant Bat-Universe created for animation.

It began in 1992 with *Batman: The Animated Series*. Warner Bros. president Jean MacCurdy enlisted artists Bruce Timm and Eric Radomski to create a pilot film for a proposed animated television series. Timm's spare, stylized character designs complemented Radomski's retro Gotham City, which he created by painting on black backgrounds for a look dubbed "dark deco." As the series moved into production, senior story editor Alan Burnett brought in writer Paul Dini to pen scripts. The team succeeded in resurrecting Batman for a serious-minded TV audience, and the Joker joined the fun starting with episode 2, "Christmas with the Joker."

The Joker of the animated series possessed an angular menace. When he bared his mouthful of discolored teeth, no one could tell whether it was a genuine smile or a prelude to murder. Mark Hamill lent the Joker a powerful, unhinged voice that could switch on a dime between mirth and menace, and a cackling laugh to chill the blood. The episode "Joker's Favor" showed the character's range, as the Joker took sadistic glee in threatening a family man who, years earlier, had cut him off in traffic.

"Joker's Favor" also introduced Harley Quinn. Her red-and-black harlequin's costume and the easy patter she shared with her boss marked her as something different from the anonymous thugs usually found in the Joker's employ. In later episodes it became plain that she loved him, using the pet name "Mister J" (or, on special occasions, "Puddin'") in her brassy New York accent. But the Joker seemed not to return the sentiment. He ignored Harley when he was busy and lied to her when it was convenient. Yet their mutual appreciation for theatricality inspired them to great heights. Unafraid to dish out mayhem, Harley often carried an oversized mallet or a fat-barreled revolver.

Above: In Timm's cover to *Batman Adventures* #3 (August 2003), the tables have turned.
Opposite: Romance turns sour between Harley and her beloved in this Bruce Timm page from *Batman: Harley and Ivy* #3 (August 2004).

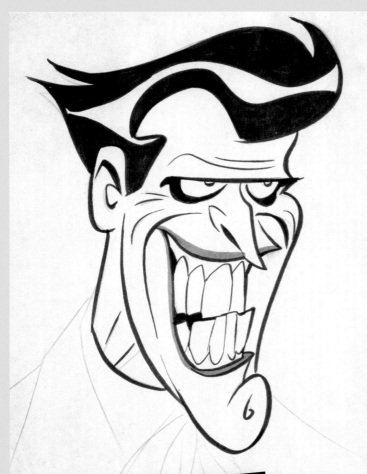

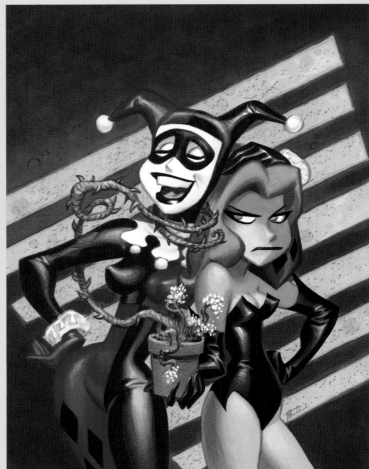

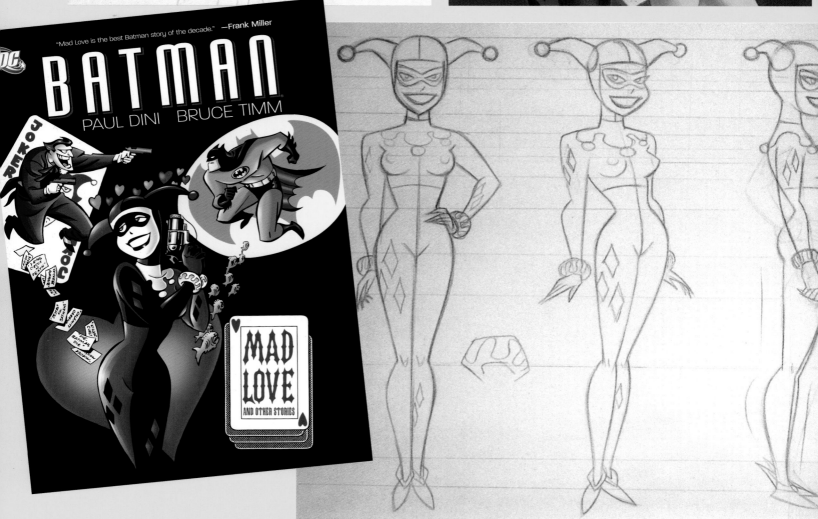

Top left: Joker concept art from *Batman: The Animated Series*.
Top right: Bruce Timm's cover to *Batman: Harley and Ivy #1* (June 2004).

Bottom left: A smitten Harley pines for her Mister J in Timm's cover to *Mad Love*.

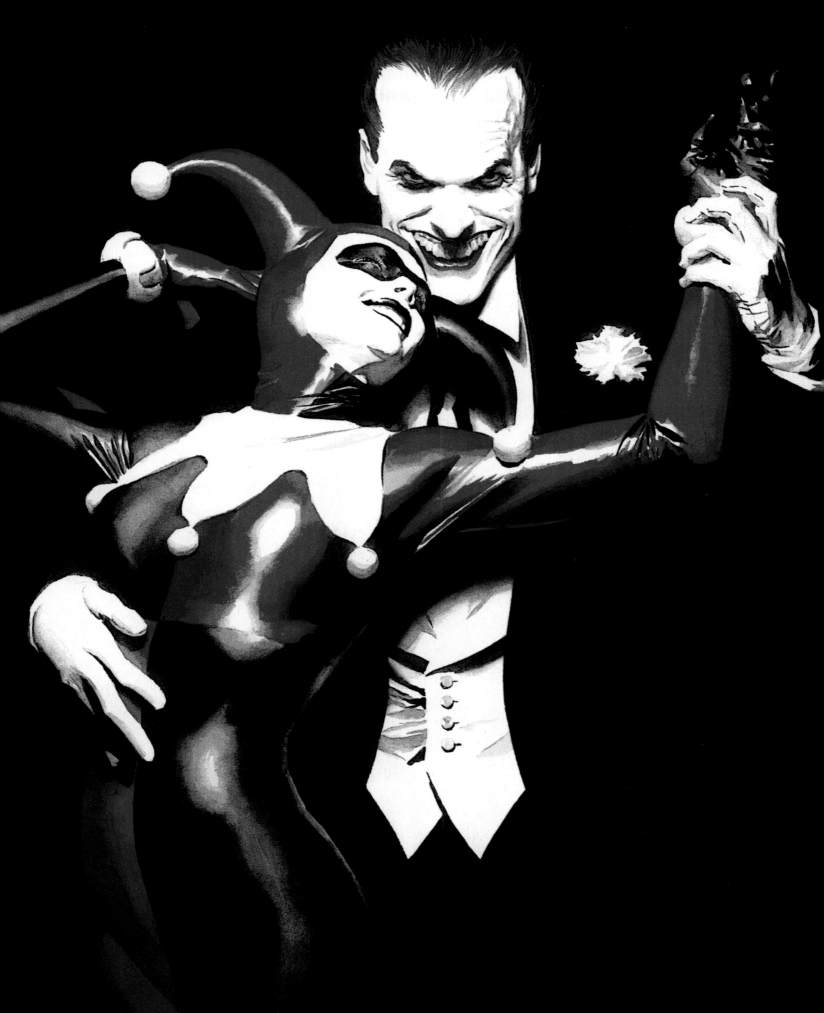

Opposite bottom right: A Harley Quinn model sheet turnaround from *Batman: The Animated Series*.

Above: Harley makes the jump from animated to photorealistic in Alex Ross' cover to *Batman: Harley Quinn* #1 (October 1999).

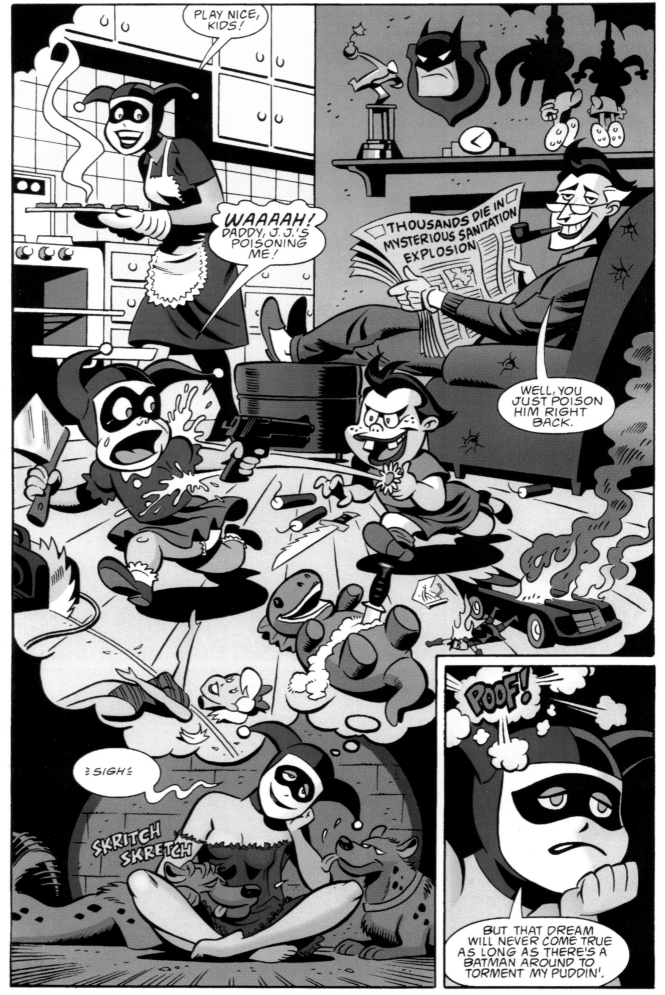

This spread: Interior pages from *Mad Love* showcase Harley's demented idea of domestic bliss. Art by Bruce Timm.

The Last Laugh

Above: The Joker becomes hilariously enraged when Batman destroys the robotic Captain Clown in "The Last Laugh," which aired on September 22, 1992.

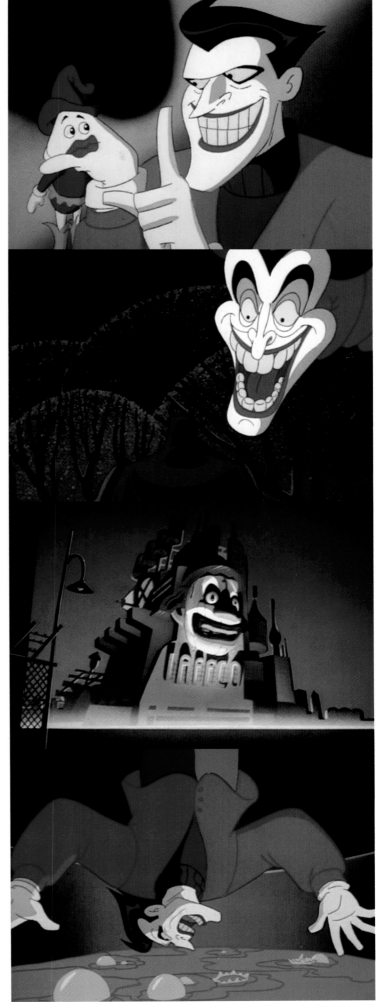

Above: Singing "Jingle Bells, Batman smells," the Joker breaks out of Arkham to spread holiday horror. "Christmas with the Joker" premiered November 13, 1992.

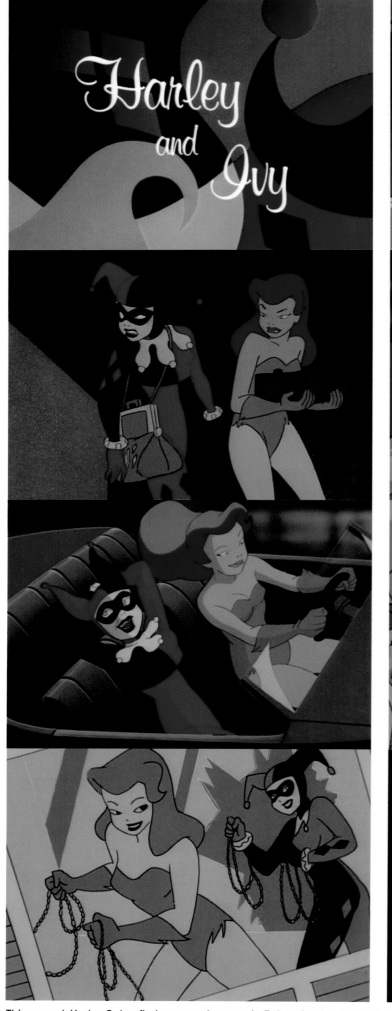

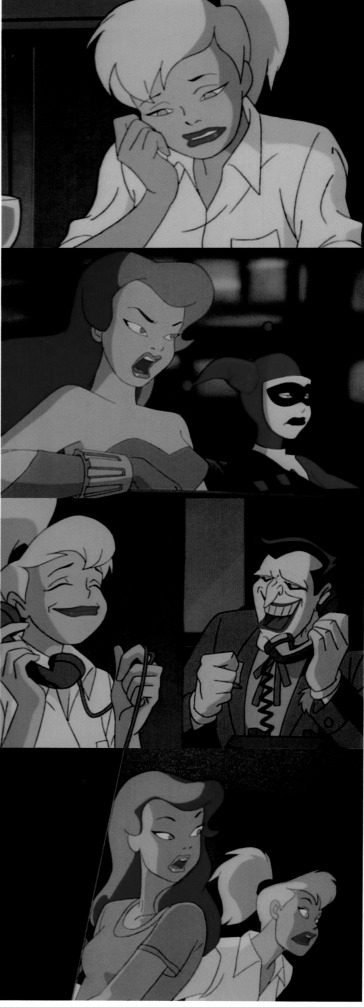

This spread: Harley Quinn finds a new playmate in Poison Ivy, but her self-destructive obsession with the Joker triggers a relapse in "Harley and Ivy" (January 18, 1993).

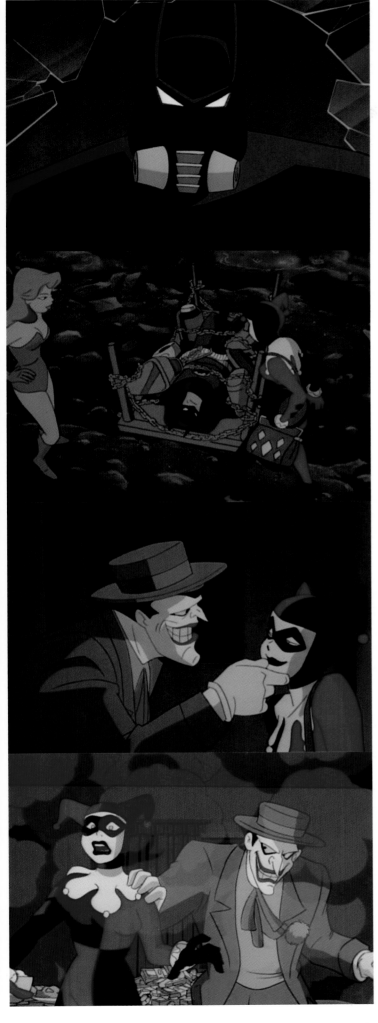

As the series continued, Harley made a friend in the green-thumbed Poison Ivy, and even abandoned the Joker in favor of a new partnership in "Harley and Ivy." But by the episode's end she had succumbed to the Joker's sweet talk and returned to him, underlining the boomerang romantic attraction that would prove to be her defining quality. She knows the Joker is bad for her, but she just can't quit.

Bruce Timm and Paul Dini explored the theme further in their one-shot comic *Mad Love*. The tale revealed Harley Quinn's origin as Arkham Asylum psychiatrist Dr. Harleen Quinzel, who became smitten with the Joker's outlaw notoriety. Dr. Quinzel broke her patient out of Arkham and signed on as his partner in crime. Although her romantic advances were repeatedly spurned, Harley held on to the conviction that she and Mister J were two sides of the same funhouse token. Yet her dream future could never come to pass as long as Batman monopolized her lover's attention.

Hoping to eliminate her rival, she dangled Batman upside down over a tank of piranhas, so that, from his inverted perspective, their toothy mouths might resemble smiles. But not only was the Joker furious with Harley for overstepping her role, he judged her guilty of crimes against comedy. "If you have to explain a joke, there is no joke!" he raged, disgusted by the complexity of the piranha prank. He threw her out of a window but later sent her flowers in the hospital—guaranteeing she would remain under his spell.

Mad Love won the 1994 Eisner award for best single-issue story, and Timm and Dini later adapted it as an episode of the animated series during its fourth and final season. By that time the series had undergone a network switch from FOX to the WB, and a name change to *The New Batman Adventures*. Timm led the implementation of character redesigns that used fewer lines than before. "We've worked it out to even more of a mathematical model," he explained. The Joker was one of the beneficiaries, gaining white, bloodless lips and pinprick eyes swimming in pools of black.

Harley Quinn, meanwhile, proved so popular that she became part of DC's regular comic book continuity. A 1999 one-shot featuring a story by Dini and a painted cover by Alex Ross kicked things off, and a monthly series, *Harley Quinn*, ran for 38 issues. The character even made the jump to live-action

Above: In the 1993 theatrical release *Batman: Mask of the Phantasm*, the Joker steals the spotlight from a mysterious new villain.
Opposite: Bruce Timm's original art from 1994's *Mad Love.*

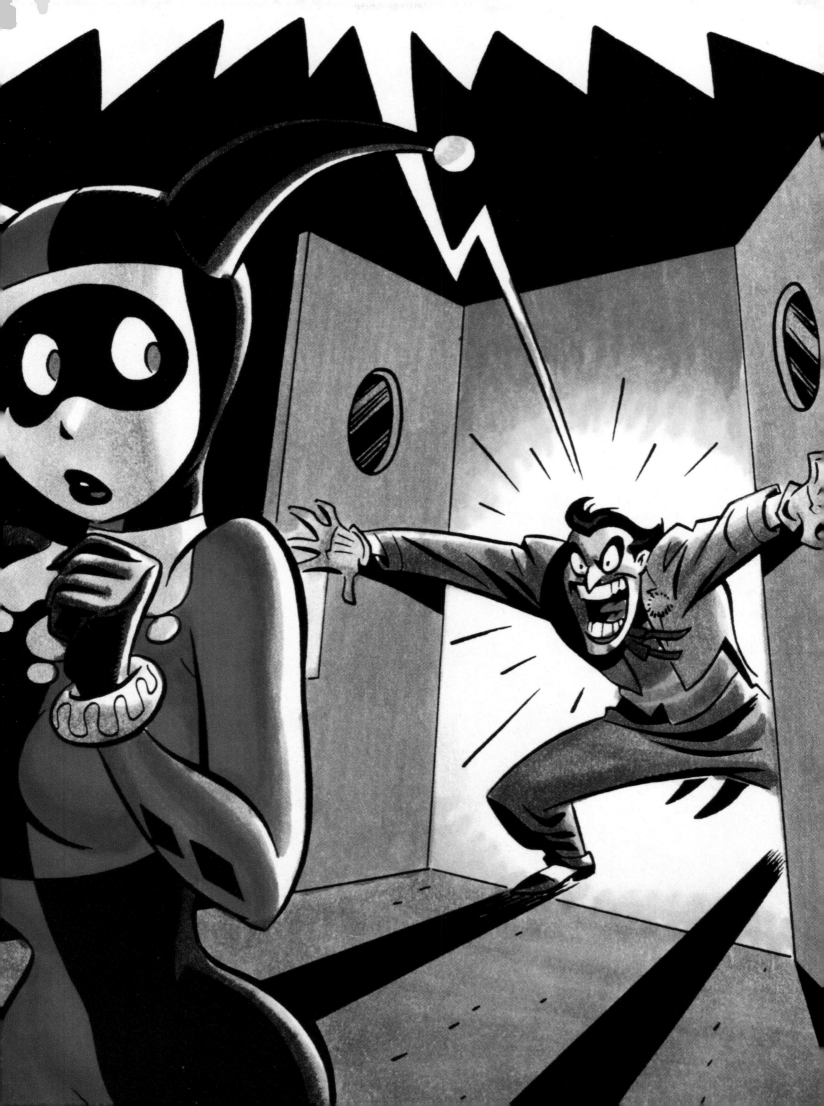

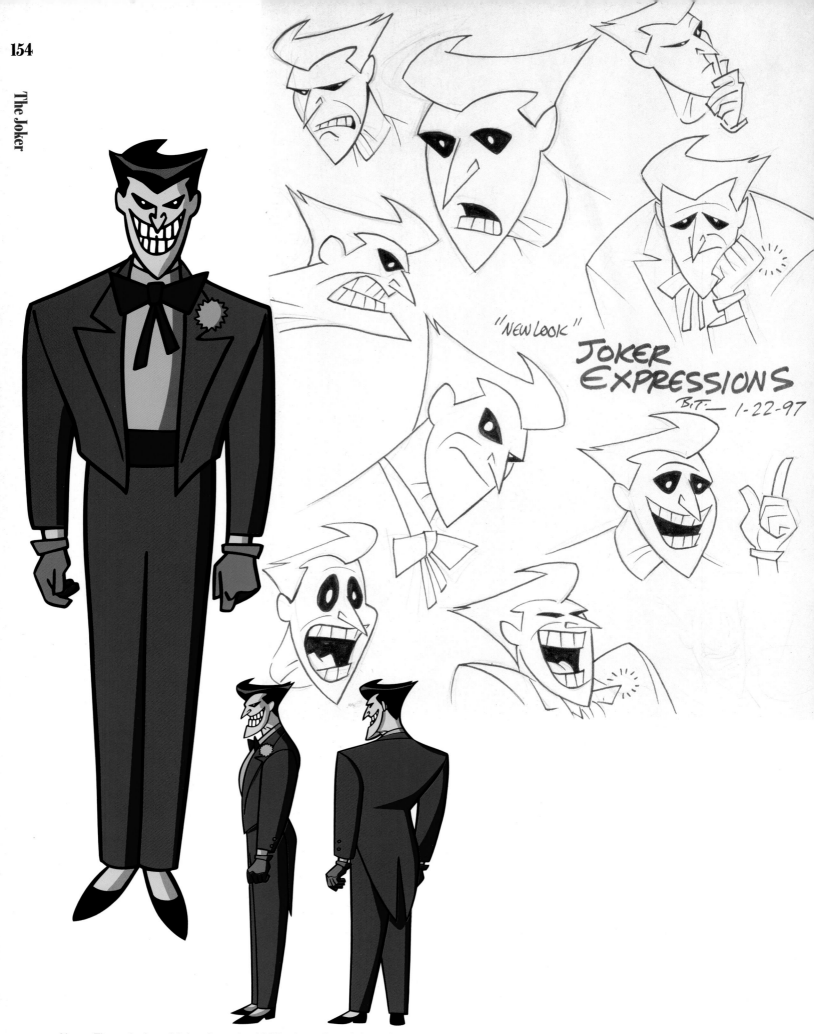

"NEW LOOK"

JOKER EXPRESSIONS

B.T.— 1-22-97

Above: The redesigned Joker from the 1997 rebranding of the animated series, which changed its name to *The New Batman Adventures*.
Opposite: This 1999 Alex Ross lithograph features *Batman Beyond*'s Terry McGuinness shadowed by his heroic and villainous predecessors.

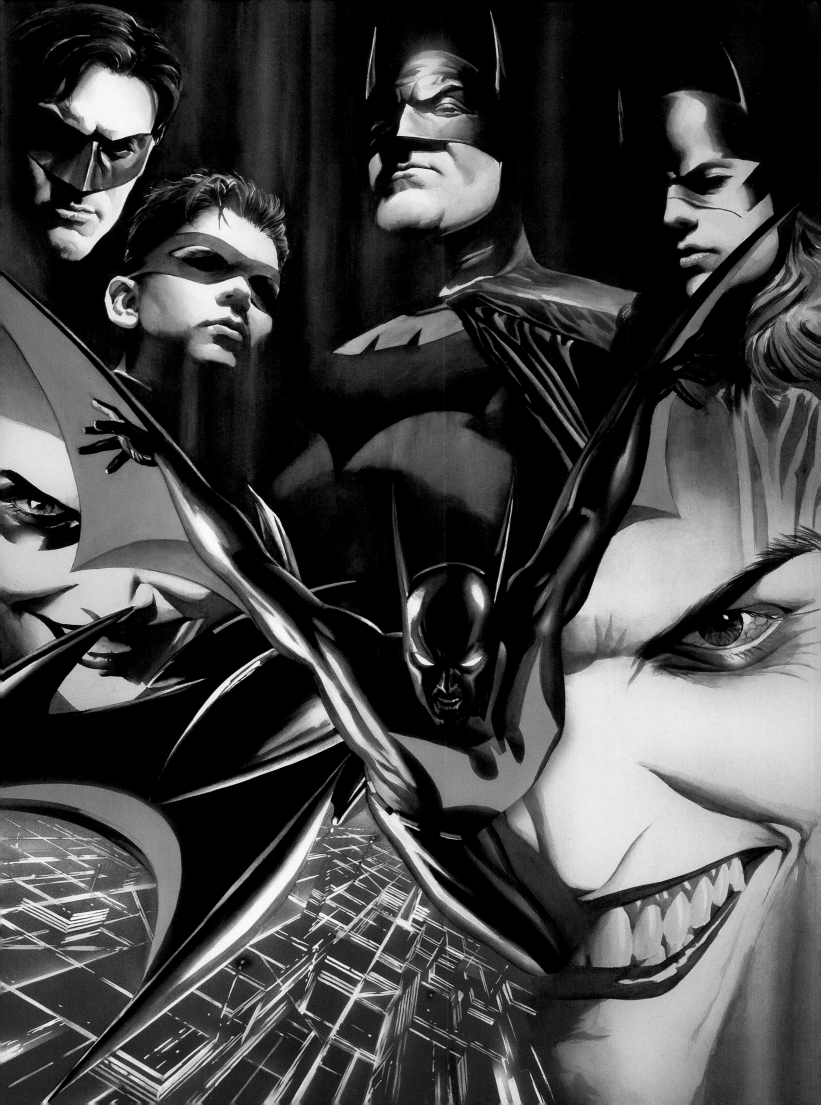

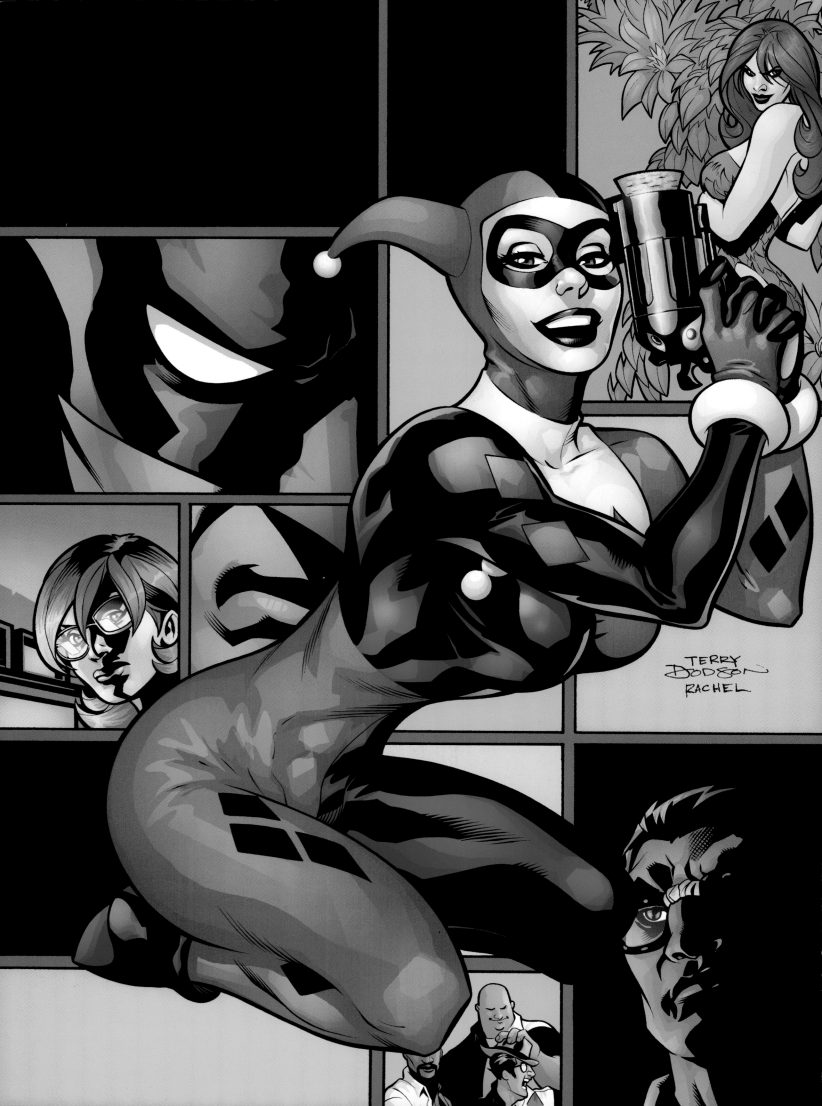

Above: In the future time frame of the 2000 animated feature *Batman Beyond: Return of the Joker*, the Joker has shed his clownish trappings and cares only for murder.

Opposite: Harley is armed and dangerous on the cover of *Harley Quinn* #12 (November 2011). Art by Terry Dodson and Rachel Dodson.

The Joker

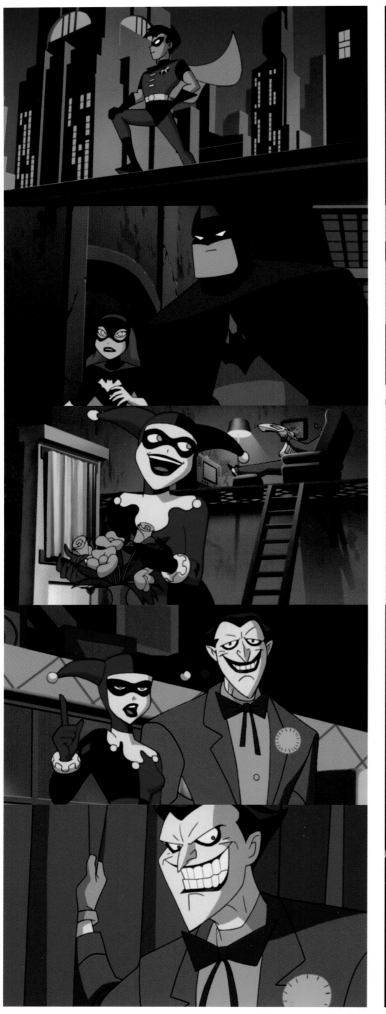
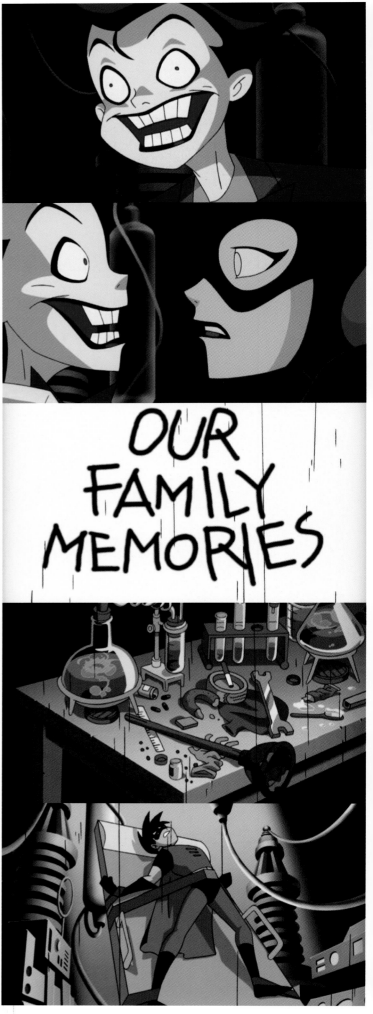

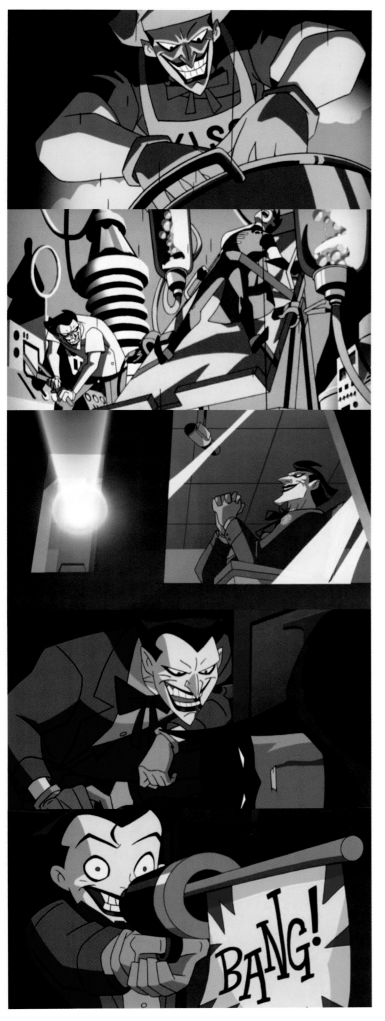

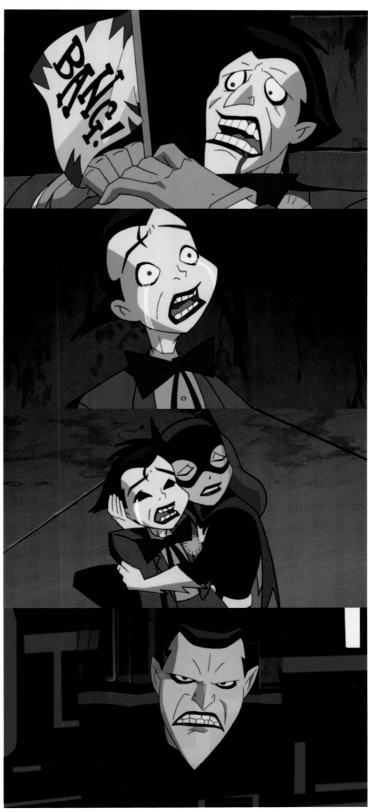

This spread: Told in flashback, the Joker kidnaps and traumatizes Robin only to die at the Boy Wonder's hands. This controversial sequence, edited for the original release, was restored in an unrated 2002 edition.

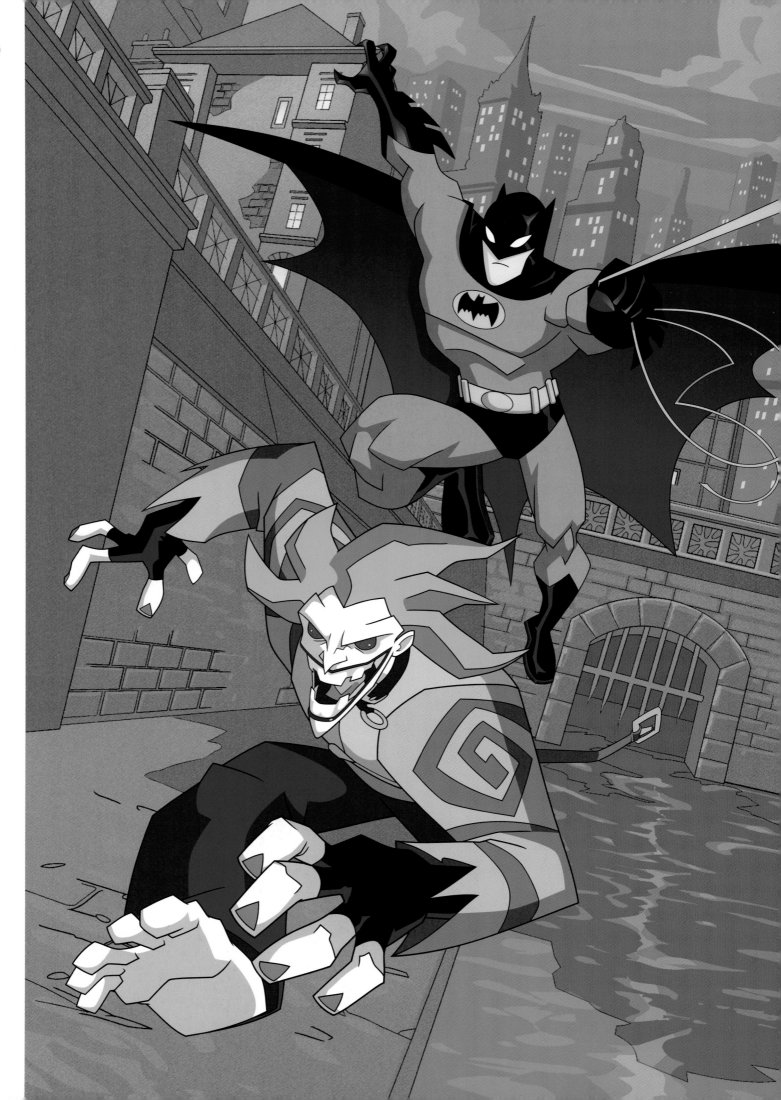

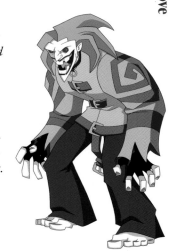

television in 2002's *Birds of Prey*. This action drama on the WB introduced Dr. Harleen Quinzel as a buttoned-up psychiatrist concealing her own psychosis, who became an antagonist for Black Canary, the Huntress, and former Batgirl Barbara Gordon. Mia Sara played the role of Dr. Quinzel, replacing Sherilyn Fenn from an unaired pilot episode.

The Joker found still more success in DC's animated continuity. He starred in the 1993 theatrical feature *Batman: Mask of the Phantasm* and again in 2000's direct-to-DVD *Batman Beyond: Return of the Joker*. The latter was a spinoff of the *Batman Beyond* series, which took place in a future Gotham where teenager Terry McGuinness had taken up the cowl from a retired Bruce Wayne. *Return of the Joker* included flashbacks of the Joker and Harley kidnapping, torturing, and brainwashing Robin—scenes considered too extreme for a children's audience and censored from the initial DVD release. Fan outcry prompted Warner Bros. to release a restored, unrated edition two years later.

The Batman, which ran on the WB network from 2004 to 2008, had no connection to the DC animated universe and offered a fresh look at the Dark Knight mythology. This high-tech Gotham was home to a young Bruce Wayne who experienced his first run-ins with a new-look rogue's gallery courtesy of artist Jeff Matsuda.

The Joker's makeover for *The Batman* was one of the most radical redesigns. The first episode, "The Bat in the Belfry," introduced a Joker with shoulder-length dreadlocks who wore a purple-and-yellow-striped straightjacket, its sleeves unfastened and flapping wildly. Possessed of an apelike agility, this Joker bounced off walls and hung from rafters, equally comfortable leading with his fists or his bare feet.

In the season 4 episode "Two of a Kind," Harley Quinn joined the continuity of *The Batman* as the host of the TV gossip show *Heart 2 Heart with Harley*. The Joker, her self-described "biggest fan," brought her to his lair, where she won his affections by bringing his hyenas to heel with a firm "SIT!" The two spent a costumed night on the town, and their demented date unfolded in montage to the tune of Hank Williams' "Settin' the Woods on Fire." It was a winning sequence that captured the mutual charge that Harley and the Joker get from their thrill-kill partnership.

The Batman won six Emmy awards, but the reboot left some fans cold and the simian-infused Joker became a focus of message-board ire. Toward the end of its run *The Batman* brought in familiar faces including Robin and Batgirl, and issued the Joker his standard purple suit—yet defiantly left his feet bare.

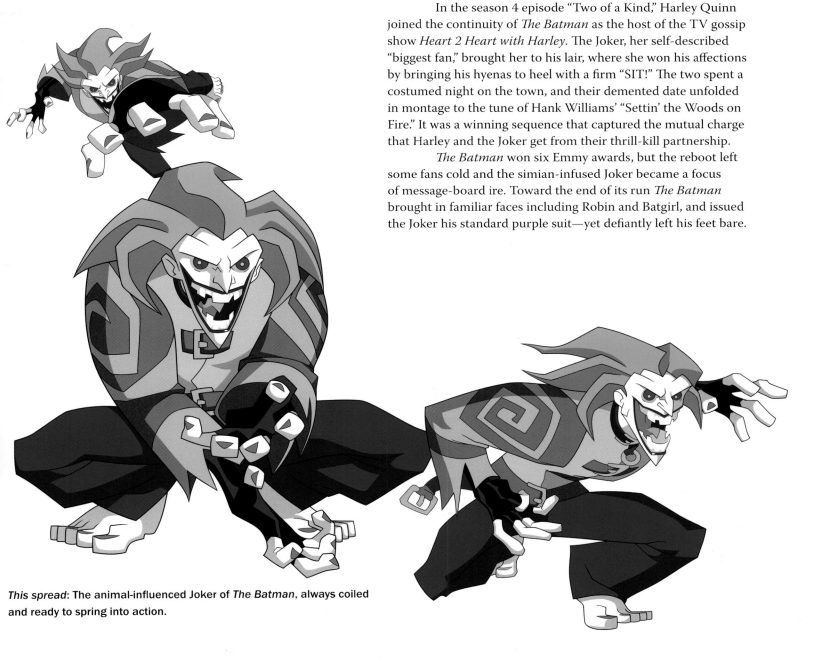

This spread: The animal-influenced Joker of *The Batman*, always coiled and ready to spring into action.

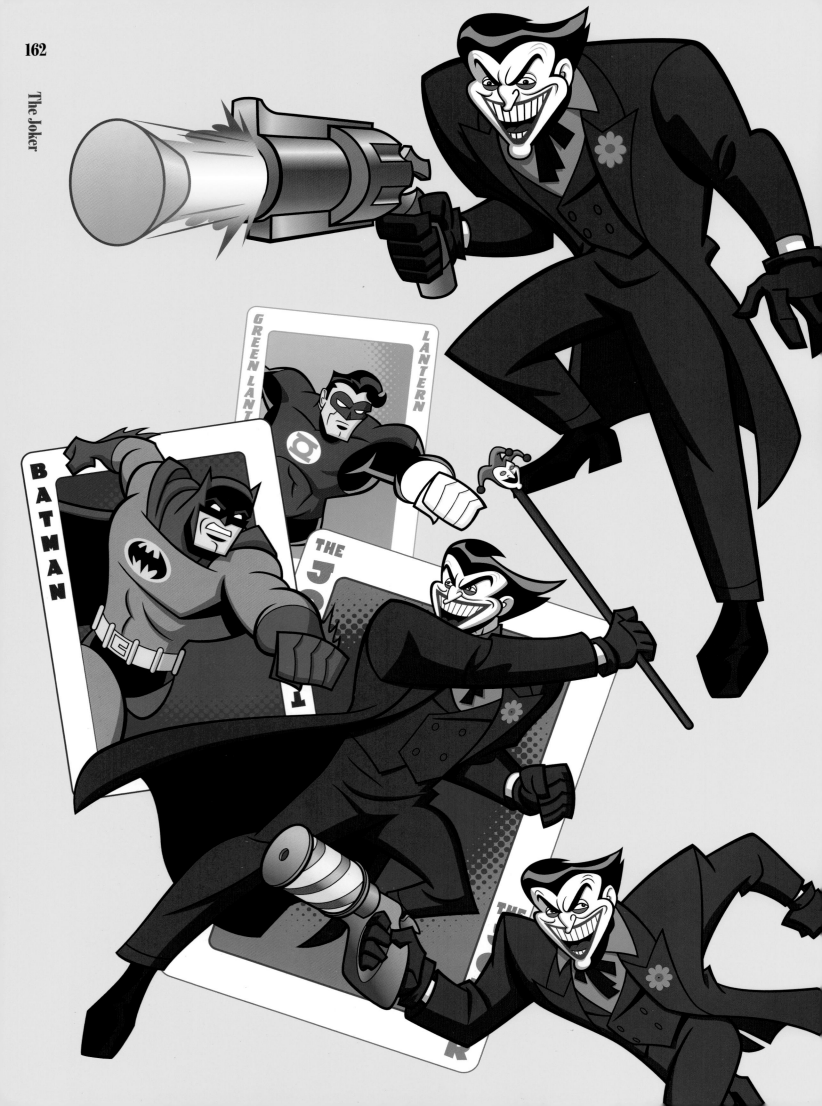

Another animated incarnation came in 2008. *Batman: The Brave and the Bold* offered a lighter tone in line with its Silver Age inspiration. Like the comic book whose name it shared, the series teamed Batman with a different DC hero in each installment. The Joker often popped up in the role of antagonist, with his heavy-lidded design inspired by the 1950s illustrations of Jack Burnley and Dick Sprang.

"Emperor Joker!" from *Batman: The Brave and the Bold*'s second season owed its premise to the Superman comics saga of the same name, though in this telling the Joker gained his godlike mastery over time and space from the fifth-dimensional imp Bat-Mite. He promptly put his powers to the test by killing and resurrecting Batman, which dismayed Harley Quinn as she became a mere castoff in the Joker's new reality. This version of Harley wore a 1920s flapper ensemble instead of her jester's togs. The costume may have boosted her independence, for she ultimately turned against her lover and rescued the Dark Knight.

This spread: Batman: The Brave and the Bold reveled in DC's Silver Age history, and its Joker bore a clear resemblance to the villain of the Dick Sprang era.

This spread: Three of Gotham's most dangerous villainesses graced the covers of *Gotham City: Sirens* #5-7 (December 2009-February 2010). Art by Guillem March.

Overleaf: Original art by Bruce Timm from the Paul Dini-scripted *Batman Adventures: Mad Love.*

SPOTLIGHT ON:
Paul Dini, Bruce Timm

They are the mutual godfathers of the DC animated universe, and if you don't believe it just ask the legions of fans who refer to it as the "Diniverse" or the "Timmverse." As producer, Bruce Timm helped launch *Batman: The Animated Series* in 1992, with Paul Dini contributing award-winning scripts such as the Mister Freeze–centered "Heart of Ice." Both collaborated to extend DC's interconnected animated storytelling into *Superman: The Animated Series*, *Batman Beyond*, and *Justice League*. Of the distinctively minimalist character design found throughout the projects, Timm said, "The more lines you have on a character, the harder it is to draw over and over. I knew that simplicity would be better." Dini has frequently written for Batman in the comics, with stints on *Detective Comics*, *Gotham City Sirens*, and *Batman: Streets of Gotham*.

The Clown PRINCE

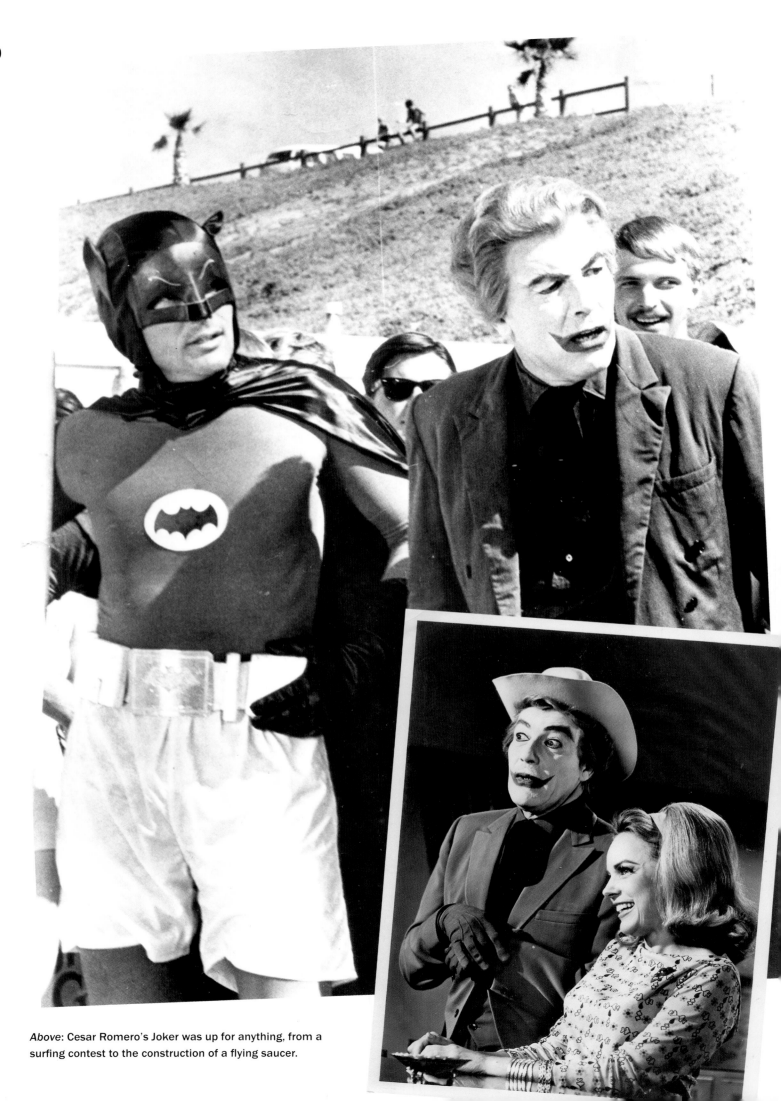

Above: Cesar Romero's Joker was up for anything, from a surfing contest to the construction of a flying saucer.

"A joke a day keeps the glum away!"
—*Batman* (1966)

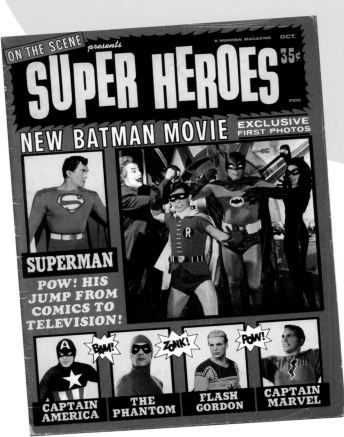

Comic books emerged from the twin parentage of newspaper comic strips and lurid pulp novels, but as comics gained mainstream popularity many publishers, including DC, dialed back the sex and violence to push the pulp roots under the rug. Some companies took the opposite route, with EC Comics (founded by former DC executive Max Gaines) releasing horrific crime and horror titles including *Tales from the Crypt.*

That ended with the 1954 enactment of the Comics Code Authority. The Code, which banned gore and innuendo, was a response to the hysterical hyperbole of the industry's chief critic, Dr. Frederick Wertham. The comics that followed in the Code's wake saw Batman lose his shadowy menace and the Joker become a figure of fun. No longer would the Joker leave a trail of grinning corpses. Instead his clownish stunts amused a Gotham populace that kept score of the rivalry he shared with Batman.

As for the Caped Crusader, he ventured even further afield. During the 1950s, Batman battled aliens and giant monsters. Hoping to find the next big hit, writers introduced new members of the "Bat Family," including Batwoman, Ace the Bat-Hound, and the mischievous Bat-Mite. Sheldon Moldoff drew the bulk of the era's stories, having worked out a freelance deal with Bob Kane and therefore receiving no credit in the books themselves. But sales of the Batman titles dropped throughout the decade, and by the mid-1960s cancellation was a growing danger. It was then that Batman and his world vaulted onto television.

The *Batman* TV show debuted in January 1966, a non-standard mid-season launch when audiences weren't expecting novelty. And *Batman* was like nothing else on the small screen. Leveraging both the Pop Art movement of Roy Lichtenstein and Andy Warhol and the increased penetration of color TV sets, *Batman* came saturated in bright images. Art director Serge Krizman made memorable visuals out of a blinking red Bat-Phone and the superimposed "BAM!" and "POW!" graphics that punctuated punches and kicks.

It was all self-aware satire. Producer William Dozier and writer Lorenzo Semple, Jr., weren't interested in Batman

Above: The success of Batman seemed to herald a mini-revival of the super hero genre, but the trend faded fast.
Previous spread: The Joker and Catwoman have the Dynamic Duo right where they want them in this still from the 1966 show, as printed in the magazine *On the Scene Presents Super Heroes*.

as a haunted vigilante. They set up a pitch-perfect spoof using ludicrous Bat-Gadgets and overheated dialogue, made funnier by the deadpan delivery of their Batman, Adam West.

"The Joker Is Wild," the series' fifth episode, introduced Cesar Romero as the Joker. Romero refused to shave his mustache for the part (it remained visible beneath his white greasepaint), but threw himself into the role with relish. Many of the characteristics now associated with the Joker—his maniacal laugh, the alternating pitch of his line deliveries, his twitchy excitement like a kid who can't wait to unwrap a surprise— originated with Romero. Until *Batman*, none of it could be conveyed on printed comic book pages.

Batman became a monster hit for ABC, airing twice per week on Wednesdays and Thursdays with a midweek cliffhanger urging viewers to return the following night, "same Bat-Time, same Bat-Channel." The Joker appeared with regular frequency, launching outrageous schemes in line with the show's arch tone. He tried to become a surfing champion, linked his crimes to the twelve signs of the zodiac, and parodied the Pop Art movement in an episode called "Pop Goes the Joker."

A 1966 feature film teamed Romero's Joker with popular villains the Penguin (Burgess Meredith), the Riddler (Frank Gorshin), and Catwoman (Lee Meriwether), but the show fell in the ratings just as quickly as it had climbed. Cutting the schedule to one airing per week, and introducing Yvonne Craig as Barbara Gordon/Batgirl couldn't resurrect interest in what was becoming

Top: A stylish moment from the opening credits of the 1966 *Batman* movie, emphasizing the importance of color.

Right: The Joker as reflected in a DC Comics style guide.

last year's fad. ABC took the show off the air in March 1968 after 120 episodes. Said DC editor Julius Schwartz, "I don't know if I was pleased with it, but it was the thing to do. When the television show was a success I was asked to be campy, and of course when the show faded so did the comic books."

Because the surge in public visibility hadn't helped stop Batman's comic book slide, editorial director Carmine Infantino vowed to turn things around. Infantino continued with the "new look" naturalistic art style that had replaced the stiffness of Sprang, and moved even further away from schoolboy-friendly adventures. Among other changes, Robin left the Bat books to study at college.

It wasn't enough. In an era of antiwar protests and mind-expanding music, it seemed that comics needed to reestablish their relevance as both an artistic and a storytelling medium. Writer/artist teams such as Denny O'Neil and Neal Adams stretched DC's boundaries with socio-political morality tales in titles like *Green Lantern/Green Arrow*. O'Neil and Adams also reinvigorated the Joker in 1973's "The Joker's Five-Way Revenge," restoring much the menace the character had shed over the previous two decades.

Above: The Joker electrifies his cohorts and dehydrates the United Nations in the 1966 Batman movie, which introduced a speedy Batboat

Above: Carmine Infantino and Murphy Anderson's memorable cover to *Detective Comics* #365 (July 1967). The smiling wall of brick was used to decorate the letter column for the Joker's self-titled 1970s series.

Above: Sheldon Moldoff and Joe Giella handled the interior art for this story from *Detective Comics* #365. In many tales, the Joker labeled his hideouts "ha-haciendas."

But as editor Julius Schwartz bemoaned at the time, "relevance is dead." O'Neil and Adams may have advanced the medium, but that didn't mean the titles had hit their monthly sales targets. The 1970s became a test bed of experimentation at DC, with new titles like the *Claw the Unconquered*, *Black Lightning*, and *Shade the Changing Man* abruptly launching at newsstands and often disappearing just as quickly.

One such risk was *The Joker*, an all-new ongoing title that was the first comic book with a villain as its headliner. But who better than the Joker to carry a series? The first issue, by O'Neil and artist Irv Novick, had the Joker bragging right on the cover. In front of Catwoman, the Riddler, Two-Face, and the Penguin, he gloated, "Eat your hearts out, you two-bit baddies! This magazine belongs to Batman's number one foe...ME!"

Above: Though other villains made guest appearances, only the Joker could headline a villain-centric comic.

Right: Filmation's *The New Adventures of Batman* debuted on February 12, 1977. Typical for the era, it featured a comic-relief sidekick in the form of Bat-Mite.

tiny titans

The stories struck a curious balance between reminding readers of the Joker's criminality yet promoting him as a protagonist worth rooting for. The first issue saw him battle a fellow villain, Two-Face, and later installments challenged him to use brains and guile to recover a painted hyena mural or steal a storehouse of platinum. Though he murdered henchmen and other unfortunates, the Joker never fought Batman. Thus his rampages weren't "evil vs. good," but rather a more palatable scenario in which the Joker's brand of villainy won out over a competing—and less entertaining—expression of same.

The Joker never found its audience and was cancelled with issue #9, despite a next-issue box that promised an appearance by the Justice League of America. But the Joker had other outlets for his antics, including repeats of the animated *The Batman/Superman Hour* that had debuted on CBS in 1968 and featured Larry Storch as the voice of the Joker. For the 1977 animated series *The New Adventures of Batman*, Lennie Winerib took over the role.

In comics, the Joker gained a spinoff character in the Joker's Daughter, who debuted in a 1976 issue of *Batman Family*. Greeting Robin with, "I don't think Daddy would want us holding hands, but I don't mind!" This frizzy-haired harlequin fought using a bubble-blowing pipe and wore a pants-and-suit coat combo that distinguished her from the spandex heroines whose curves had long been sexualized in superhero comics. Her claim to have been fathered by the Joker later proved false, with her real name, Duela Dent, instead pointing her parentage in the direction of Two-Face.

When Jenette Kahn became DC's publisher in 1976, she took over a stable of comic book titles that had drifted off course in search of an audience. Under her tenure, the DC universe would undergo a dramatic facelift, and the Joker would become one of the most terrifying villains in fiction.

Top: Duela Dent reappeared in *Countdown* #51 (2007), illustrated by Jesus Saiz.
Above: Art Baltazar's *Tiny Titans* presented a fun, all-ages take on the DC Universe. In issue #17 (August 2009), Duela encounters a downside to the continuation of her daddy's legacy.

Overleaf: Batman leads the Joker back to Arkham in this Neal Adams/Dick Giordano panel from *Batman* #251 (September 1973).

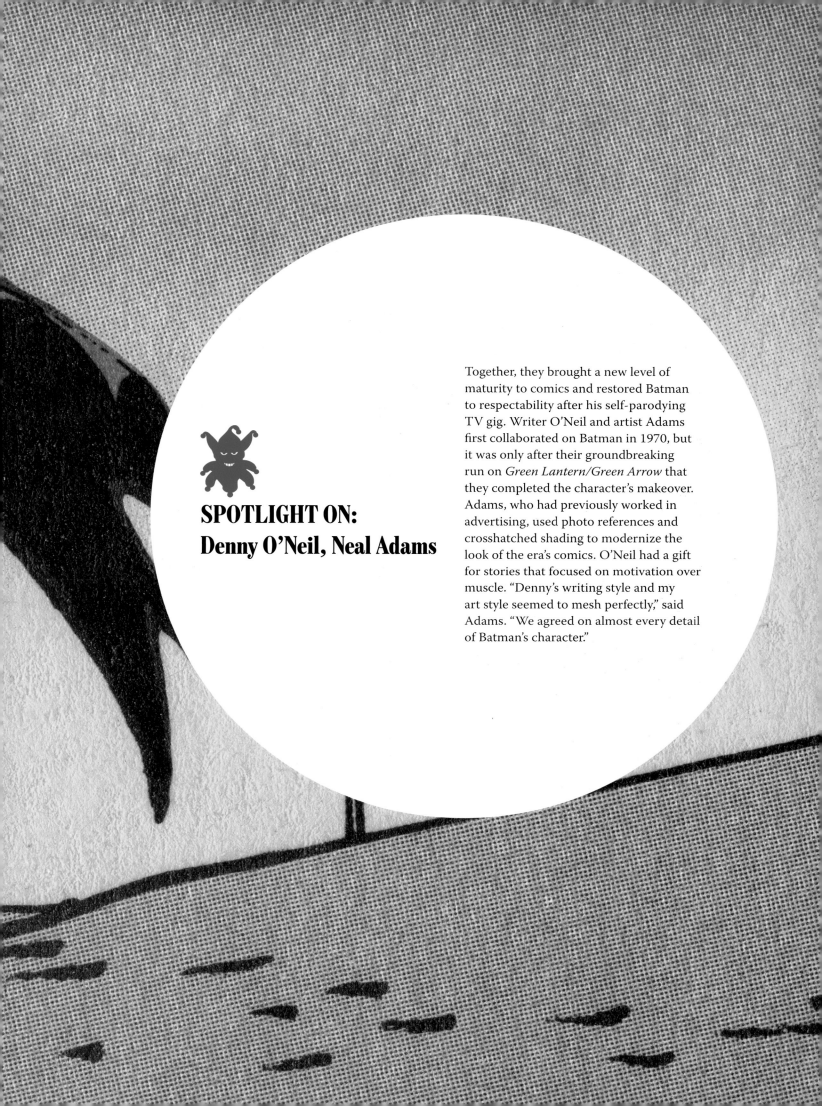

SPOTLIGHT ON:
Denny O'Neil, Neal Adams

Together, they brought a new level of maturity to comics and restored Batman to respectability after his self-parodying TV gig. Writer O'Neil and artist Adams first collaborated on Batman in 1970, but it was only after their groundbreaking run on *Green Lantern/Green Arrow* that they completed the character's makeover. Adams, who had previously worked in advertising, used photo references and crosshatched shading to modernize the look of the era's comics. O'Neil had a gift for stories that focused on motivation over muscle. "Denny's writing style and my art style seemed to mesh perfectly," said Adams. "We agreed on almost every detail of Batman's character."

Killer SMILE

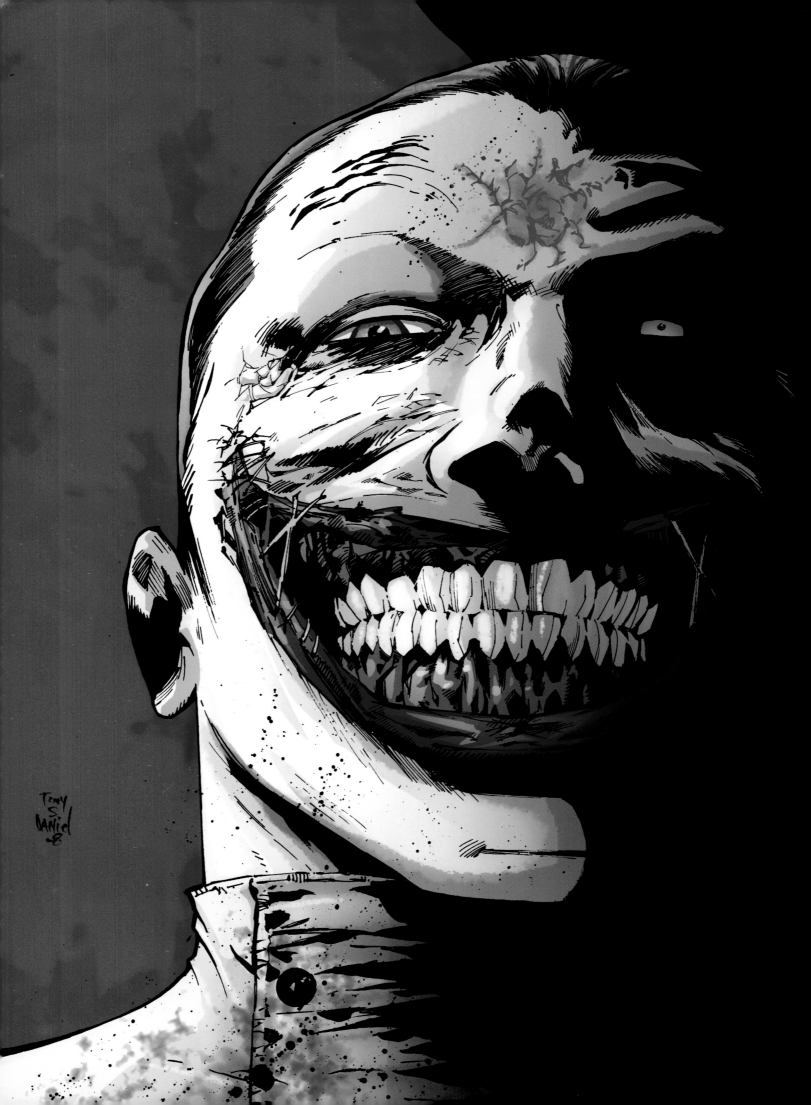

"Kid, I'm the Joker. I don't just randomly kill people. I kill people when it's funny."
—*Batman* #686 (2009)

The Joker emerged from the Golden Age of comics and lost his edge during the Silver Age. It wasn't until the 1980s that the character truly came into his own, as DC pioneered a new era of comics that might be dubbed the Dark Age.

Dark, in this case, meant mature tales of death and destruction. The movement was derided by some critics as an unnecessary dirtying-up of the superheroes they'd loved in their youth, but comics simply weren't just for kids anymore. The growth of specialty retailers moved comics away from grocery store spinner racks, and the public began to wake up to the idea that superheroes could be proxies for sober explorations of obsession, vigilantism, and fame.

DC birthed the Dark Age with the twelve-part *Crisis on Infinite Earths*. Not only did the series kill off Silver Age icons the Flash and Supergirl, it cleared out decades of continuity bramble and invited writers and artists to start fresh.

Batman: The Dark Knight Returns hit stores mere months later. The brainchild of Frank Miller, the prestige format series presented an aged, bitter Batman forced to don the cape once more. With Klaus Janson inking Miller's pencils, Batman became a bulked-up force of nature and the Joker a lipsticked celebrity who oozed sexual menace. In the third issue, Miller presented his version of the pair's final showdown. After pummeling each other inside a carnival's Tunnel of Love, the Joker realized his nemesis would never strike a killing blow. "They'll kill you for this, and they'll never know you didn't have the nerve," he said, before snapping his own neck and leaving Batman alone in the dark with a grinning corpse.

Above: Frank Miller's sketch of a Jokerized victim, collected in the hardcover *Absolute Dark Knight* (2006).

Opposite: A post-surgery Joker is more gruesome than ever in Tony S. Daniel's page from *Batman* #682 (January 2009).

Previous spread: Lee Bermejo's cover to the 2008 graphic novel *Joker*.

Overleaf: The Joker snaps his own neck to ensure Batman will be pegged as his murderer in 1986's *Batman: The Dark Knight* #3. Art by Frank Miller and Klaus Janson.

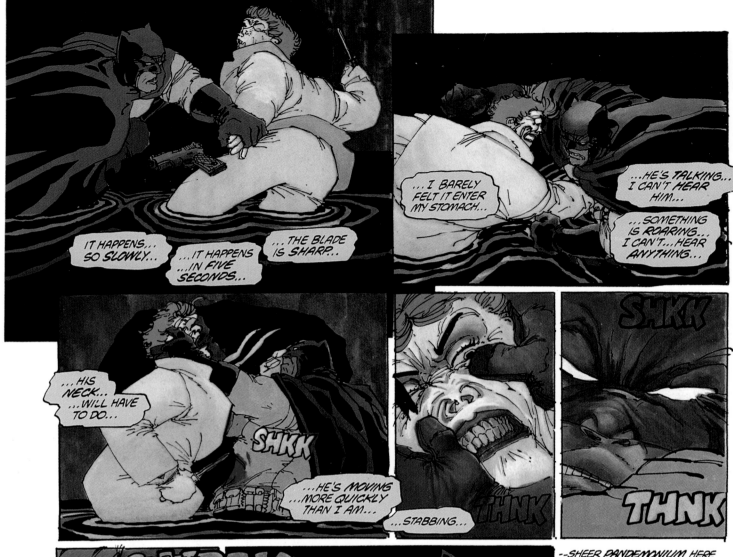

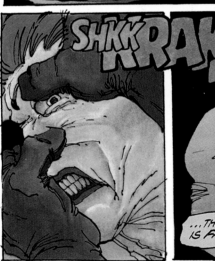

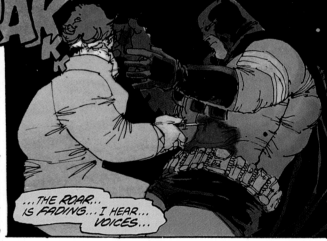

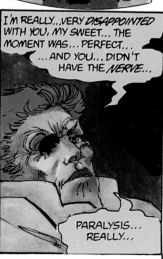

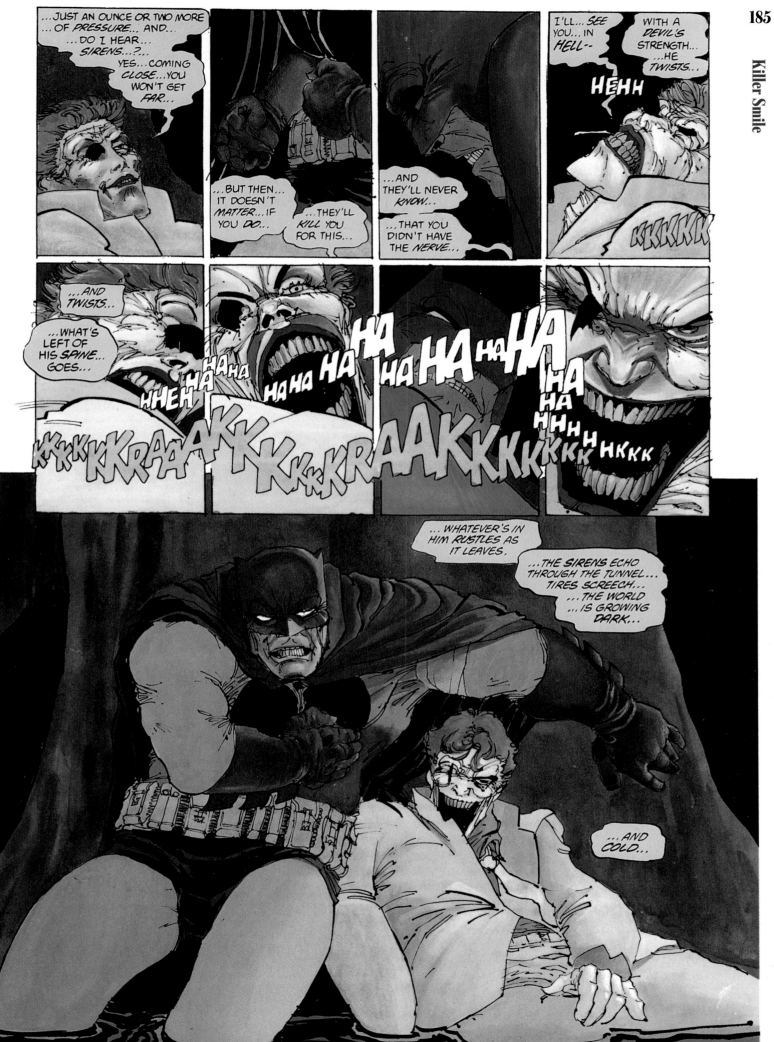

Above: This Brian Bolland sequence from 1988's *Batman: The Killing Joke* carried a permanence rare in superhero comics, transitioning Barbara Gordon into a wheelchair and ending her time as Batgirl.

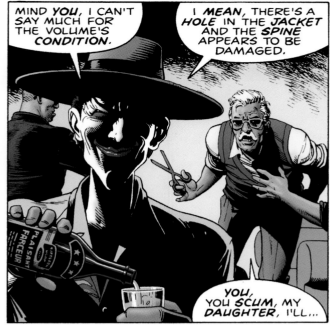

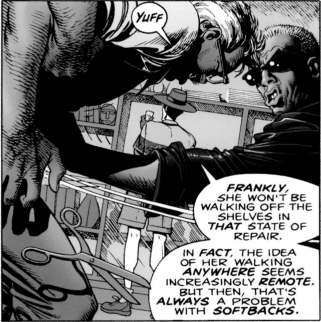

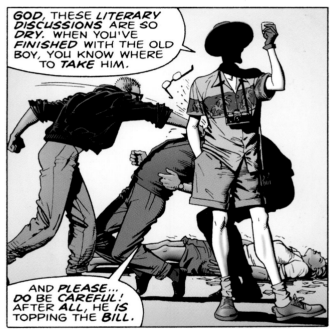

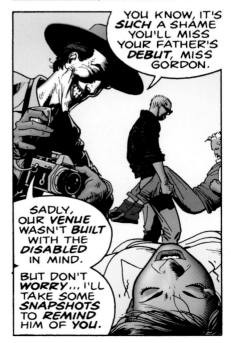

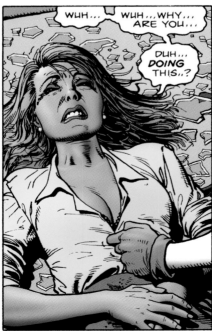

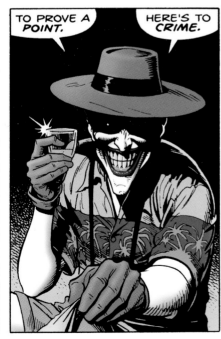

Alan Moore's *The Killing Joke* appeared in 1988, though it had been in the works for years due to the complexity of its Brian Bolland artwork. Unlike *The Dark Knight Returns*, this graphic novel took place within the mainstream continuity of the Batman comics. It changed that continuity forever when the Joker fired a bullet into Barbara Gordon's spine, ending her career as Batgirl and leaving her a paraplegic. Despite this act and other nightmarish crimes including the psychological torture of a naked Jim Gordon, the *Killing Joke*'s Joker came across as a tragic, even sympathetic figure. Moore updated the "Red Hood" origin from 1954's *Detective Comics*, but added the loss of a wife and an unborn child to the Joker's emotional baggage. The Joker's madness hinged on the conviction that it only takes "one bad day" to transform a functioning member of society into a psychopath, and the parallels to Batman's own origin couldn't be clearer. The final page showed the two enemies sharing a quiet chuckle that became a cackle of dementia.

DC chose not to roll back Barbara Gordon's paralysis after *The Killing Joke*, and in the process made her more important to the DC universe than she had ever been as Batgirl. Training her upper body to perfection but using a wheelchair for mobility, she moved into a Gotham clock tower and used her skills as a networked data-gatherer to feed information to other superheroes as the mysterious Oracle. In time she took her revenge on the Joker in her comic *Birds of Prey*, smashing him in the face with an eskrima fighting stick and shattering his teeth. The Joker forced a dentist to perform reconstructive surgery, but as Barbara noted, "It's not his smile anymore. It's a fake, a reconstruction, and that preening narcissist will cringe from now on every time he grins."

Above, opposite: Jim Lee and Scott Williams revisited Barbara Gordon's journey from caped crimefighter to omniscient computer hacker in these panels from *Batman* #614 (January 2003).
Right: A modern Joker, as reflected in a DC Comics style guide.

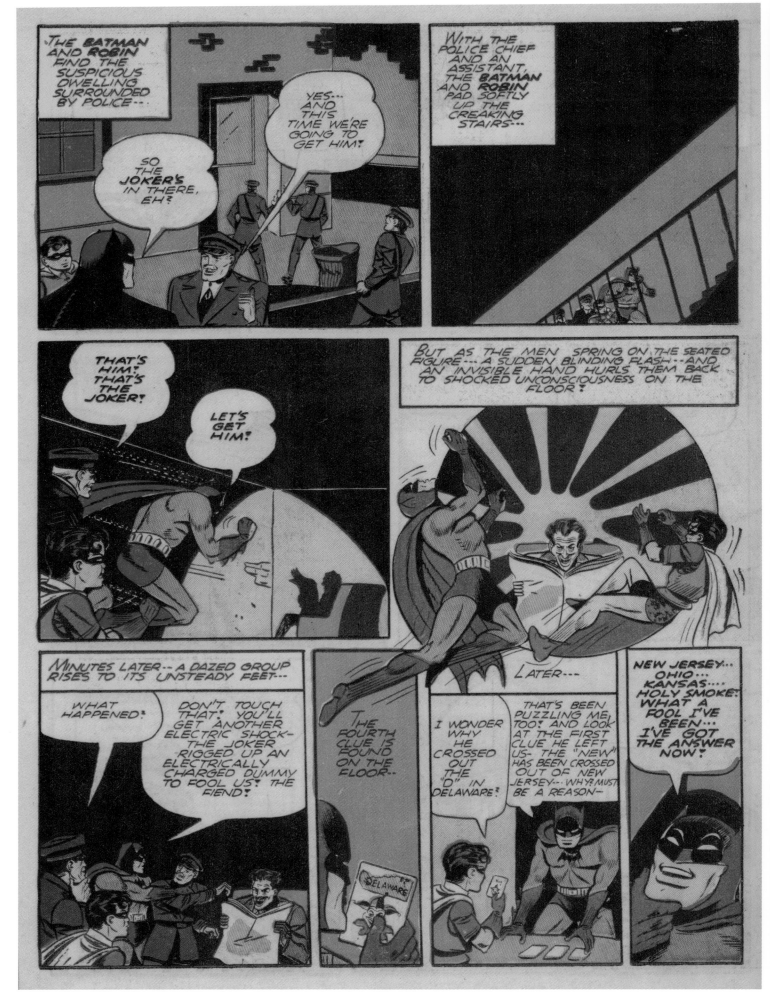

This spread: Batman tracks down a roaming Joker in this story written by Bill Finger with art by Bob Kane and Jerry Robinson from *Batman* #8 (December 1941/January 1942).

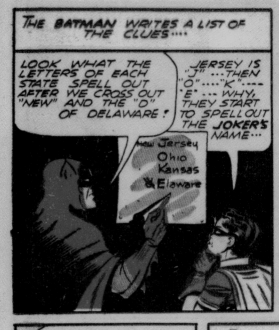

THE BATMAN WRITES A LIST OF THE CLUES....

LOOK WHAT THE LETTERS OF EACH STATE SPELL OUT AFTER WE CROSS OUT "NEW" AND THE "D" OF DELAWARE!

JERSEY IS "J" ...THEN "O"....."K"--- "E"--- WHY, THEY START TO SPELL OUT THE JOKER'S NAME...

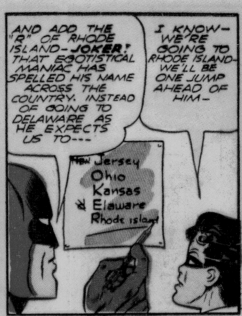

AND ADD THE "R" OF RHODE ISLAND—JOKER! THAT EGOTISTICAL MANIAC HAS SPELLED HIS NAME ACROSS THE COUNTRY. INSTEAD OF GOING TO DELAWARE AS HE EXPECTS US TO---

I KNOW— WE'RE GOING TO RHODE ISLAND— WE'LL BE ONE JUMP AHEAD OF HIM—

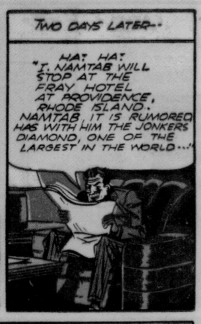

TWO DAYS LATER--

HA! HA! "I. NAMTAB WILL STOP AT THE FRAY HOTEL AT PROVIDENCE, RHODE ISLAND. NAMTAB, IT IS RUMORED, HAS WITH HIM THE JONKERS DIAMOND, ONE OF THE LARGEST IN THE WORLD...."

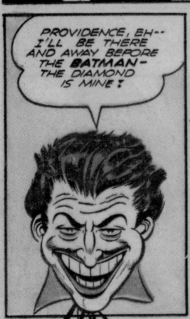

PROVIDENCE, EH-- I'LL BE THERE AND AWAY BEFORE THE BATMAN— THE DIAMOND IS MINE!

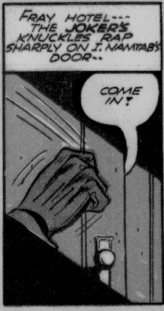

FRAY HOTEL--- THE JOKER'S KNUCKLES RAP SHARPLY ON I. NAMTAB'S DOOR..

COME IN!

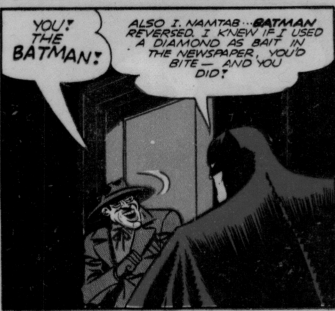

YOU! THE BATMAN!

ALSO I. NAMTAB...BATMAN REVERSED. I KNEW IF I USED A DIAMOND AS BAIT IN THE NEWSPAPER, YOU'D BITE — AND YOU DID!

I'M NOT CAUGHT YET, BATMAN! NOT YET!

BUT YOU SOON WILL BE, BROTHER-- YOU SOON WILL BE!

YOU LITTLE BRAT— GET OUT OF MY WAY!

Both *The Dark Knight Returns* and *The Killing Joke* proved that Batman had completed an evolution. No longer TV's Day-Glo Caped Crusader who felt no shame dancing the Batusi, this vigilante was driven and dangerous, and only came into his element after sunset. This dead-serious take on the character led to Tim Burton's 1989 film *Batman*, which put Michael Keaton in the title role, with Oscar-winner Jack Nicholson as the Joker.

Batman set designer Anton Furst created a Gotham City made of sharp Gothic points and lit by moonlight, a grim environment in which the Joker stood out like a piebald anarchist. The film tied in with the comics backstory by having its Joker plunge into a vat of chemicals, but tweaked the formula by making him the thug who shot Bruce Wayne's parents. Nicholson devoured the role, retaining some of Cesar Romero's giggling showmanship but mainlining the malevolence of *The Killing Joke*. This Joker could electrocute a rival crime boss while crooning "There'll Be a Hot Time in the Old Town Tonight,"

and laugh at his mix of low comedy and a high body count. But the Joker died before the closing credits, and the movie's three sequels featured other members of Batman's rogue's gallery.

Throughout the subsequent decades the Joker popped up any time a creator wanted to explore themes of terror or demented genius. Ed Brubaker's *Batman: The Man Who Laughs* retold the *Batman* #1, updating the basic outline of the Joker's first adventure by incorporating details such as Arkham Asylum, all of it captured through the hyper-detailed artwork of Doug Mahnke. Paul Dini's "Slayride," in *Detective Comics* #826, saw the Joker kidnap Robin (Tim Drake, Jason Todd's replacement) and chauffeur him in a stolen car through Gotham on Christmas Eve, killing pedestrians and laughing all the way.

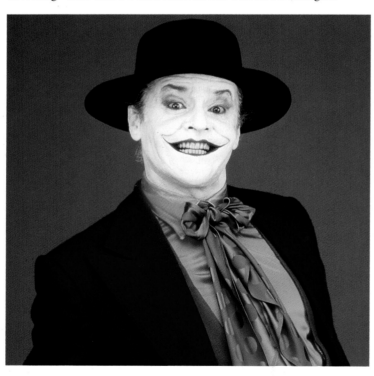

Above: Jack Nicholson, known for playing characters with manic intensity, had no problem slipping into the Joker's skin.
Top right: It's a gas! These storyboards detail the Joker's plan to take down Gotham City.

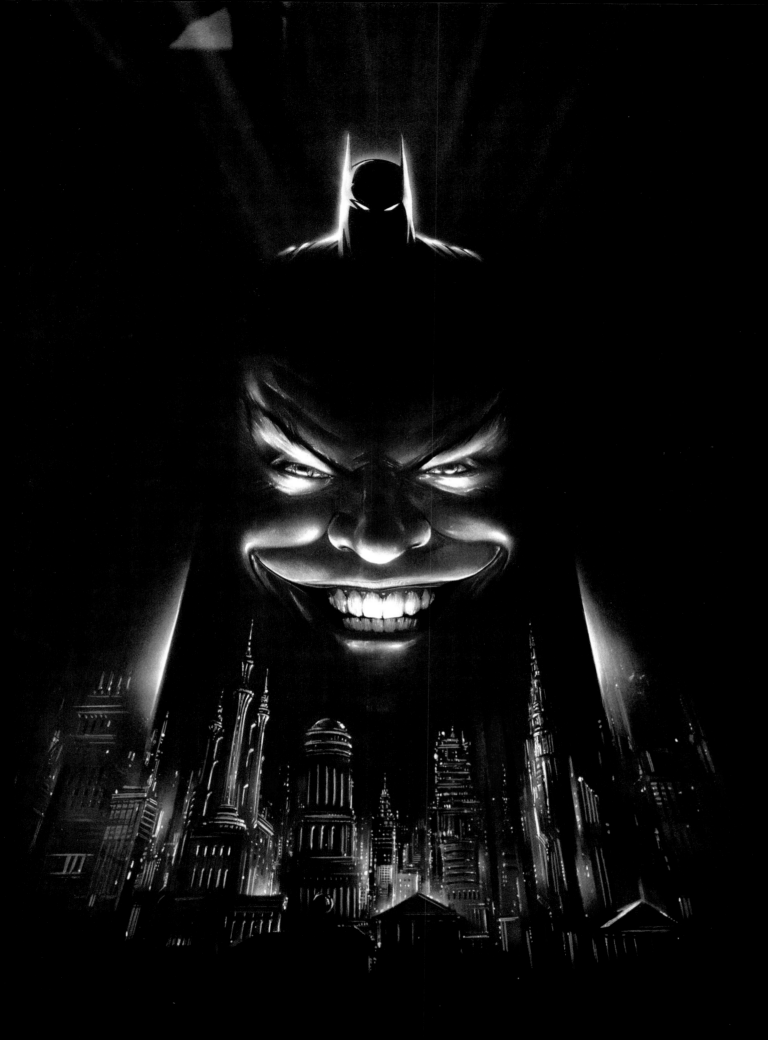

Above: An unused poster for the 1989 *Batman* movie leaves little doubt that the Joker will steal the show.

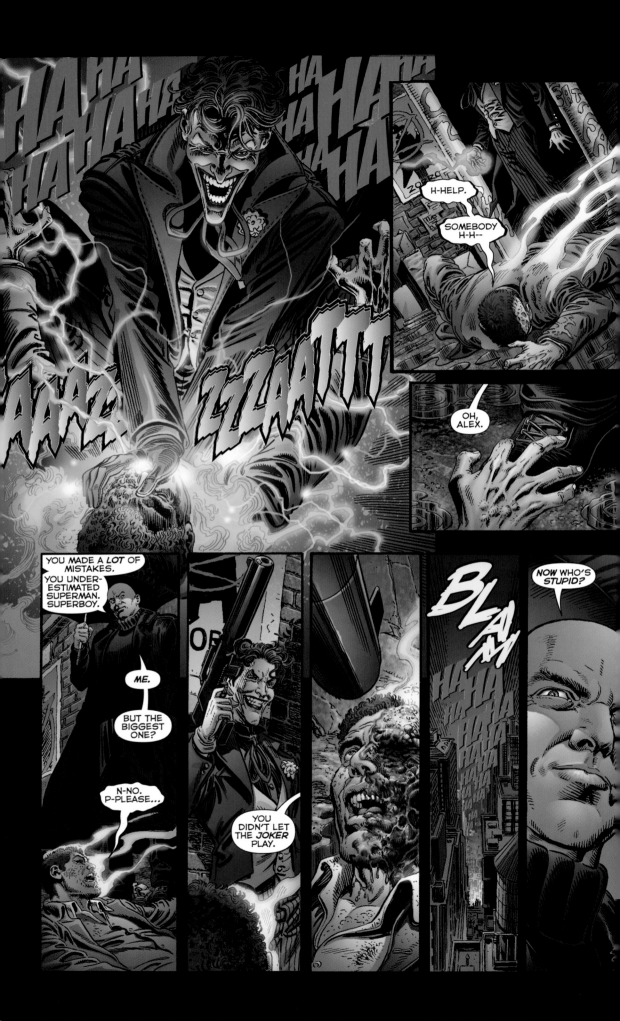

Above: One villain dies at the hands of another while Lex Luthor looks on approvingly. Text by Geoff Johns and art by George Perez and Jerry Ordway from *Infinite Crisis* #7 (January 2006).

Geoff Johns and Phil Jimenez's *Infinite Crisis* shook the DC universe to its foundations twenty years after *Crisis on Infinite Earths*, with the reality-warping cosmic god Alexander Luthor trying to re-create entire universes and snuffing out billions of lives. The Joker remained conspicuously absent from the epic events, but turned up at the end of the final issue to provide the capper. After all his omnipotent achievements, Alexander Luthor found himself in a dirty alleyway, cornered by the Joker and reduced to whimpering pleas by the Joker's acid flower and electric joy buzzer. Lex Luthor, who watched the takedown from a safe distance, delivered an explanation just before the Joker ended the torture with a fatal gunshot. "Oh, Alexander. You made a lot of mistakes. You underestimated Superman. Superboy. Me. But the biggest one? You didn't let the Joker play."

Grant Morrison, whose graphic novel *Arkham Asylum: A Serious House on Serious Earth* defined the Joker's shifting characterizations as an outcome of his "super sanity," took over as writer of the flagship title *Batman* in issue #655. Morrison removed the Joker from the table by hospitalizing him after he took a bullet from a Batman impersonator, making room for the introduction of new characters including Damian, Bruce Wayne's ten-year-old son.

"The Clown at Midnight," Morrison's issue-length prose story in *Batman* #663, restored the Joker as an unknowable, cruel god. Lurching Frankenstein-like from his post-gunshot catatonia, this new iteration of the Joker attempted to kill Harley Quinn to prove to Batman that he had become more than human. In subsequent appearances the Joker exhibited far more deviousness than before, pulling off a long con by gaining the public's trust with a secret identity, and manipulating Damian (now the newest Robin) into entering a locked room where he lay in wait. "A Robin who even brings his own crowbar to the party?" he exulted. "You might be the funniest one yet."

Top: Sam Kieth's early concept artwork for *Arkham Asylum: Madness* (2011).

Right: This is definitely not your lucky card. Joker art from a DC Comics style guide.

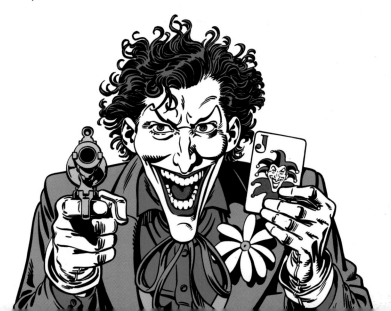

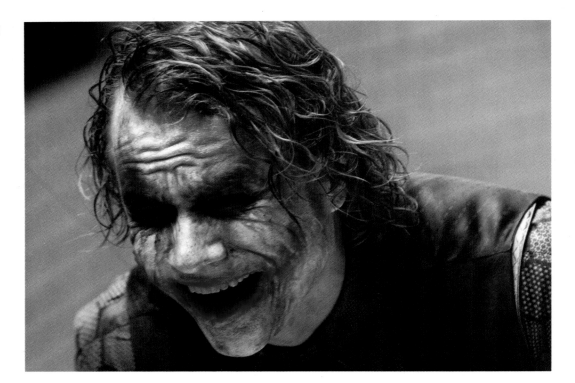

In the summer of 2008 the Joker was everywhere, the subject of a massive marketing campaign that saw his painted smile emblazoned on posters bearing the tagline, "Why So Serious?" It led up to the July premiere of Christopher Nolan's *The Dark Knight*, the sequel to his 2005 *Batman Begins* that rebooted the Batman film franchise after the Tim Burton (and later Joel Schumacher) era. Heath Ledger played the Joker as a ratty-garbed hobo capable of shocking bursts of violence—just ask the gangsters who had a ringside seat for his infamous pencil trick. "I locked myself away in a hotel room for six weeks," explained Ledger. "I just formulated a voice and a posture and found a real psychology behind the Joker." Little remained of the light-footed prankster of earlier eras. Ledger's mesmerizing performance brought to life a villain who, in the words of Bruce Wayne's butler, Alfred, just wanted to "watch the world burn."

The real-world tragedy of Ledger's death in January only added to the impact of his final on-screen performance. He earned a posthumous Academy Award for Best Supporting Actor. *The Dark Knight* became the year's biggest film, grossing more than $1 billion worldwide.

Above: Critics praised Ledger's portrayal of the Joker as a bringer of anarchy. "Madness is like gravity," he says in the film. "All it takes is a little push."

Right: A design sketch from *The Dark Knight*'s development showing an unused costume concept.
Opposite: This Batman collage is clearly the Joker's demented handiwork. Warner Bros theatrical poster.

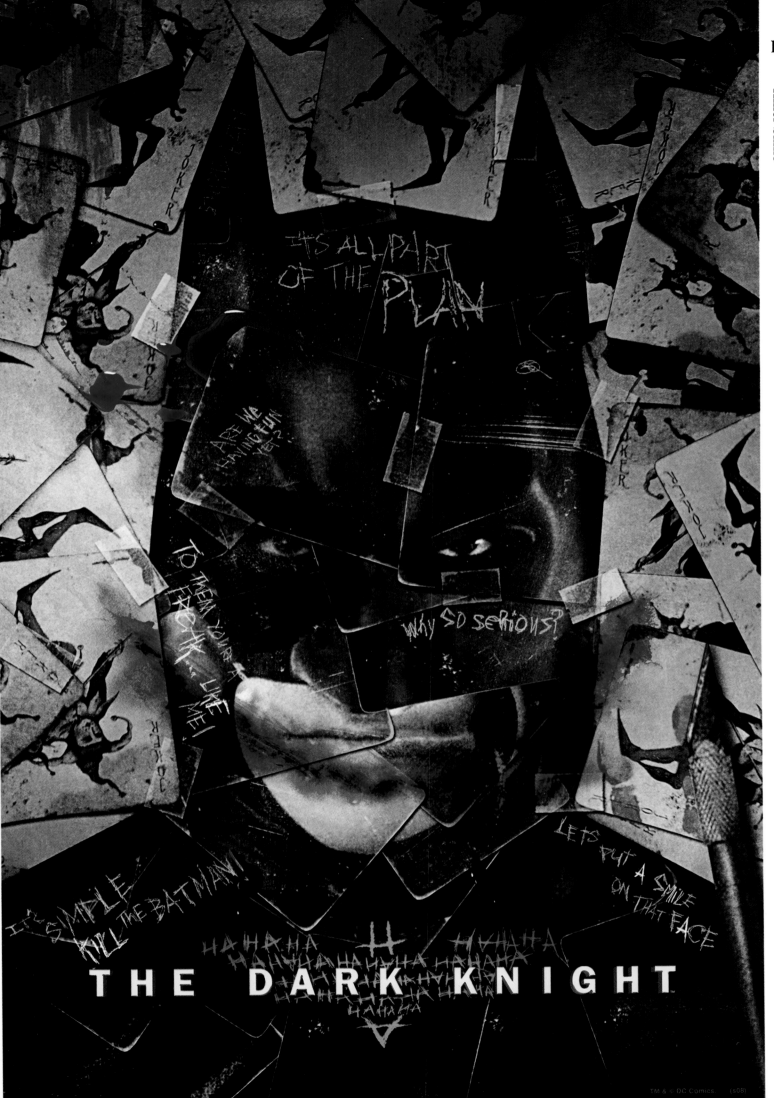

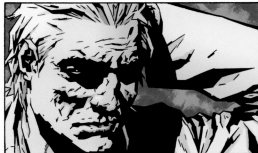
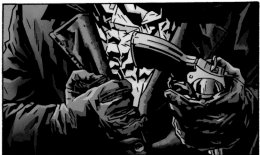
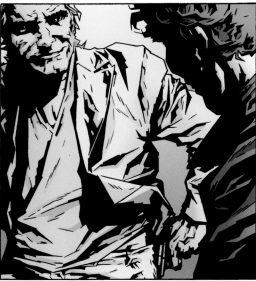
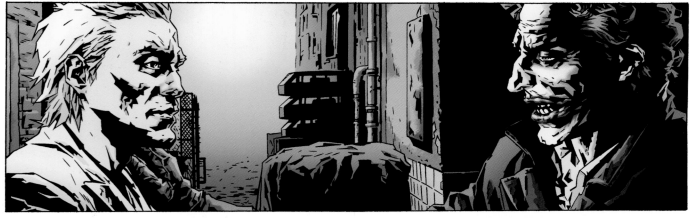

The take-no-prisoners nihilism of *The Dark Knight*'s Joker didn't go unnoticed in comics. Brian Azzarello and Lee Bermejo released the *Joker* graphic novel the same year. It presented the world of Gotham City through the film's lens of realism, which had eschewed elaborate sets in favor of location shooting in Chicago. In Azzarello's tale, no one but Batman wore a costume, and the Joker possessed not a single drop of mirth. But his conflict with his enemy remained the central focus. As the Dark Knight's legend evolves throughout the twenty-first century, it seems that a bat will forever remain locked in combat with a clown.

Above: Doug Mahnke's Joker is a figure of fear in 2008's origin story *Batman: The Man Who Laughs*.
Opposite: Lee Bermejo and Mick Gray captured the realism of Christopher Nolan's *The Dark Knight* in 2008's graphic novel *Joker*.

This spread: In these Tony S. Daniel pinups from 2008's *Batman: RIP*, the Joker is armed with a snakelike physicality and a pair of straight razors.
Overleaf: The Joker delivers a love tap in Alan Moore's *Batman: The Killing Joke* (1988). Art by Brian Bolland.

NNMF

SPOTLIGHT ON:
Alan Moore

Acclaimed as one of the best writers in comics, Alan Moore started at DC as part of a 1980s "British Invasion" of influential talent. Moore invigorated the genre title *Swamp Thing* with thoughtful, provocative scripts, and provided the final story of the classic Superman in "Whatever Happened to the Man of Tomorrow?" Moore's *Watchmen* took apart the super hero archetype, while *Batman: The Killing Joke* proved to be a hugely influential take on the psychology of the Joker. In 1999 Moore launched America's Best Comics, published under DC's WildStorm line, which grew to encompass occult-tinged *Promethea*, sci-fi police procedural *Top 10*, science hero *Tom Strong*, and the fantasy/Victorian team-up *The League of Extraordinary Gentlemen*.

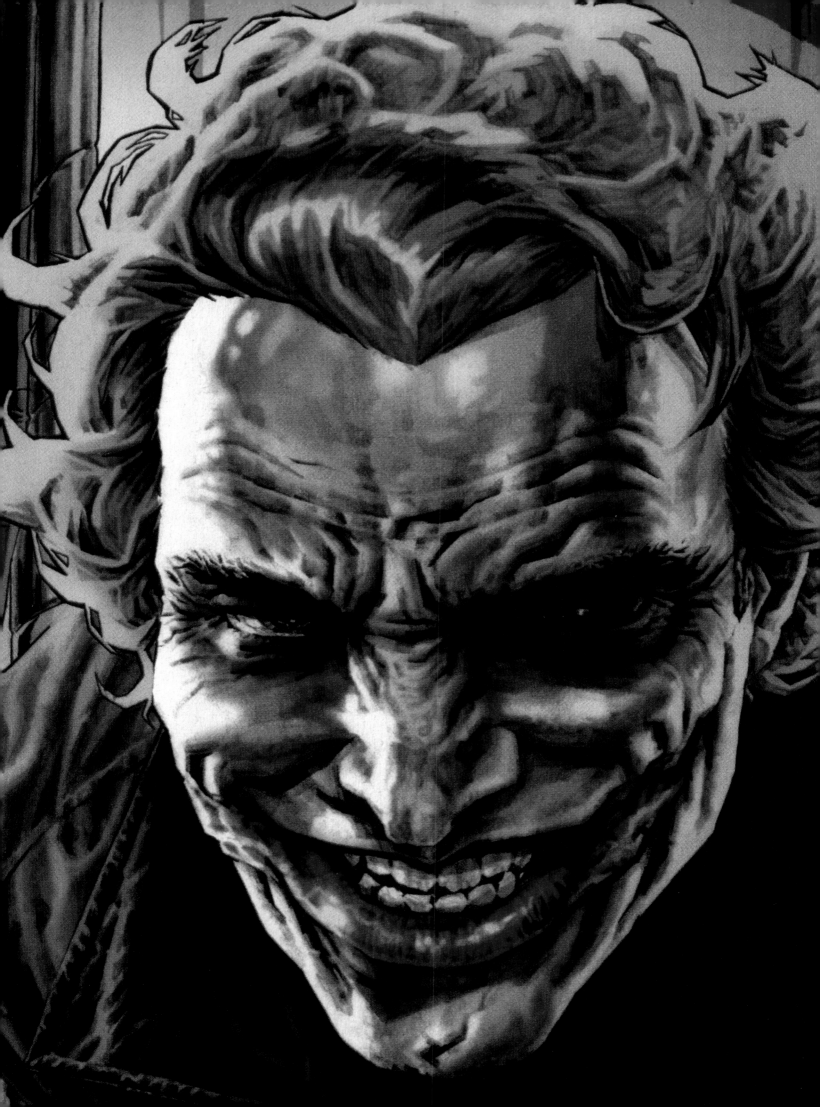

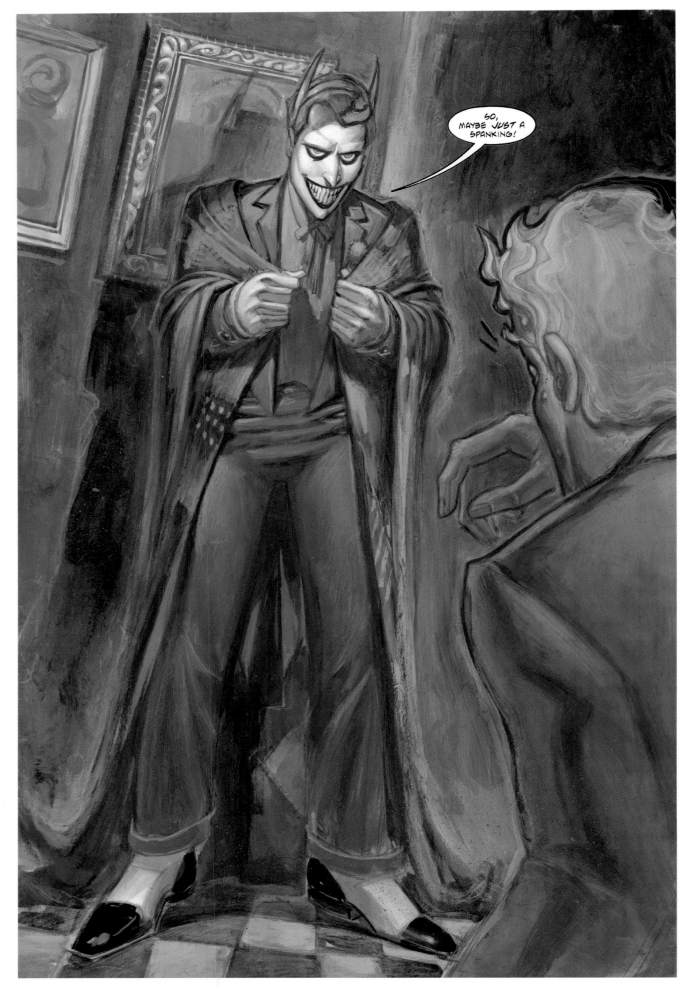

Previous spread left: Alex Ross presents the Joker's triumphs in *Batman: Black and White* vol. 2 (2001).
Previous spread right: Lee Bermejo created this chilling portrait for *Joker* (2008).

Above: Simon Bisley crafted this color-free battle for *Batman: Black and White* (1996).

Opposite: The Joker proposes a spanking good time to Two-Face in *Harley & Ivy: Love on the Lam* (2001), written by Judd Winick and drawn by Joe Chiodo.

Overleaf: A madcap Joker from a DC Comics style guide.

Thanks and Acknowledgements

I'd like to thank Rizzoli/Universe editor, Robb Pearlman, for thinking the world wanted—needed—as he calls it, "*the* book devoted to the multiverse's most-loved homicidal psychopath," and DC Comics Group Editor Steve Korté, for thinking I was the right one to write it! Thanks also to designer Chris McDonnell for his amazing ability to visually translate insanity into book form, production manager Jessica O'Neil for making sure all the blood was the right shade of red, Elizabeth Smith for literally dotting i's and crossing t's, and Rizzoli/Universe publisher Charles Miers for his support. Bat-Collector Saul Ferris provided rare photos, and DC Comics and Warner Bros. staffers Claudia Chong, Meredith Greenberg, John Morgan, Frank Pittarese, Shane Thompson, and Michael Wooten all offered their help. Special thanks to Mark Hamill for his wonderful introduction, and the hundreds of talented artists, writers, and editors who made the Joker the super-villain he is today.